The King's Pictures

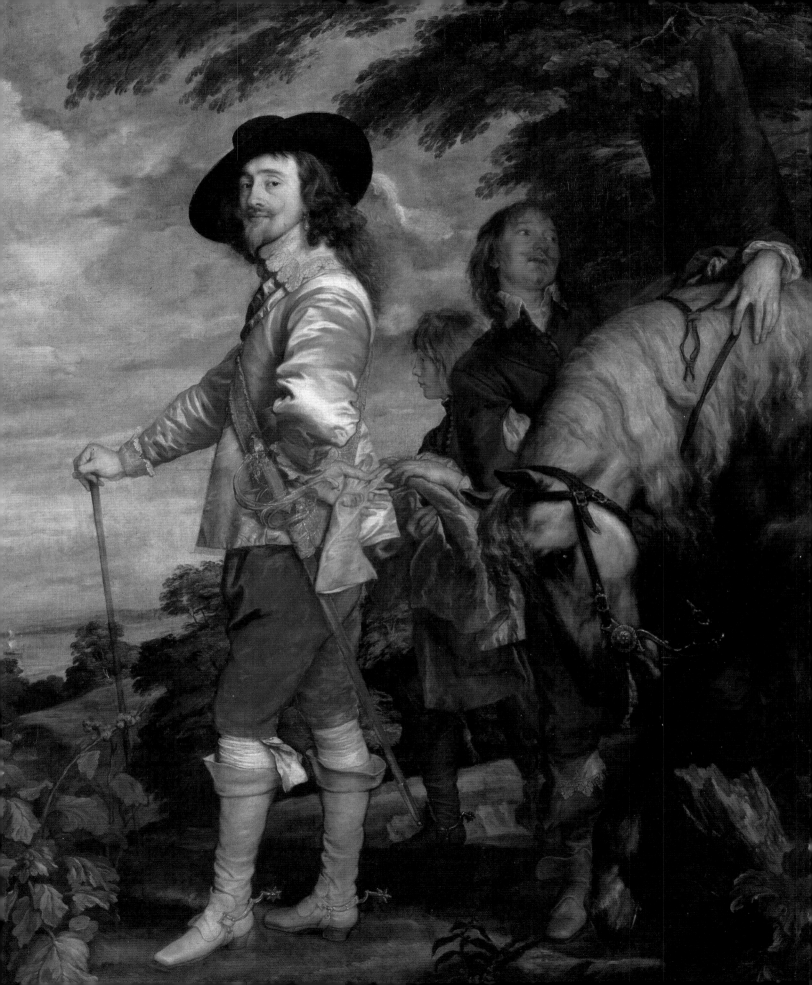

The King's Pictures

THE FORMATION AND DISPERSAL OF THE COLLECTIONS OF CHARLES I AND HIS COURTIERS

FRANCIS HASKELL

Edited and introduced by

KAREN SERRES

With a foreword by

NICHOLAS PENNY

Published for

THE PAUL MELLON CENTRE FOR STUDIES IN BRITISH ART

by

YALE UNIVERSITY PRESS NEW HAVEN AND LONDON

Designed by Gillian Malpass

Printed in China

Library of Congress Control Number: 2013944778
ISBN 978-0-300-19012-0

A catalogue record for this book is available from
The British Library

Frontispiece: Anthony van Dyck, *Charles I (Le Roi à la chasse)* (detail of fig. 86)

CONTENTS

FOREWORD

NICHOLAS PENNY

THIS PUBLICATION OCCUPIES A CENTRAL PLACE IN FRANCIS HASKELL'S ACHIEVEMENT AS AN ART HISTORIAN, DEVELOPING THEMES FOUND IN his first book, *Patrons and Painters*, and anticipating some topics touched on in his last, *The Ephemeral Museum*. It would have appeared long ago, but for Francis's misplaced apprehensions concerning work by other art historians: he thought that there was a limit to public interest in this subject. In this interval of anxiety, his other interests gained momentum and grew in size, preventing him from returning to the task.

Had he lived longer, he would have returned to it, and in doing so he would probably have deepened some of the arguments and allowed some of the personalities a larger role. And he often spoke of his ambition to uncover, in some continental European archive, the true circumstances in which the Duke of Hamilton's collection was sold. But what he had written was suitable for publication. It needed only proper editing, and Larissa Salmina Haskell and I are delighted to have found in Dr Karen Serres an exact scholar with knowledge of the relevant literature and a real sympathy for the range of Francis's interests and the character of his intelligence – someone in fact with whom Francis would have been very happy to collaborate.

That the book is published by Yale University Press for the Paul Mellon Centre would have gratified Francis, who enjoyed close relations with both organisations and in particular with Gillian Malpass at the former and Brian Allen at the latter.

Between visiting a church rich in seventeenth-century epitaphs and a country house with portraits by Van Dyck, Francis might speculate on which of our acquaintance most resembled the proud and solitary Lord Arundel or the diligent and anxious Abraham van der Doort. The Civil War and the Restoration appealed to him perhaps partly because he was fascinated by ideological divisions and compromises, by cosmopolitanism and its limits, by drastic change within venerable foundations – all of which found some echo in his own experience. He loved the seventeenth century because it seemed so close, but also because it was at the same time 'another country'.

1 (*facing page*) Anthony van Dyck, *Rinaldo and Armida* (detail of fig. 12)

The book reveals, more clearly perhaps than anything else that Francis wrote, his outlook as a historian. The past has a vivid hold on those who strive to divest themselves of contemporary values and fashionable ideas. The inevitable measure of ignorance should not inhabit the formation of bold, if provisional, generalisations, provided these arise from the study of particular situations, personalities, words, or indeed significant silences (which Francis was especially astute in detecting). Consequences, in the way art or indeed politics evolved, are often unintended, never predictable, often paradoxical. But one consequence of this sort of historical approach is clear. It extends our imaginative sympathy whilst encouraging scepticism – reinforcing the conviction that it is often best to lack conviction.

December 2012

INTRODUCTION

KAREN SERRES

IN 1994, PROFESSOR FRANCIS HASKELL RECEIVED AN INVITATION FROM THE PAUL MELLON CENTRE FOR STUDIES IN BRITISH ART IN LONDON TO deliver the inaugural Paul Mellon Lectures. Over the course of six lectures, he expanded the subject of his landmark essay 'Charles I's Collection of Pictures' and presented the fruits of more than a decade of research on art collecting in seventeenth-century England. In particular, he explored the dramatic story of the dispersal during the English Civil War of the extraordinary holdings of Old Master paintings assembled by the King and his courtiers only decades earlier. A testament to their reputation and quality, these art collections attracted interest all over Europe, from Madrid to Paris, Brussels, Vienna and Cologne, and their sales reshuffled the international distribution of art, with consequences felt to this day. A large number of works entered collections that would eventually constitute the core of the Continent's greatest museums. It is thus no exaggeration to say that, with these events, 'the artistic map of Europe was transformed' (chapter 1).

Early in the seventeenth century a new chapter in the history of collecting was opened. The signing of the Treaty of London in 1604 marked a respite in the decades-long hostilities with Spain and the resumption of relations between England and other European powers. Diplomatic gifts were actively encouraged by the royal family, especially by Henry, Prince of Wales, who also attempted to attract foreign artists to the English court. This project was developed by his brother Charles but met with limited success. Even the artists who did come to London, including Anthony van Dyck and Orazio Gentileschi, never worked exclusively for the royal family. However, this tentative patronage of contemporary artists was surpassed by an unprecedented secondary market for pictures by the most famous masters of earlier centuries. While restrictions on the importation of paintings remained nominally in effect until the late 1680s, prominent courtiers and their agents scoured Europe to find works of art, both of quality and in quantity, wherever possible purchasing collections en bloc. The ability to engage in knowledgeable conversation about Titian, Veronese and Tintoretto, as well as Raphael and Leonardo, became an indispensable tool in the arsenal of every courtier.

Connoisseurship turned into a mark of nobility, enthusiastically encouraged by the King, who once rebuked Peter Paul Rubens for misleadingly presenting as autograph a painting executed by his studio assistants.

The six chapters of this book follow the format chosen by Haskell for his lectures. The first two introduce the key collectors at the Stuart court, from the Earl of Arundel to the Duke of Buckingham, the Duke of Hamilton and Charles I, and the types of collections they amassed, sometimes in collaboration but most often in competition with one another. They also focus on the fascinating men employed as advisers and explore how these individuals were able to assemble such spectacular holdings in so short a time. Chapters 3 and 4 address respectively the problematic reception of works of art, particularly of paintings from Catholic Italy, in post-Reformation England, and the beginning of the dispersal of some of the most important art collections in the years leading up to and during the Civil War, which broke out in 1642. In the 1640s, the exile and death of the Earl of Arundel and troubled circumstances of the second Duke of Buckingham and the dukes of Hamilton resulted in the sale on the Continent of their most important paintings, in order to cover expenses or raise funds for the King's cause. In 1649, the defeated King's own collection was inventoried and slowly dispersed to pay his creditors and finance the new Commonwealth. The final two chapters address the vicissitudes of the sale of the 'Late King's Goods' from 1649 to 1653, especially the rivalry between the Spanish and French ambassadors to obtain the finest examples for their sovereigns, and the efforts, a decade later, by Charles II to reclaim his father's property. While the chapters adopt a roughly chronological approach, the compressed nature of the events described and the parallel fortunes of the key figures preclude a strict linear narrative. Haskell's aim was above all to provide 'a synopsis of a vast topic that has never yet been treated as a whole' (chapter 1). He shed light on collecting patterns in seventeenth-century England and set them within a wider European context, highlighting the importance of cultural networks throughout the Continent, the role played by emulation among art collectors and the impact of political and economic tides.

From his earliest publications on the history of collecting, most famously *Patrons and Painters: A Study in the Relations between Italian Art and Society in the Age of the Baroque* (1963, revised 1980), Haskell emphasized the importance of the individual in understanding the history of taste and demonstrated that, more than any overarching theoretical stance, a collector's personality, his political and cultural networks and his private relationships constituted key factors in determining the character of his collection. This is especially interesting in Stuart England, where access to the fine arts was initially limited to a small circle of courtiers and their agents. The history of taste must thus take into account the widely varying impulses behind each man's collection. The Earl of Arundel, for example, was a voracious collector, who even in the face of his changing fortunes at court and financial difficulties

perceived his endeavour within a wider humanistic programme of supporting scholarship, as well as an emblem of his august lineage. The recently created Duke of Buckingham, on the other hand, had a tactical understanding that a superlative art collection would secure his position within the royal household. The men who, decades later, acquired items from the late King's sale had similarly diverse motivations, whether financially opportunistic, as in the case of several enterprising officers and tradesmen of luxury goods, aesthetic or simply nostalgic.

Scholars working in the field of English collecting owe a great debt to the pioneering publications of Sir Oliver Millar, who generously shared his expertise with Haskell. The latter also benefited from the work of a younger generation of scholars including Arthur MacGregor, Paul Shakeshaft, Jeremy Wood, Timothy Wilks and Philip McEvansoneya, who brought important new archival material to light. Haskell himself combed through parliamentary papers, dispatches, tracts, pamphlets, memoirs, diaries and correspondence, which allowed him to bring a fresh perspective to the history of English collecting and question some long-ingrained assumptions. He was, in particular, struck by 'how rare are the [contemporary] references to what were, by any standards, the most amazing art collections of the seventeenth century, or perhaps ever' (correspondence with Christopher Hill, 28 July 1994). Scholars debating the causes of the Civil War have often argued that Charles I's expenses in the field of the fine arts undermined his political credibility, with disastrous results. In fact, as Haskell noted, the King's collection was barely mentioned in the dozens of pamphlets vilifying the royal family published during the Commonwealth, at a time when its sale was under way at Somerset House. While these public sales theoretically gave access to the King's goods to all, in practice only a small number of individuals acquired works of art. Even fewer purchased them for purely aesthetic reasons, valuing them instead as commodities and using them to pit foreign buyers against each other. Despite claims at the Restoration that the paintings recovered by Charles II's agents in the homes of merchants and artists were being saved for England, the 'preserved treasures' were often what had remained unsold.

In the almost two decades since the lectures, the field of Stuart court studies has been the subject of renewed attention, albeit with an emphasis on performance arts and architecture more than on art collecting. One exception is *The Sale of the Late King's Goods: Charles I and his Art Collection* (2006) by Jerry Brotton, which covers a chronological span similar to Haskell's study, roughly from 1610 to 1660. Their approaches and conclusions, however, differ significantly. In particular, Haskell's analysis of the reputation of individual artists and hierarchy of desirable paintings, as well as his charting of international artistic networks, the development of the market for Italian painting and the rise of connoisseurship, find no echo in Brotton's study. While the latter contends that the sale of Charles I's collection increased

awareness of art in England and provided access to the fine arts to a wider segment of the population than ever before, Haskell demonstrates how many of the best pieces rapidly left the country, never to return.

The avid European art collectors who benefited from this turn of events, such as Cardinal Mazarin, Archduke Leopold Wilhelm and the Spanish minister and Grandee Luis de Haro, have been the subject of recent valuable studies. In addition, the important exhibition by Jonathan Brown and John Elliott, *The Sale of the Century: Artistic Relations between Spain and Great Britain, 1604–1655* (2002), shed light on the complex cultural relations between England and Spain in the first half of the seventeenth century, with a particular focus on the circulation of paintings and the Spanish purchases during the Commonwealth sales. Most valuably, the catalogue makes available to a wider audience archival documents previously published in sources difficult to access. Jonathan Brown's earlier landmark study *Kings and Connoisseurs: Collecting Art in Seventeenth-Century Europe* (1995) provided a broader overview, examining the evolving patterns of collecting that took place throughout Europe over the course of the century. Foreign figures are not the only beneficiaries of the sales to have been the subject of further research. In the wake of Haskell's lectures, the role of English art patrons during the Commonwealth, most prominently Philip Sidney, Lord Lisle, has also been reassessed (see especially Hilary Maddicott's two articles of 1998 and 1999). Like the collections assembled decades before, those created during the Commonwealth have not survived intact, but the collecting enterprise during those complex times retains its fascination. Similarly, the recent survey *The British as Art Collectors* by James Stourton and Charles Sebag-Montefiore (2012) draws heavily on Haskell's conclusions for its chapters on collecting in the seventeenth century.

One of the most interesting aspects of the period, and one that Haskell was keen to emphasize, was the irresistible appeal Italian art of the Renaissance held for Charles I and his courtiers, an appeal even more intriguing when one considers how sixteenth-century masterpieces – nude goddesses and ostentatious religious scenes – could have been perceived in an Anglican country still reeling from war with 'Popish' European powers. The issue of the market for Italian art in seventeenth-century Europe was the subject of one of Haskell's earliest publications (*Past & Present*, April 1959). It was in response to this article that the historian Lawrence Stone drew attention to the then overlooked 'passionate hunt for Italian old masters and a certain patronage of works by living Italian artists at the Court of the Early Stuarts' (letter to the editor, *Past & Present*, November 1959). This passionate hunt, and equally feverish dispersal, had to wait for Haskell's 1989 essay and later his Paul Mellon lectures to receive extensive treatment and analysis. In recent years, aspects of the interest in Italian art have been explored further in a collection of essays edited by Edward Chaney, *The Evolution of English Collecting: Receptions of Italian Art in the Tudor and Stuart Periods*

(2003), and in the beautiful exhibition *The Art of Italy in the Royal Collection: Renaissance and Baroque* (2007) curated by Lucy Whitaker and Martin Clayton at the Queen's Gallery. Another development has been the number of studies on the collecting and reception of individual Italian painters in seventeenth-century England, including the Bassano family, Correggio, Titian and Adam Elsheimer (who spent most of his career in Rome). These studies complement important monographic publications on foreign artists at the Stuart court, such as the monumental catalogue raisonné *Van Dyck: A Complete Catalogue of the Paintings* (2004).

The references accompanying Haskell's text were partly reconstructed from his personal papers, which he continued to augment until his death in January 2000 (they have now been deposited in the archive of the National Gallery, London). He pursued his research on the topic meticulously, filing new publications, recording discoveries in the field and tracking paintings on the market and in museums that bore the mark of Charles I. His files indicate that he also had an ongoing interest in the visual representation of the King (the subject of a lecture posthumously published in 2002); in the commissioning of copies after Italian masters in England, their status in the royal collection and their impact on the perception of the originals; and in issues surrounding the distribution and display of art in aristocratic homes in London and in the country. Insights on all of these topics would have undoubtedly enriched the present lectures had Haskell been able to expand them fully into book form. As it is, the endnotes focus on the sources he drew on for his lectures and are augmented by the editor with an updated list of publications, some of which include research and archival material that Haskell had consulted in manuscript form. Whenever new or complementary information has come to light, the text itself has been updated. It has also been edited to moderate the conversational tone of the lecture format, but not altered substantially.

In addition to the scholars mentioned above, the following colleagues and friends corresponded with Professor Haskell and provided crucial guidance and insights: Gerald Aylmer, Jonathan Brown, Howard Colvin, Clive Griffin, Christopher Hill, Alastair Laing, Patrick Michel, Iain Pears, Lois Potter, R. Malcolm Smuts and Christopher White. The lectures greatly benefited also from the assistance of the staffs of the Bodleian Library, the British Library, the Yale Center for British Art and the Getty Provenance Index. Their publication would not have been possible without the decisive support of Larissa Salmina Haskell, Gillian Malpass and the Paul Mellon Centre for Studies in British Art (in particular, Brian Allen and Maisoon Rehani). The extensive illustration of this volume was made possible by a generous grant from the Centre. Nicholas Penny guided this project with his customary zeal and erudition and made innumerable contributions.

A NOTE ON DATES

Dates follow the style adopted by the authors of the documents cited. Thus, English writers used the Old Style Julian calendar, as did Parliamentary papers (though the editors of the latter adjusted the start of the year to 1 January), whereas writers from continental Europe abided by the New Style Gregorian calendar.

2 (*facing page*) Domenico Fetti, *Hero and Leander* (detail of fig. 79)

I

ART COLLECTORS IN LONDON ON
THE EVE OF THE CIVIL WAR

In 1697 THE CONNOISSEUR AND DIARIST JOHN EVELYN REFERRED, WITH TANTALIZING RETICENCE, TO A CERTAIN 'GREAT PERSON, WHO, WHEN THE Turks invaded [the city of] Cand[ia] [on the island of Crete] and alarm'd the Venetians, was wont (not without some secret pleasure) to reckon, at how easie rates Statues would be purchas'd, should the Turks [also] set foot in Italy'.[1] As this clear-sighted, if chilling, observation suggests, the keenest art collectors (as distinct from art patrons) have nearly always achieved their principal triumphs at the expense of others less fortunate than themselves. Charles I, Lord Arundel, the Duke of Buckingham and other courtiers who followed their example in London were not exceptions to this rule, but neither were Cardinal Mazarin, Philip IV of Spain and the Habsburg Archduke Leopold Wilhelm, who, as we shall see, were able to enrich their cabinets to immeasurable effect thanks to the scaffolds that were to be erected in Whitehall. But this book is very definitely not intended to constitute a lament for a lost and dubious 'national heritage'. What I aim to do, above all, is to emphasize that the dispersal of the Stuart collections – even more than their formation – represents one of the most important movements in the history of European taste and collecting as a whole. Never before had pictures travelled so extensively or been seen (and even owned) by so many different people. The artistic map of Europe was transformed, so that it is no exaggeration to claim that a series of sales between 1643 and 1654 decidedly influenced which works have entered national canons of art history, and even affected our holidays destinations.

Much of what follows will be broadly familiar in outline. But I have to emphasize that qualifying phrase 'in outline' because – astonishingly enough – it is only very recently indeed that a number of scholars have made systematic attempts to track down the objects and dig up and evaluate the scattered and fragmentary documents that need to be collated if we are to get an accurate impression of what was a brief, but in retrospect very influential, moment

3 (*facing page*) Daniel Mytens, *Aletheia, Countess of Arundel* (detail of fig. 22)

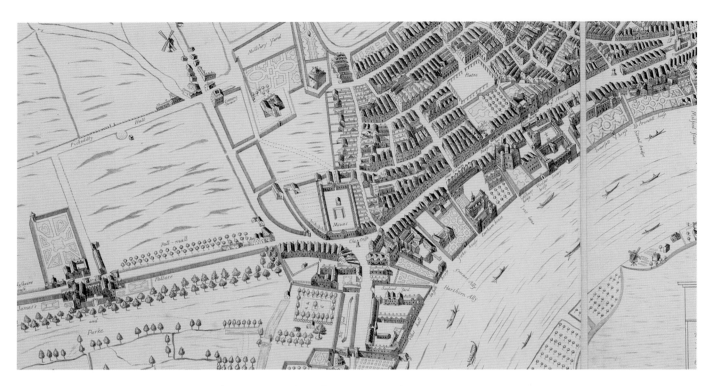

4 *An Exact Delineation of the Cities of London and Westminster* (detail), composed by Richard Newcourt and engraved by William Faithorne, surveyed 1643–7, published 1658, reprinted 1857. London, British Library. St James's Palace stands to the west. Along the river are Whitehall Palace and houses of Charles I's courtiers (from south to northeast)

in cultural history. I am acutely aware of the fact that a great deal more needs to be done, and that an adequate treatment of the subject would require an analytical, perhaps even a theoretical, approach, as well as one that relies essentially on narrative. But profounder insights will be possible only when we have become familiar with the material at our disposal, and I must therefore explain at once that I shall be trying to do no more than give a synopsis of a vast topic that has never yet been treated as a whole and, above all, to set it within the wider context of European collecting.

When on 10 January 1642 Charles I left London for the last time until his forced return to be tried and executed seven years later, the concentration of great paintings in his capital was so great that if, on that day, you had chosen to go for a stroll through the centre of town it would have taken you barely half an hour to pass the principal palaces in which were to be found masterpieces of a kind unrivalled, in quantity and quality, in any other single city in Europe, except for Rome and perhaps Madrid, and capable indeed of standing comparison with what could be seen in all of them combined (fig. 4).

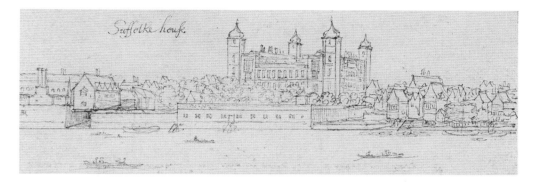

5 Wenceslaus Hollar, *Suffolk House*, Cambridge, Magdalene College, Pepys Library

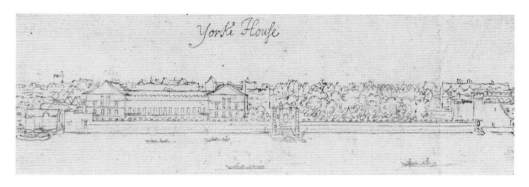

6 Wenceslaus Hollar, *York House*, Cambridge, Magdalene College, Pepys Library

We might have started with St James's Palace, home of some of the King's most magnificent pictures and the finest of his ancient statues, and then moved across the park to Wallingford House (near the site of the present Admiralty), which was sufficiently close to Inigo Jones's Banqueting House on the other side of the road to enable the spectators who were to assemble there in 1649 to get a good view of the beheading of Charles I. In this sprawling Elizabethan edifice were almost certainly to be seen not exactly the Duke of Hamilton's six hundred pictures – more than half of them Venetian – but at least the crates into which they had recently been packed in preparation for their shipment to Scotland. Whitehall Palace, made up of a series of loosely connected buildings crammed with great and famous pictures, extended down to the Thames. Walking along the Strand we would have passed one mansion after another with gardens overlooking the river. Suffolk House (fig. 5) would, within a few months, come into the possession of Lord Northumberland and be magnificently rebuilt and redecorated to accommodate the splendid pictures that were to be hung in it. Next door stood York House (fig. 6), where the treasures acquired by the 1st Duke of Buckingham still

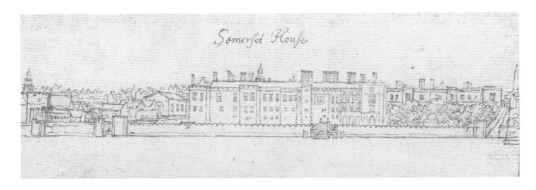

7 Wenceslaus Hollar, *Somerset House*, Cambridge, Magdalene College, Pepys Library

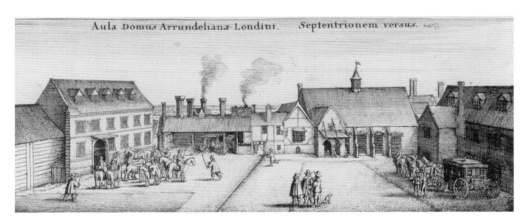

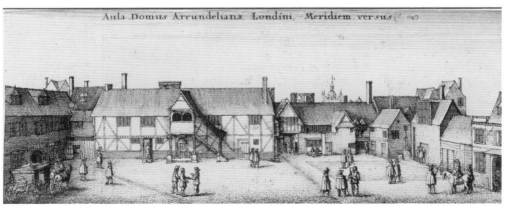

8 and 9 (*above and centre*) Wenceslaus Hollar, *Arundel House*, Cambridge, Magdalene College, Pepys Library

survived more or less intact fifteen years after his murder, much to the satisfaction of the same Lord Northumberland, who was to rent it while his own neighbouring mansion was being made ready for him. Durham House was leased by the Bishop of Durham to the 4th Earl of Pembroke, who owned some striking Venetian pictures and, above all, the superb group of van Dyck portraits, later to be transferred to his country house of Wilton where they remain in the Double Cube Room. Beyond this was Denmark House (or Somerset House; fig. 7), which Charles I had given to his wife Henrietta Maria. Antique statues adorned its terraces and grounds, but to most visitors its distinguishing feature must have been the Roman Catholic chapel filled with rather indifferent pictures of the Virgin Mary and Mary Magdalene and with richly embroidered copes and altar cloths.[2] Finally, near what is now Temple underground station stood Arundel House (figs 8 and 9) with its great gallery of portraits 'by old German and Dutch masters; some by Raphael of Urbino, by Leonardo da Vinci, by Titian, Tintoretto, and Paul Veronese'[3] and its grounds so full of 'ancient statues of naked men and women' that Francis Bacon is supposed to have exclaimed 'The Resurrection!' when he first caught sight of them.[4]

To get a complete impression of the greatest works of art in England in 1642, it would also have been necessary to make a few expeditions further afield: down the river to Blackfriars, for instance, where van Dyck's collection of nineteen Titians still remained precariously untouched a month or so after his death;[5] to the village of Chelsea; and to the countryside, so as to inspect the royal palaces of Richmond, Windsor Castle, Greenwich, Hampton Court and Nonesuch. But even so, the impact of so much excellence crammed into so small an area must have been overwhelming to those able to gain access to it. This and the next chapter speculate a little on the aspects that might especially have struck the more cultivated members of the English court (or foreign visitors to England) who were also familiar with some of the principal collections that had, more gradually, been assembled on the Continent.

It would not have been too difficult to come across a number of such men in the London of Charles I, and it is fitting to meet them first because it was essentially their taste, rather than that of most of the princely figures around whom they gravitated, that determined which pictures should come to London in the first place; their enterprise that ensured that they did come; and their connoisseurship that can give us some idea of what in 1642 was to be seen in the palaces of Whitehall and the Strand. If their attributions sometimes appear to us to have been over-optimistic, we need to remember how much of what they were able to see cannot be seen by us because it has been lost or destroyed.

We can begin with the devious, scheming, boastful and extremely gifted Balthazar Gerbier (1592–1663/7; fig. 10), born in the Low Countries of Huguenot parents and himself an artist – although in view of his very limited talents in this field it is not surprising that he later denied this.[6] Before being employed by the King, he had been taken up by the Duke of

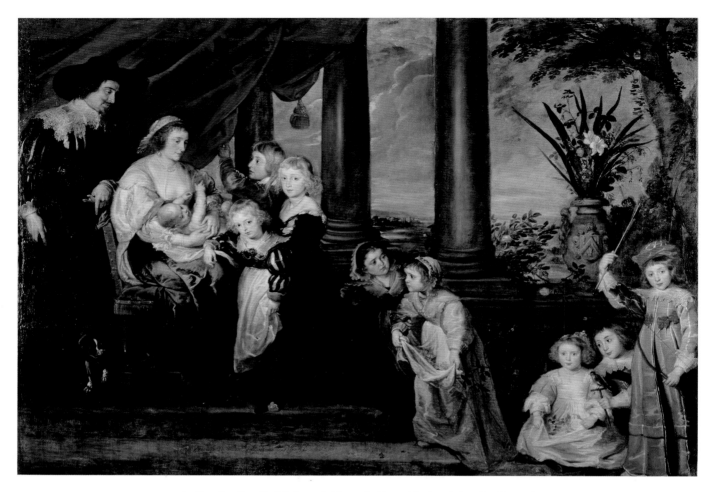

10 Attributed to Peter Paul Rubens, *Balthazar Gerbier and his Family*, Royal Collection Trust

Buckingham, partly on the strength of his knowledge of foreign languages, and he was thoroughly familiar with artistic (and political) developments in Spain, France, Italy and the Low Countries. He made use of his contacts to build up a spectacular collection for the Duke, but the only two men to whom he remained consistently loyal were himself and Rubens – for whom he sought to obtain commissions until the last possible moment.

Almost as influential was Endymion Porter (1587–1649; fig. 11), a man extravagantly pleased with his own appearance and not too scrupulous about the financial arrangements he had had to make to ensure his social advancement.[7] He was a friend of Gerbier and of most of the poets and painters of the day, and his tastes too were markedly cosmopolitan. As an adolescent he had spent some years in Spain, to which he returned on a number of occasions

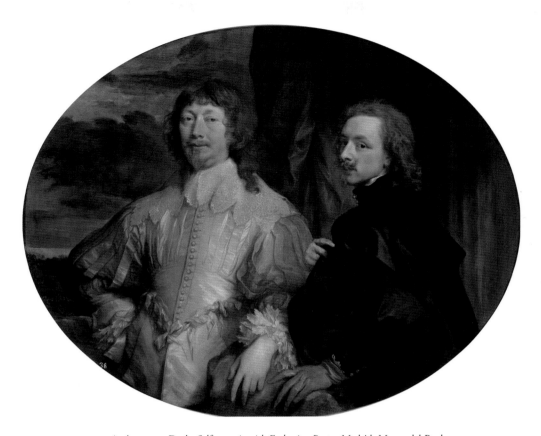

11 Anthony van Dyck, *Self-portrait with Endymion Porter*, Madrid, Museo del Prado

and where he bought pictures for himself and for the King. But he was also actively involved in the art market in the Low Countries, and it was on a visit to Antwerp that he commissioned for Charles one of the most splendid and ambitious of all his van Dycks, *Rinaldo and Armida* (fig. 12).[8]

Then there was the part-time naval commander Kenelm Digby (1603–1665; fig. 13), one of the most prodigal characters of the age, equally at home in Paris, Madrid and Rome. As a young man of eighteen, he had been the unwilling recipient of advances from Marie de' Medici then 'in the prime of middle life',[9] and later he was to become the tireless champion of the much-denigrated morals of his own wife, who was painted for him by van Dyck in the guise of Prudence, sitting calmly, unbesmirched by two-faced Envy, as she awaits the crowning acknowledgement of her virtue (fig. 14).[10] A Catholic convert after Venetia's premature death (but had he ever *not* been a Catholic?), a philosopher and alchemist who promoted a 'powder of sympathy' capable of healing wounds at a distance of thirty miles,

12 Anthony van Dyck, *Rinaldo and Armida*, Baltimore Museum of Art

13 Anthony van Dyck, *Sir Kenelm Digby*,
London, National Portrait Gallery

14 Anthony van Dyck, *Venetia, Lady Digby as Prudence*,
London, National Portrait Gallery

this friend of Ben Jonson and admirer of Galileo and Descartes interests us chiefly on account of his excavations on the Greek island of Delos, which added to the antiquities in the royal collection, and as one of the few men in England who really sympathized with van Dyck's frustration at being forced to confine himself to endlessly repetitive portraiture. Digby encouraged him to paint allegories, commissioned devotional pictures from him and in a well-meaning, but surely misleading, account of his life circulated exaggerated stories about the number of mythologies he had painted for the court.[11]

Of more immediate practical use to Charles was Nicholas Lanier (bap. 1588–d. 1666; fig. 39), 'Master of the King's Musick', who was sent to Mantua first to spy out the art collections built up by the Gonzaga dukes of the city, which were rumoured to be for sale, and then – a year later – to pull off (with the help of a number of other agents) the most important coup of the whole period: the acquisition of most of them en bloc and their

15 Anthony van Dyck, *Inigo Jones*, St Petersburg, State Hermitage Museum

removal to London.[12] Lanier is not quite so well known to us as some of his contemporaries, but his enthusiasm for art comes across vividly in a letter he wrote to a dealer who invited him to see some drawings (which he collected for himself as well as for Lord Arundel): 'ma, ma, ma che i disegni siano buoni, buoni, buonissimi'.[13] Above all, he lives for us in van Dyck's wonderfully refined portrait (fig. 39), which, so it was said, when seen by the King very understandably persuaded him to invite van Dyck to England as his court painter.[14]

I should perhaps have mentioned earlier the most distinguished, as well as the oldest, of all these connoisseurs in London on the eve of the Civil War, but, in fact, it was just his age that might have presented some difficulties for Inigo Jones (1573–1652; fig. 15) in this respect. He was now sixty-nine, and he had not been abroad for nearly thirty years, although it is true that he had then been able to study the arts of Italy (partly in the company of Lord Arundel) more carefully than any of his predecessors or contemporaries. His place at court as architect and designer of masques remained, however, of supreme importance and he always followed the purchases of his patrons with intense enthusiasm. Thus when Titian's double portrait *Cardinal Georges d'Armagnac and his Secretary, Guillaume Philandrier* (fig. 16) reached England in 1624 from Paris, where Balthazar Gerbier had bought it for the Duke of Buckingham, Jones 'almost went down on his knees before it'.[15] A dozen years later we find him flinging off his cloak and taking up his eyeglasses and a candle to examine the latest consignment of pictures sent from Rome to Queen Henrietta Maria through the mediation of the papal agent – among them the *Portrait of a Lady* now attributed to Puligo (fig. 17) and then believed to be by Andrea del Sarto, for which he expressed special admiration.[16] Thus, although Inigo Jones was somewhat out of touch with most of the dramatic changes that had come over the arts in Italy since his visit, he – like the other figures I have mentioned – was well able to apply the highest criteria of European taste to estimate the nature and value of what was now to be seen in London.

So too was the only other man I have room – but also the obligation – to mention: the most modest (and saddest of them all), Abraham van der Doort (d. 1640; fig. 18).[17] This Dutch modeller in wax and numismatist had been employed at the court of the Emperor Rudolf II in Prague, and after he came to England, Charles inherited his services from his elder brother Prince Henry. Van der Doort's role in designing, and encouraging others to design, the admirable coinage that marked the reign of Charles I was a major one,[18] but here I must refer to him only in his capacity as 'Surveyor of all our pictures of Us, Our Heires and Successors . . . at Whitehall and other our houses of resort'.[19] Anyone who has read through van der Doort's catalogue of the royal collection will surely agree with Oliver Millar that it 'is perhaps the finest inventory of its kind ever compiled in England'.[20] The detailed, and often vivid, description of each picture and discussion of its frame, the information given about provenance, and the distinctions drawn between originals, copies and insecure

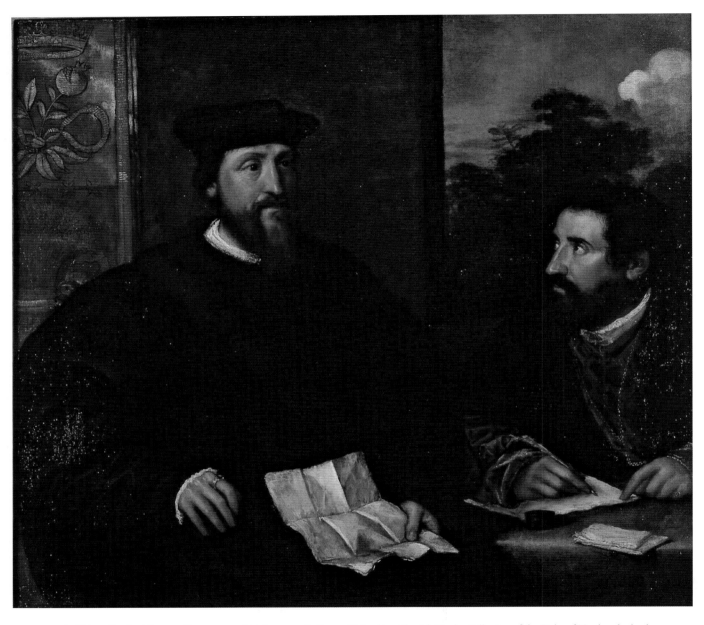

16 Titian, *Cardinal Georges d'Armagnac and his Secretary, Guillaume Philandrier*, Alnwick Castle, Collection of the Duke of Northumberland

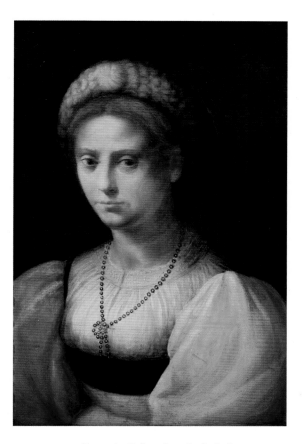

17 Domenico Puligo, *Portrait of a Lady*,
Royal Collection Trust

attributions reveal an extraordinarily informed and perceptive approach to art. It is painful to think of this major, but anxiety-ridden, scholar driven to suicide by intrigue and unfounded rumours that the King was planning to replace him.

Just what might these men have thought of the handful of collectors who, for a couple of generations at most, had been filling with masterpieces (acquired from Spain, Italy, France, Germany and the Low Countries) the interiors of their unfashionable and ramshackle London houses, to which they would, from time to time, add a façade or a new wing in the modern Italianate style? They would certainly not have been as surprised as their fathers might have been that it was by now commonplace for works of art to be imported into England from the Continent, for in many parts of Europe, and especially in Italy, it was taken for granted that a rise in status should be accompanied by an interest in the arts. This was a process much encouraged, for obvious reasons, by artists themselves, their biographers

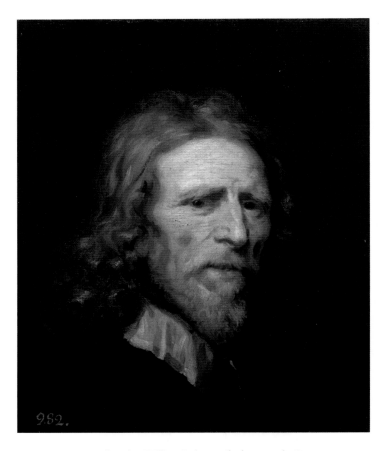

18 Attributed to William Dobson, *Abraham van der Doort*,
St Petersburg, State Hermitage Museum

and also by dealers, and it had become incorporated into that very popular form of litera-
ture, soon translated and adapted by English writers, which set out to analyse the role of the
ideal courtier.[21]

Since the early years of the century, ambassadors in Venice and the Low Countries espe-
cially had come to look upon it as part of their jobs to select, and to send back, pictures and
luxury goods to a steadily growing number of prominent peers, as well as 'many Knights
and Gentlemen'[22] – and this became easier as England kept free of continental wars.[23] And
although James I showed little interest in such transactions, the short-lived enthusiasm of his
elder son, Prince Henry (1594–1612), was sufficiently well known to attract welcome gifts
from friendly governments, including a set of small bronzes by Giambologna from the Medici
Grand-Dukes of Florence.[24] In addition, the demand for portraits, whether by resident

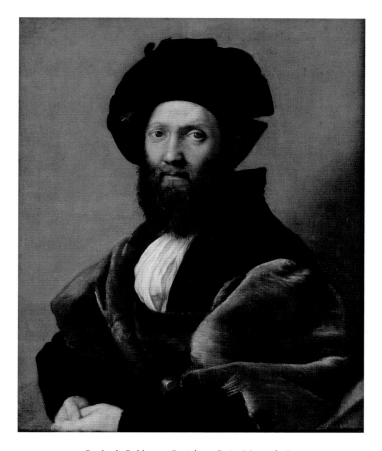

19 Raphael, *Baldassare Castiglione*, Paris, Musée du Louvre

English artists or foreign visitors, was always intense. Despite all this, the scale of British col-
lecting remained relatively limited and did not make a major impact on the international
market until the mid- to late 1620s and especially the 1630s, when it increased prodigiously.
The connoisseurs I have been referring to would have realized that a similar phenomenon
was happening in other parts of Europe at much the same time. After many years of relative
dormancy, the Spanish court was galvanized into action under Philip IV and the Count-
Duke of Olivares – much to the distress of English competitors – and in France the patron-
age and collecting of Marie de' Medici and then of Cardinal Richelieu moved to a climax.
Major Italian pictures, such as the portrait by Raphael of Baldassare Castiglione (fig. 19), were
already to be found in Amsterdam when in about 1634 two Calvinist merchants, the broth-
ers Gerard (1599–1658) and Jan (1601–1646) Reynst began to build up a private cabinet of
pictures that could rival any of the kind in Europe.[25] Developments in England thus

followed a fairly typical pattern, one consequence of which would have been as apparent to contemporaries as it is to us. Increasing competition for the best led to increasing prestige and prices, and this in turn restricted the number of those who could become involved. By the time the Civil War broke out, four men utterly dominated the scene – men whose temperaments, factional allegiances, and personal relationships were often mutually uncongenial despite the interests they shared.

Thomas Howard, 2nd Earl of Arundel (1585–1646; fig. 21), who was aged fifty-seven at the beginning of the Civil War, had been a collector ever since the second, and even possibly the first, decade of the century.[26] Arundel was brought up as a Catholic, and his childhood was lonely and unhappy. He became a proud, somewhat haughty, man who felt out of place in Stuart England, so that, in Clarendon's expressive phrase, 'he seemed to live as it were in another nation'.[27] Like many such men he made little conscious attempt to impress or gain favour with his peers. One of his contemporaries in the House of Lords described the impact he made in a telling description: 'Here comes the Earl of Arundel in his plain Stuff and trunk Hose, and his beard in his Teeth, that [yet] looks more like a Noble Man than any of us'.[28] Like many proud men, he found it difficult to get on easily with his social equals, including both his wife, Aletheia Talbot (d. 1654; fig. 22), who was a remarkable collector in her own right,[29] and his sovereign, of whom he disapproved because of his 'too great Affability'[30] – not a complaint anyone else made about Charles I, and a surprising one to hear from Arundel, who at one time had been imprisoned, banished and humiliated by the King.

Fortunately for us he was far more at ease with artists and scholars and, above all, in Italy, which he visited in 1612 and again, at length, in 1613 and 1614, partly in the company of Inigo Jones. He also travelled to France and the Low Countries, from which he was able in about 1619 to obtain what became probably the most famous picture in England, for it was believed to be by Raphael (though it is, of course, a masterpiece by Sebastiano del Piombo), the portrait of Ferry Carondelet with his secretaries (fig. 20).[31] In addition to all this, a diplomatic mission took him to the Holy Roman Empire, accompanied by the Bohemian draughtsman and etcher Wenceslaus Hollar (1607–1677), who recorded for him some of the more striking sights of their journey (fig. 23).[32] During the Civil War, Arundel remained abroad. He raised money for the royal cause, but in effect he abandoned the King whom he had served in many positions of great importance but whom he had never much liked. His experiences on the Continent made Arundel more famous there as a collector than anyone else in England.

George Villiers (1592–1628; fig. 24), later 1st Duke of Buckingham, owed his position at court – and thus in the international circle of art collectors – not to his birth, though he came of an old family, but to his looks, which in 1614 caught the roving eye of the *louche* James I.[33] He soon began to accumulate posts, titles and a fortune. Moreover, such was his

20 Sebastiano del Piombo, *Ferry Carondelet and his Secretaries*, Madrid, Museo Thyssen-Bornemisza

21 Peter Paul Rubens, *Thomas Howard, 2nd Earl of Arundel,*
Oxford, Ashmolean Museum

charm, the polish of his manners, his supreme self-confidence (not to say arrogance) and his reckless ambition that he won the equally devoted, though chaster, affection of James's diffident and more straight-laced son Charles. That polish was acquired in France, where he had spent three years as a young man and where (rather surprisingly) were to be found a number of the finest pictures that he was later to acquire. He also learnt to speak French, not very well, but enough to make communication with Rubens easier than it might other-

22 Daniel Mytens, *Aletheia, Countess of Arundel*, London, National Portrait Gallery

23 Wenceslaus Hollar, *Würzburg Castle*, London, British Museum

wise have been when they met some years afterwards in Paris (fig. 25). Buckingham began to collect in the late 1610s when he was in his twenties, and within two years or so he was able not only to rival but even to outclass Arundel (who for a decade or so was the only Englishman to make an outstanding mark on the international market) with the purchase, made through Balthazar Gerbier and for a considerable price, of one of the most spectacular and famous pictures in Venice, Titian's *Ecce Homo* (fig. 26), for which, half a century earlier, the King of France had yearned and which Arundel was also desperate to get hold of.[34] It would be absurd to claim that the always uneasy and sometimes bitter relations between Arundel and Buckingham were due to such (well-documented) rivalries – matters of policy, as well as of style and of dynastic pride, played a notable part – but they were certainly exacerbated by them, and it is difficult not to wonder whether Arundel may not have remembered yet again his disappointment over Titian's *Ecce Homo* when, in an extraordinary gesture, he and his wife went to visit the Duke of Buckingham's murderer in prison on the night before his execution.[35] That murder took place in August 1628, when Buckingham was aged thirty-six. It was only four months since he had been able to see that the King's collection of pictures and sculptures was beginning to surpass his own in splendour. How Buckingham might have been able to meet this challenge we may wish to speculate when we turn to the acquisition by his one-time protégé, the Duke of Hamilton, of a wonderful collection of paintings from Venice. Even without such additional treasures, however, Rubens could write in 1629 that he had 'never seen such a large number [of fine pictures] in one place as in the royal palace and in the gallery of the late Duke of Buckingham'.[36]

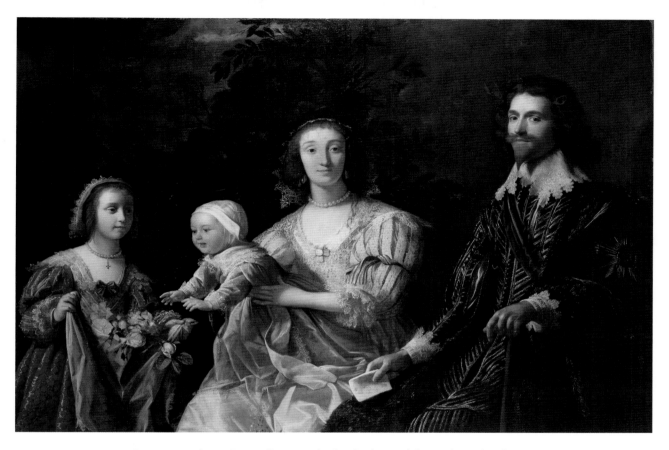

24 Gerrit van Honthorst, *George Villiers, 1st Duke of Buckingham, with his Family*, Royal Collection Trust

Charles (1600–1649) – the most conspicuous, but not necessarily the most successful figure among those who concern us – had no doubt been inspired to take up picture collecting partly through the example of his revered elder brother, Henry, but it was surely Buckingham who intensified what was to develop into an insatiable enthusiasm for painting: although the Prince was eight years younger, the two men began collecting at almost exactly the same time.[37] It was, however, not until they travelled together to Madrid (figs 27 and 28) in a futile attempt to overcome the obstacles standing in the way of Charles's marriage to the Infanta Maria that he was able to see an outstanding group of masterpieces and, through a rashly generous gift of the Infanta's brother, the eighteen-year-old Philip IV, to himself own a picture that could rival those to be found in the galleries of Arundel and Buckingham: Titian's *Venus del Pardo* (fig. 29).[38] As King, of course, he had opportunities to buy on a lavish scale – notably almost the entire collection that had, over many generations,

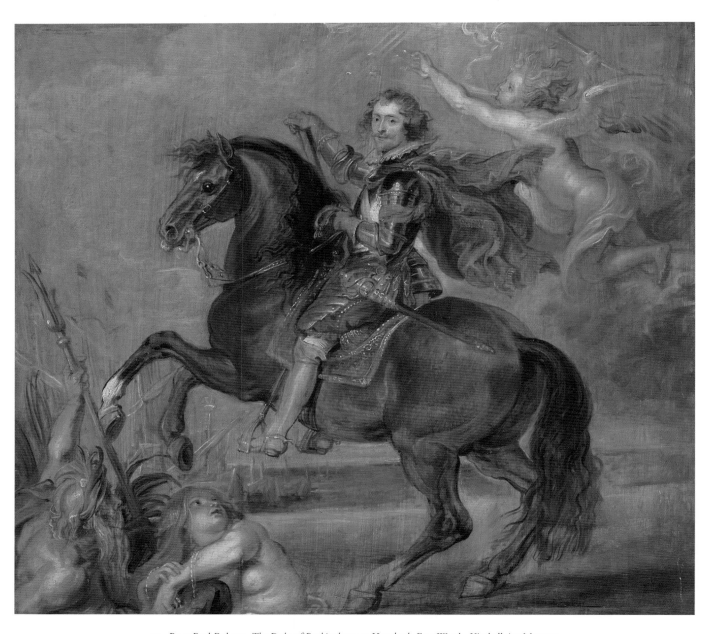

25 Peter Paul Rubens, *The Duke of Buckingham on Horseback*, Fort Worth, Kimbell Art Museum

26 Titian, *Ecce Homo*, Vienna, Kunsthistorisches Museum

been built up by the Gonzaga dukes of Mantua, whose most admired picture, Raphael's *Holy Family* (*La Perla*) (fig. 58), will also be of much concern to us.[39]

But although Charles held supreme power, and although his well-known love of painting attracted notable gifts from foreign governments and international dealers as well as from his courtiers and agents, he was not always in a position to obtain what he wanted. Money could often be a problem. This emerges clearly in his dealings with the last of the outstanding court collectors of the period, James, 3rd Marquess and later 1st Duke of Hamilton (1606–1649; fig. 30).[40] Hamilton, a great landowner close in line to the throne of Scotland, was twenty years younger than Arundel and fourteen younger than Buckingham, whose niece he married when she was aged nine and he fourteen. In 1623, he was among those who joined Charles's retinue in Madrid, and in the autumn of 1625 he accompanied Buckingham on a diplomatic mission to the Low Countries. In Scotland, where he spent the next three years looking after

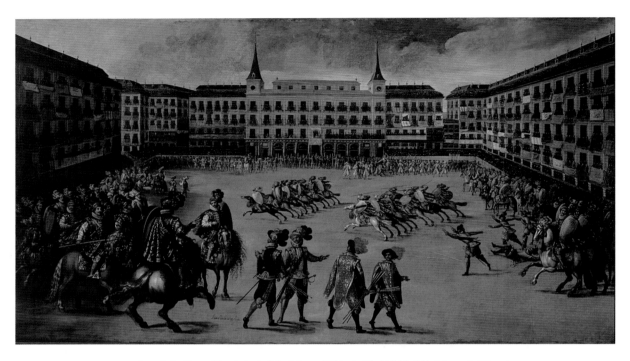

27 Juan de la Corte, *The Arrival of the Prince of Wales in Madrid*, Madrid, Museo de Historia

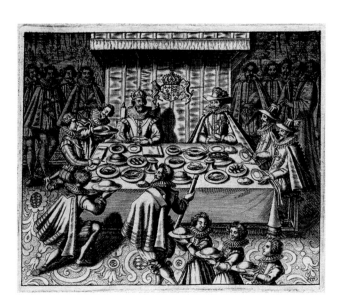

28 Melchior Tavernier, *Prince Charles, James I and Diego Hurtado de Mendoza, the Spanish Ambassador, at a Banquet in York House, London, Held in Honour of the Ambassador*, London, British Museum

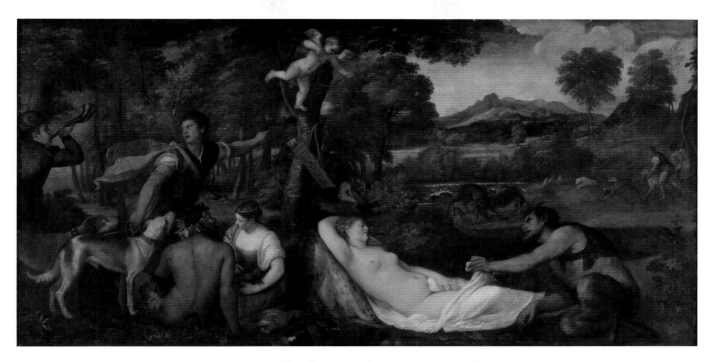

29 Titian, *Venus del Pardo* ('*Jupiter and Antiope*'), Paris, Musée du Louvre

his estates, and in England, he was encouraged by Charles to recruit a company of soldiers to serve under Gustavus Adolphus of Sweden in his devastating and triumphant campaigns in support of the Protestant cause in Germany and – so it was optimistically hoped – of Charles's brother-in-law, the Elector Palatine and deposed King of Bohemia. Although Hamilton was the only one of the collectors we are considering who had no compromising associations, either through birth or through marriage, with Catholicism, neither he nor his troops were able to contribute anything whatsoever either to that devastation or to that triumph, but it was – oddly enough – then that he first became involved in the acquisition of art, for Charles asked him to look out on his behalf for pictures in Munich. Even more oddly, Hamilton, both then and later, proved to be more successful as a connoisseur than as a soldier, and he brought back some good paintings for the King, including an *Adam and Eve* by Cranach.[41]

Encouraged, perhaps, by this success, he seems to have made a conscious effort to emulate the achievements of Buckingham.[42] He rented Wallingford House from the widow of the murdered Duke and began buying art on a lavish scale. His plentiful surviving letters make it clear that for him picture collecting signified essentially the continuation of politics by other means,[43] and Arundel and Charles (true art lovers), who had at first welcomed this new

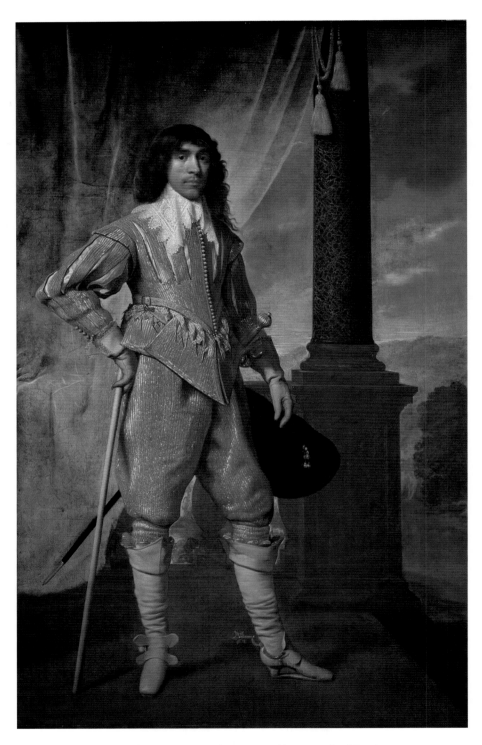

30 Daniel Mytens, *James, 3rd Marquess and later 1st Duke of Hamilton*,
Edinburgh, Scottish National Portrait Gallery

recruit to their ranks, must soon have had cause to regret their initial reaction. Hamilton's brother-in-law had been posted to Venice as ambassador, a political blunder of the worst kind but the greatest artistic triumph ever achieved by the British Foreign Office, for as important collections came on to the market the ambassador snapped them up for Hamilton, who derived as much pleasure from thwarting Arundel as from adding to his own treasures.[44] How satisfying, for instance, to be able to buy from the aged Procuratore Priuli, who soon afterwards 'entangl[ed] his foote in his gowne [and] fell downe a paire of staires' to his death,[45] the very Raphael that Arundel had particularly wanted for himself, *Saint Margaret* (fig. 31).[46] It must have been almost as gratifying that, thanks to the worsening political and financial situation, it was in the end he who was able to keep every single one of the finest pictures of the best collection to be sold in Venice, that of Bartolomeo della Nave, including Giorgione's *Three Philosophers* (fig. 32) and Antonello da Messina's San Cassiano Altarpiece (fig. 33), despite the fact that the King himself would have liked to buy them – for the collection was fully comparable to the Mantua pictures in quality – but had been able to do no more than demand first choice in return for substantial financial backing.[47] But this gratification was short-lived. The troubles swept Hamilton into their midst, and he hardly had time even to glimpse the marvellous pictures that he had struggled so hard, against so much competition, to bring to London.

Might any common ground between these collectors have been detected by the sort of well-informed connoisseurs I referred to earlier? An utter lack of distinction, in the traditional attributes of a ruling class perhaps. It would be difficult to decide who, among Buckingham, Hamilton, Arundel and Charles, was the least successful as a military commander. That one of them died in exile, one at the hands of an assassin and two on the scaffold was not, of course, due to their love of art, nor is it necessarily to their discredit, but it does emphasize how narrowly based and politically involved were the outstanding collectors of the time. It also makes something of a contrast with the happier (though at times difficult) careers of King Philip IV of Spain and the Count of Monterrey, Frederick Henry Prince of Orange and Constantin Huygens, Cardinal Francesco Barberini and Cassiano dal Pozzo, all men whose pursuit of art combined with life at court, or in the service of a court, would have been well known to cultivated circles in England. The extent of this contrast can, of course, be exaggerated, as could have been pointed out by the Duc de Montmorency, owner of the two so-called 'Slaves' by Michelangelo (fig. 34), which Balthazar Gerbier had tried very hard to acquire for Buckingham but which were instead to adorn the château of Richelieu, after the Cardinal had had the rebellious Duc's head cut off.[48]

More to the point perhaps is the contrast with such very different figures as the Reynst brothers of Amsterdam, who owned, among much else, Lorenzo Lotto's *Andrea Odone* (fig. 181), or Nicolas Fabri de Peiresc of Aix-en-Provence, or Bartolomeo della Nave of Venice

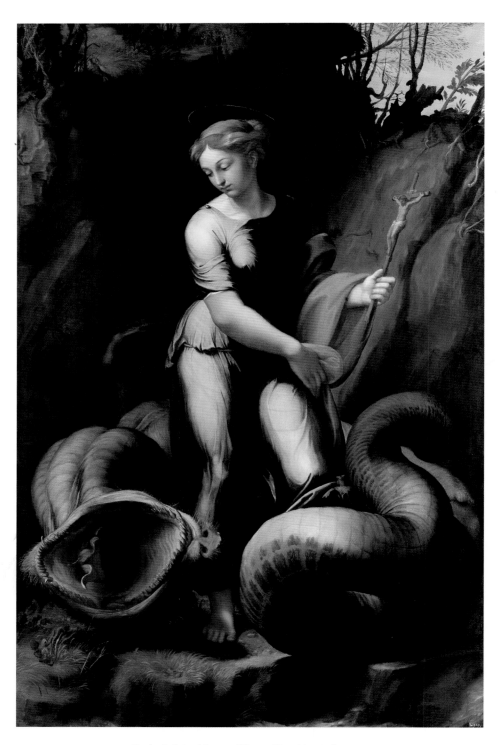

31 Raphael, *Saint Margaret*, Vienna, Kunsthistorisches Museum

32 Giorgione, *The Three Philosophers*, Vienna, Kunsthistorisches Museum

33 Antonello da Messina, the San Cassiano Altarpiece, Vienna, Kunsthistorisches Museum

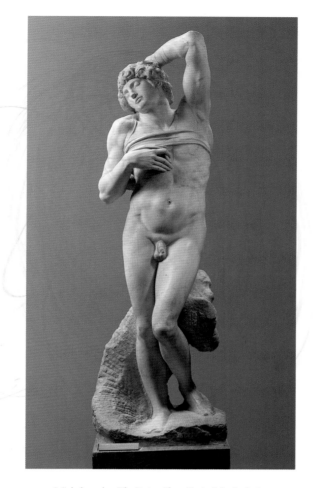

34 Michelangelo, *The Dying Slave*, Paris, Musée du Louvre

or Gaspar Roomer of Naples, whose masterpieces included Rubens's *Feast of Herod* (Edinburgh, National Galleries of Scotland). Many more names could be cited to demonstrate that, outside England, it was perfectly possible for private citizens, even ones far removed from government service, to build up collections of sculptures and paintings that acquired an international reputation. In fact, perhaps the most significant link between the four failed politicians whose artistic ambitions I have outlined is that they (as well as their advisers) had spent decisive, if sometimes brief, periods of their careers on the Continent. Let us now look much more closely at the specific nature of their various collections in the light of what they might or might not have experienced there.

2

ART COLLECTIONS IN LONDON ON THE
EVE OF THE CIVIL WAR

CONNOISSEURS FAMILIAR WITH THE MOST IMPORTANT ART COLLECTIONS ON THE CONTINENT WOULD HAVE FOUND MUCH THAT WAS UNSURPRISING had they visited Whitehall and other palaces in its vicinity in January 1642. Venetian art, for instance – the art of Titian, in particular – so well represented in Madrid and Prague thanks to the patronage and collecting of Philip II and Philip IV of Spain, the Holy Roman Emperor Rudolf II and other members of the Habsburg dynasty and their entourage, was equally popular in London (fig. 36, from Charles I's collection, and fig. 37, from the Duke of Hamilton's collection). By contrast, the French royal collections contained only one certain Titian, the portrait of François I commissioned by the Italian poet Pietro Aretino as a present to the King in 1539. Although the very young Philip IV had presented two of his masterpieces by the artist to the Prince of Wales in 1623, the Titians in Madrid were beyond the grasp of other collectors, and the Venetian pictures inherited, bought and commissioned by Rudolf II remained safely in Prague; safely, that is, until 1648, when the Swedish army seized the city and sent off most of its treasures to Queen Christina, who was waiting impatiently in Stockholm.

Fortunately it was not usually necessary to resort to such means in order to get hold of major works by Titian. The artist had lived into his late eighties or even longer, and he had employed an extremely productive team of workshop assistants. He was very laggardly in carrying out his obligations to the State, and like other Venetian artists he was only very rarely required to produce frescoes. Indeed, it was the Venetians who had largely pioneered the cabinet picture for private galleries, and it was partly for this reason that Charles, Arundel, Buckingham and Hamilton, who appeared on the scene so late in the day – long after the deaths of the artists they so admired – were able to gather such amazing examples of their work, not just from old collections bought en bloc, but from private families in Italy, France and elsewhere. There was a further reason for such success: England retained friendlier diplomatic relations with Venice than with any other government on the Continent.[1]

35 (*facing page*) Raphael, *The Holy Family* (*La Perla*) (detail of fig. 58)

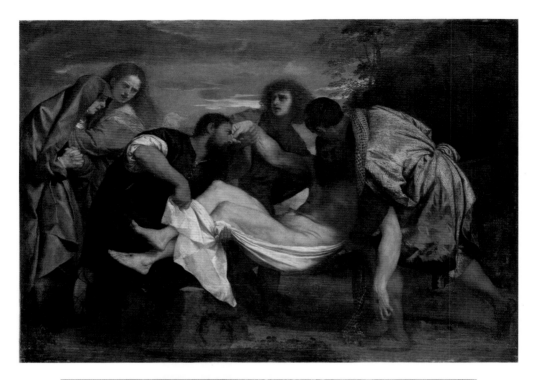

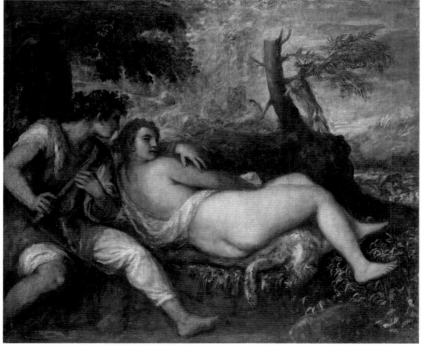

36 Titian, *The Entombment*, Paris, Musée du Louvre

37 Titian, *Nymph and Shepherd*, Vienna, Kunsthistorisches Museum

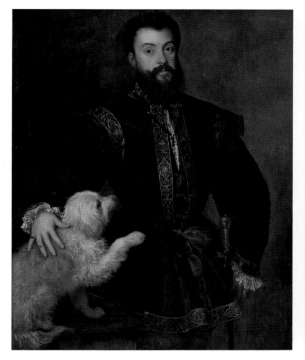 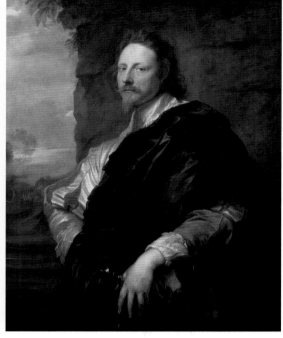

38 Titian, *Federico Gonzaga, Duke of Mantua*,
Madrid, Museo del Prado

39 Anthony van Dyck, *Nicholas Lanier*,
Vienna, Kunsthistorisches Museum

Such factors were of decisive importance for Stuart collectors of Titian but they do not account for the Stuart appreciation of Titian.[2] It is obviously not difficult to give some explanation of this appreciation, quite apart from the fact that most art lovers all over the world would still endorse it today. Unlike the other great court artists of the sixteenth century, such as Holbein, Bronzino and Anthony Mor, Titian had perfected a style combining sensuousness and elegance that, because it could nourish the genius of later generations of artists, never ran the risk of appearing old-fashioned. Basing himself on that style, van Dyck could make his sitters appear as beautiful as the Titians that they owned, or at least coveted (figs 38 and 39). Thus although the richness of English holdings of Titian would have impressed visitors, it would certainly not have struck them as in any way eccentric, as might perhaps the exceptional number of pictures in London by Jacopo Bassano.

Bassano, who spent all his life (which ended only when he was eighty) in the little town near Vicenza from which he took his name, worked largely for a local clientele for whom he created superb altarpieces. But as he also painted extensively for dealers, works by him were

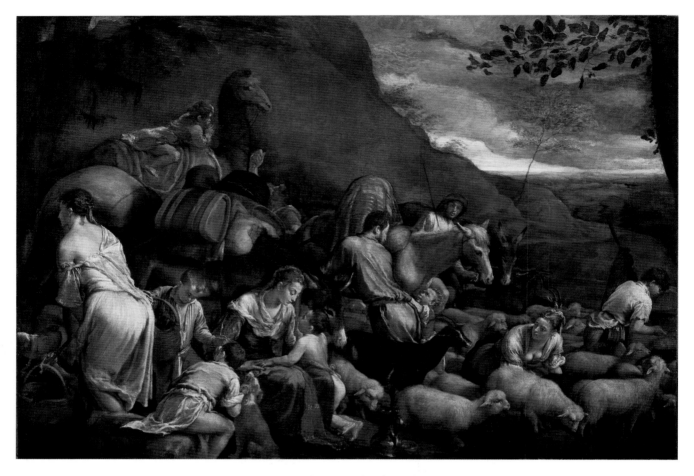

40 Jacopo Bassano, *The Journey of Jacob*, Royal Collection Trust

to be found in other Italian towns, and he became known above all for his easel paintings, which were usually of religious subjects but which often appeared at first sight to be scenes of rural genre, markedly naturalistic in character, and often featured animals. Apart from fulfilling one notable commission from the particularly alert Rudolf II, Jacopo Bassano seems to have produced very little for collectors outside Italy, though after his death in 1592 his pictures gradually began to attract foreign interest, especially in England, Spain and Rome, where the ruling Borghese family built up a sizeable collection of pictures by him.[3] Arundel obtained nearly fifteen and not very long afterwards Charles I was the owner of about half a dozen, including the particularly fine *The Journey of Jacob* and *The Good Samaritan* (figs 40 and 41). Of much more significance, however, is the fact that Buckingham owned

41 Jacopo Bassano, *The Good Samaritan*, Royal Collection Trust

some twenty-seven pictures attributed to Bassano and his followers, more than of any other painter represented in his collection and a larger group than was to be found in any other collection in Europe at that time. Because these pictures were of all kinds – religious and historical, allegories and portraits, as well as scenes of genre – it must have been the artist and not the subject-matter that was of special interest. I am, in fact, very tempted to claim that Buckingham's apparently unreserved enthusiasm for Bassano – or the artist whom he believed to be Bassano, as his family continued to turn out pictures in his style over a number of generations – provides us with our first indication of a specific, individual, English taste in Italian painting, one that, unlike the passion for Titian, owes nothing to literary prompting, to precedent or to international fashion, and it would be interesting to know what

42 Paolo Veronese, *Christ and the Woman of Samaria*, Vienna, Kunsthistorisches Museum

visitors to Buckingham's gallery thought of the prominent place held in it by such 'prosaic', though engaging, pictures.

Veronese would probably have been more to their taste, although for some inexplicable reason Charles I did not care for him.[4] The enthusiasm of Arundel and Buckingham, however, was boundless. Arundel was said to have tried (but failed) to buy one of the artist's grandest and most famous altarpieces from a church in Verona,[5] while Buckingham went so far as to inform the Venetian Senate that he desired to have 'by any means possible' some of the pictures in the ducal palace itself. Passing on this request to the Doge, the embarrassed Venetian ambassador reported that he had 'turned a deaf ear'.[6] Despite these rebuffs, both men were able to buy some very fine pictures by Veronese: Buckingham owned, among others, *Christ and the Woman of Samaria* (fig. 42) and Arundel's collection included *Christ and the Centurion* (fig. 43). Buckingham's inventories list about eighteen (for Veronese was Gerbier's favourite artist) and to foreign, as much as to English connoisseurs these must surely have been among the rarest and most remarkable treasures to be seen in London, because, unlike Titian, Veronese had devoted most of his labours to adorning public buildings in Venice and the Veneto. He had turned down an invitation from Philip II to come to Spain to decorate the Escorial, and although he sent occasional pictures to him and other foreign patrons, he

43 Paolo Veronese, *Christ and the Centurion*, Madrid, Museo del Prado

did not work much for dealers. His pictures rarely came on to the market and, apart from London, the only place outside Venetian territory where works by Veronese could then have been seen in any quantity was Prague, where some of his most magnificent paintings were to be found in the collection of Rudolf II (figs 44 and 45).[7]

Tintoretto also worked primarily for churches and palaces in Venice itself and – like Veronese – he attracted the attention of Philip II of Spain (to whom he sent a number of pictures) and of the Emperor Rudolf II, who acquired one of his most attractive mythologies, *The Origin of the Milky Way* (fig. 46). All the leading English collectors owned significant works by him (or at least attributed to him), some of them extracted from Venetian churches, such as the King's *Christ Washing the Feet of his Disciples* (fig. 47) and some from Venetian private collectors, such as *The Woman Taken in Adultery* (fig. 48) in Buckingham's collection. But the fact that Tintoretto was so well represented in London was due more to

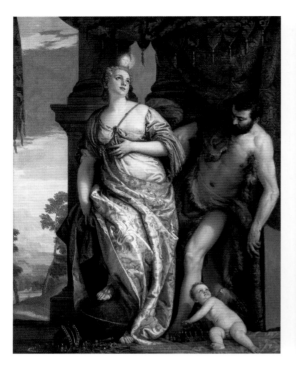

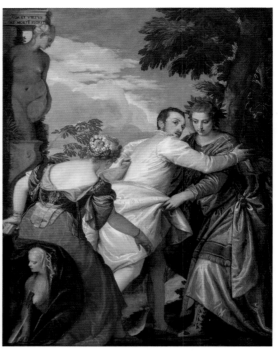

44　Paolo Veronese, *Wisdom and Strength*,
New York, The Frick Collection

45　Paolo Veronese, *The Choice between Virtue and Vice*,
New York, The Frick Collection

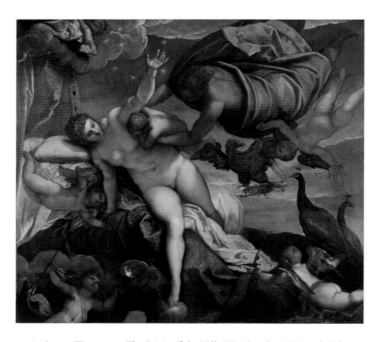

46　Jacopo Tintoretto, *The Origin of the Milky Way*, London, National Gallery

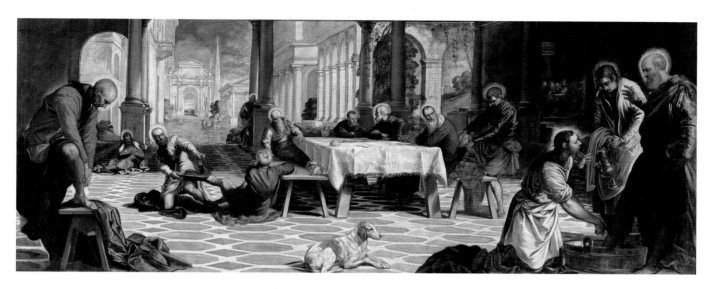

47 Jacopo Tintoretto, *Christ Washing the Feet of his Disciples*, Madrid, Museo del Prado

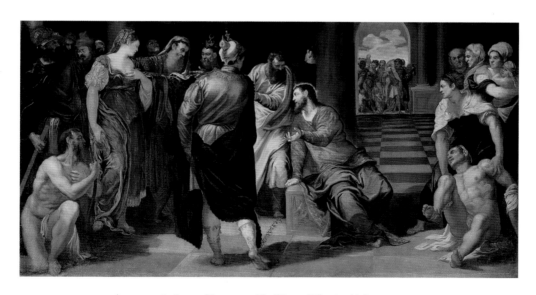

48 Jacopo Tintoretto, *The Woman Taken in Adultery*,
Dresden, Staatliche Kunstsammlungen, Gemäldegalerie Alte Meister

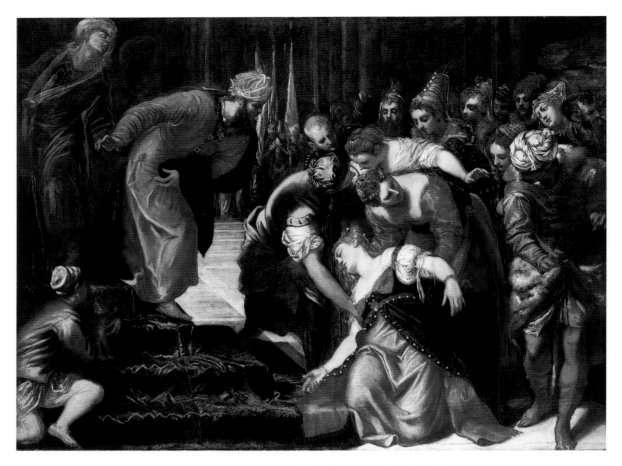

49 Jacopo Tintoretto, *Esther before Ahasuerus*, Royal Collection Trust

accident than design. Tintoretto had been employed by the dukes of Mantua, and although the eight pictures he painted to celebrate notable events in the family's history were not among those sold to Charles I, other major pictures by him did come to London when the bulk of the Gonzaga collection was bought, including *Esther before Ahasuerus* (fig. 49) and *The Muses* (fig. 50), and were installed in Whitehall and Greenwich.[8]

The fact that paintings by Correggio could be seen in greater numbers in London than anywhere else in Europe outside Parma (twenty miles from where he was born) was due to very similar circumstances. Unlike Tintoretto, who lived until the age of seventy-six, Correggio's life was short – he was only forty-five when he died – and this, combined with the fact that frescoes constituted a major part of his output, meant that genuine pictures by him were rare. But towards the end of his life he had come to the attention of Isabella d'Este

50 Jacopo Tintoretto, *The Muses*, Royal Collection Trust

and her son, Federigo Gonzaga, in Mantua, thirty miles from where he lived, and for
Federigo he had painted a series of 'The Loves of Jupiter', among the most ravishing mytholo-
gies of the Renaissance (figs 51 and 52). Federigo had apparently intended these as gifts for
the Emperor Charles V, but (very understandably) had not been able to part with all of them.
Some of the series reached Madrid, where amazingly they were not much admired even by
so fine a connoisseur as Philip II – not a man who was unduly troubled by erotic art. Because
of this, the Emperor Rudolf II was able to buy them for Prague early in the
seventeenth century. By then, although Correggio's fame had begun to spread throughout
Europe, pictures by him were almost unobtainable. Buckingham claimed no more than two
pictures by him, and although about a dozen are listed in an inventory of Arundel, some
of these are drawings and none sounds very important. The enrichment, therefore, of

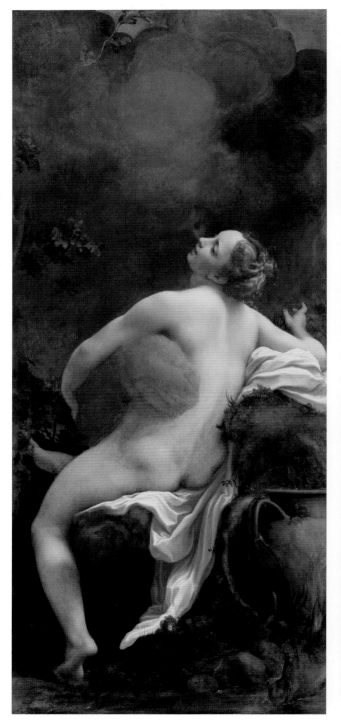

51 Correggio, *Jupiter and Io*, Vienna, Kunsthistorisches Museum 52 Correggio, *Jupiter and Ganymede*, Vienna, Kunsthistorisches Museum

53 Bernardino Luini, *Salome with the Head of Saint John the Baptist*, Madrid, Museo del Prado

54 Leonardo da Vinci, *Saint John the Baptist*, Paris, Musée du Louvre

Charles I's collection by at least nine – and possibly more – authentic and superb Correggios from Mantua (figs 156, 157 and 158) must have made a spectacular impression on the connoisseurs around his court – and, as we shall see later, it gave them a greater insight into the artist's style than was possible for their counterparts in Paris and Madrid.

Correggio was, in fact, one of the three artists singled out by Arundel for special admiration. The others were not the great Venetians who, as we have just seen, were so cherished by English collectors, but Leonardo da Vinci and Raphael.[9] Most serious connoisseurs of the time, in England and elsewhere, would have agreed with him, at least as far as Raphael was concerned. But this, of course, meant that pictures by these masters were not easily available. Outside Italy, only the King of France had inherited major works by them from his predecessor François I, and it is characteristic of Buckingham's self-confidence (and the flair of his agents) that he tried to buy the *Mona Lisa* from the French royal collection.[10] He had to satisfy himself with a copy, but he was able to buy a *Salome with the Head of Saint John the Baptist* believed to be by Leonardo himself (it is now thought to be by his follower Bernardino Luini; fig. 53).[11] Arundel's agents were able to procure from Spain another version of this much-copied composition, and it would be interesting to know whether these rivals ever

55 Raphael, *Saint Paul Preaching at Athens*, Royal Collection Trust

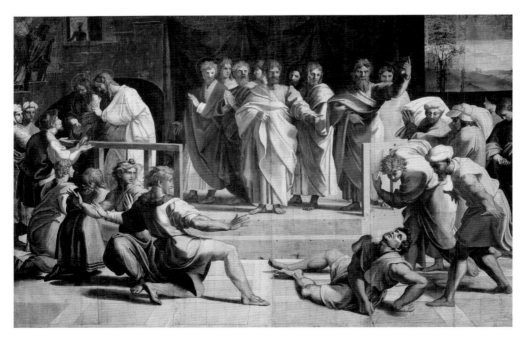

56 Raphael, *Death of Ananias*, Royal Collection Trust

compared their two pictures.[12] Charles I was more successful than either, for he was able to obtain from France an incontestable (if not very appealing) Leonardo, *Saint John the Baptist* (fig. 54), in exchange for a Titian and a magnificent portrait by Holbein, an artist for whom he did not much care.[13]

As we saw, both Arundel and Hamilton owned pictures that they believed to be major Raphaels. Buckingham made no such claims, but the King's collection of works by the artist rivalled that belonging to the French royal family, though it is unlikely that he or anyone else at the time would have acknowledged this.[14] When still Prince of Wales he bought (perhaps on the advice of Rubens) the cartoons designed by Raphael and painted by him and his assistants (figs 55 and 56) for a set of tapestries for the Sistine Chapel.[15] The cartoons had been sent from Rome to Brussels to be woven, and additional sets were later produced, including a particularly fine one (now destroyed) purchased by Henry VIII and kept in the Tower of London. Charles acquired the cartoons for purely functional purposes, namely to serve as models for the production of further sets of the tapestries by a new work-shop he had recently established at Mortlake. When they were not being copied, the designs were kept in storage at Whitehall and not displayed as works of art. It seems almost certain that Charles would have derived much more pleasure from the little *Saint George and the Dragon* by Raphael (fig. 57), which was traditionally believed to have been sent to Henry VII by the Duke of Urbino in gratitude for the Order of the Garter.[16] But the problem of how to obtain a major Raphael was to be resolved only with the arrival of the pictures from Mantua, among which one work stood out from a mass of copies as being of spectacular importance: *The Holy Family* (*La Perla*; fig. 58).

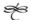

Antique sculpture was as important – more important perhaps – for the international community of seventeenth-century art collectors as sixteenth-century pictures, and major pieces were even more difficult to obtain than Raphaels or Correggios. For nearly two hundred years, the popes had been trying, quite successfully on the whole, to retain in Rome all the most beautiful and interesting statues excavated in their domains. In these circum-stances Charles could do no more than follow the precedent set by the King of France more than a hundred years earlier, and commission modern casts in bronze of some of those that were most admired, such as the *Borghese Gladiator* (fig. 59).[17] Of course, it was sometimes possible to evade or circumvent the export regulations, and where outstanding works were not at stake no problems were raised. Arundel, for instance, was allowed to finance private excavations, and a number of the sculptures he sent back to London can still be identified,

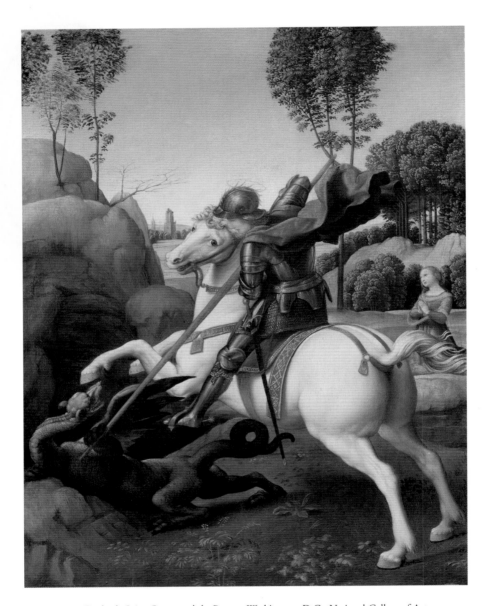

57 Raphael, *Saint George and the Dragon*, Washington, D.C., National Gallery of Art

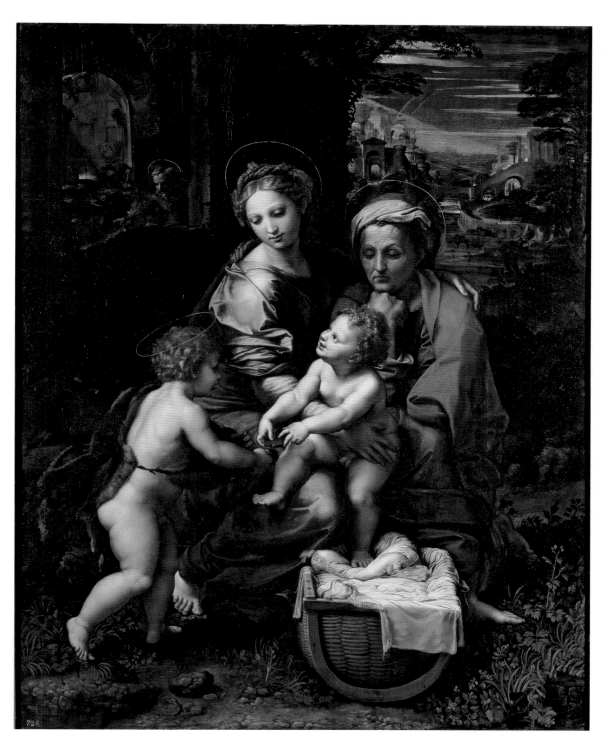

58 Raphael, *The Holy Family* (*La Perla*), Madrid, Museo del Prado

59 Hubert Le Sueur, *Borghese Gladiator*,
Royal Collection Trust

60 Roman copy of a 5th- or 4th-century BC
Greek original, *Aphrodite*,
Oxford, Ashmolean Museum

including an *Aphrodite* (fig. 60).[18] But if their presence in a picture of an imaginary gallery by Mytens (fig. 61) suggests that Arundel was particularly proud of them, it tells us nothing about their wider reputation in Europe generally, which is unlikely to have been very great.

It was, however, scholars who were most excited by what had been Arundel's most remarkable venture in the collecting of antiquities: the removal from Turkey and the Greek islands, by an extremely enterprising agent working on his behalf, of a number of important inscribed marbles. To have arranged archaeological expeditions to the eastern Mediterranean, where Ottoman rulers were, on the whole, not excessively rigid in trying to preserve a 'heritage' that they certainly did not look upon as their own, was among his most imaginative enterprises. Although he was quickly imitated by Buckingham, it was not a move that was characteristic of aristocratic collecting in general.[19] The 'Great Person' who confided in Evelyn his secret hopes that a Turkish invasion of Italy would bring ancient statues on to the market at cheap prices had no such dreams about their activities in Crete. Arundel's thwarted rival for the most valued inscriptions had been the great French antiquarian Peiresc. By arranging

61 Daniel Mytens, *Thomas Howard, 2nd Earl of Arundel*, London, National Portrait Gallery

62 Unknown British artist,
Four Antique Sculptures: Sleeping Cupids,
Royal Collection Trust

for their publication, Arundel certainly established their European fame, but just as certainly diminished their appeal as possessions to be paid for.[20]

Buckingham, for his part, was dead by the time that the antiquities that he was trying to acquire from Turkey reached London, and unfortunately we know next to nothing about the great many that he already owned and that he had purchased from Rubens: none of them seems to have been singled out as especially remarkable.[21]

It was the King's collection of ancient marbles, located mainly around St James's Palace, that was the most conspicuous in London. This was obviously a very desirable possession but not, I think, an outstanding one. Nearly all the busts and statues in the collection came from the Gonzagas, but seventeenth-century Mantua was not looked upon as an important centre of antique art, to be compared, for instance, with Rome, Florence or Venice.[22] Only three sculptures were widely known: Isabella had been given by Cesare Borgia a marble *Sleeping Cupid* by Michelangelo, carved in emulation of the antique, and to this was added, some time later, two sculptures of the same subject, one said to be by Praxiteles, one of the two most famous of all ancient sculptors, and the other by Jacopo Sansovino.[23] All of these

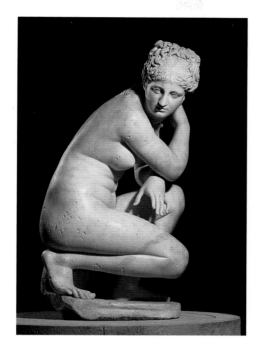

63 Roman, *Aphrodite* or *Crouching Venus*,
Royal Collection Trust

64 Unknown British artist, *Four Sculptures: Helen of Troy,
a Divinity, a Standing Male and a Lely Venus*,
Royal Collection Trust

evidently looked alike and there was much confusion between them, but they were certainly celebrated, and it remains inexplicable that, after they arrived in London, none of them was ever referred to (fig. 62). Only one other ancient sculpture from Mantua was famous – or, I suspect it would be truer to say, became famous – as a result of some astute publicity by dealers at the time of its purchase. In Mantua, an *Aphrodite* or *Crouching Venus* (fig. 63) had been listed simply as a 'large naked woman seated on her heels'.[24] In London, we now suddenly find it described as 'the most beautiful statue of all', which 'some call Helen of Troy'[25] (fig. 64), and it was much admired. But in general, although the valuations made of Charles's antique sculptures for the Commonwealth sale show that many of them must have been highly regarded, they appear to have aroused no interest outside England.

There was some excellent post-classical sculpture in England, but only two pieces met the highest international standards acceptable to seventeenth-century taste: Bernini's bust of Charles I, which was tragically destroyed by fire in 1698,[26] and Giambologna's *Samson Slaying a Philistine* (fig. 65), commissioned by the Medici and later sent to the Duke of Lerma, who transferred the work to the King of Spain, who presented it to the Prince of Wales, who in

65 Giambologna, *Samson Slaying a Philistine*, London, Victoria and Albert Museum

turn gave it to Buckingham.[27] In this respect English collections could not hope to rival Spain with its superb bronzes by Leone and Pompeo Leoni, Prague with its plentiful statues by Adrien de Vries, and France with its bust of Richelieu by Bernini, its three large Michelangelo marbles and the magnificent sculptures by Jean Goujon and other French masters, let alone half a dozen towns in Italy.

In two respects, however, London collections were outstanding in Europe during the first half of the seventeenth century, and this was entirely the result of Lord Arundel's very idiosyncratic tastes. 'Old Master drawings' had been collected well before his birth, of course, but, with rather rare exceptions, they tended to be acquired by artists or by writers on artists (Giorgio Vasari falls into both categories) or by connoisseurs of somewhat limited means. Arundel was among the earliest princely collectors in Europe, and certainly the earliest in England, to amass drawings on a major scale.[28] In 1632 his son claimed that 'he chiefly affects drawings',[29] and it seems probable that nine years later, when the Civil War broke out, his was the greatest collection of drawings in Europe. Arundel was as proud of his drawings as he was of his ancient inscriptions. He was delighted to show them to visitors, and he had many of them engraved (figs 66 and 67) – not only finished works, but also rapid sketches.[30] From these and other sources it becomes clear that among his many thousands of drawings the ones he cherished most were by Leonardo and Parmigianino: he had reason to be satisfied because he owned, among much else, a volume containing six hundred drawings by Leonardo.[31]

66 Hendrick van der Borcht the Younger, after Parmigianino, *The Virgin Embracing the Christ Child*, London, British Museum

67 Hendrick van der Borcht the Younger, after Parmigianino, *The Death of Lucretia*, London, British Museum

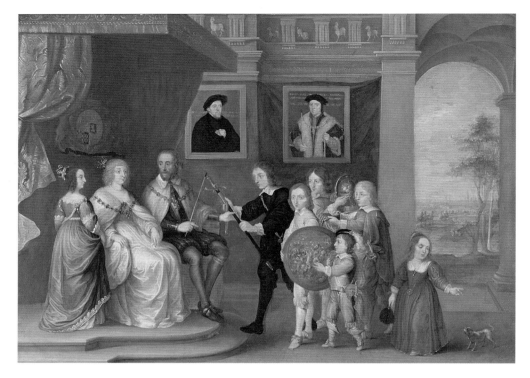

68 Philip Fruytiers, *Thomas Howard, Earl of Arundel is Presented with Arms by his Children
to Mark his Appointment to Lead the Army against Scotland in 1639,*
Arundel Castle, Collection of the Duke of Norfolk

It was, however, the quantity and quality of Arundel's drawings and paintings by Holbein that would probably have astonished foreign visitors to English collections more than anything else.[32] Holbein had, of course, worked in England more than a century earlier, and large numbers of his pictures remained there. Arundel, who had a very strongly developed sense of family pride and an evident feeling of nostalgia for the Tudor court, was deeply attracted to an artist who had painted his own ancestors at their moment of greatest power, and peril. There was, for instance, his great, great-grandfather, the 3rd Duke of Norfolk, whose portrait by Holbein (fig. 69) is seen hanging in the background of a clumsy family portrait painted by Fruytiers for Arundel before he finally left England (fig. 68). But, unlike the King, whose much more tepid interest in Holbein seems to have been motivated only by ancestral piety, Arundel's enthusiasm had extended to every aspect of the artist's achievements, and he had 'spared neither gold nor silver if anything by Holbein was to be had'.[33] In his London house, pride of place was given to two enormous allegories – one of them twenty feet long – representing *The Triumph of Riches* and *The Triumph of Poverty*, which are

69 Hans Holbein the Younger, *Thomas Howard, 3rd Duke of Norfolk*, Royal Collection Trust

now known only through a preliminary drawing (Musée du Louvre, Paris) and later copies (figs 70 and 71).[34] By the eve of the Civil War, he owned some forty paintings by Holbein, including some of his most attractive ones such as *Christina of Denmark* (fig. 72), and large numbers of drawings. Only one collection in Europe could rival his: that assembled in Basel by the great Swiss publishing family, the Amerbachs, and Arundel, who spent some time in the city had tried – but failed – to buy one of their masterpieces by Holbein, *Dead Christ*

70 Lucas Vorsterman the Elder, after Hans Holbein the Younger, *The Triumph of Riches*,
Oxford, Ashmolean Museum

71 Lucas Vorsterman the Elder, after Hans Holbein the Younger, *The Triumph of Poverty*,
London, British Museum

72 Hans Holbein the Younger, *Christina of Denmark,
Duchess of Milan*, London, National Gallery

(Kunstmuseum, Basel).[35] So famous was Arundel's interest in the artist that as early as 1620
he received a letter from the Grand Duke of Tuscany who, in a manner characteristic of
royalty, wrote to ask him for a picture by the artist. Arundel put a brave face on the matter,
thanked Cosimo II 'for having deigned to honour me with such a request' and sent him one
of his finest and best-preserved Holbeins, *Sir Richard Southwell* (fig. 73).[36] It was presumably
chosen with some care for it portrayed the man responsible for the hounding to death of one
of his ancestors. In exchange, he received a set of pictures of the *Exaltation of the True Cross*

.Xº IVLII. ANNO.
.H. VIII. XXVIIIº.

ETATIS SVÆ
ANNO XXXIII.

73 Hans Holbein the Younger, *Sir Richard Southwell*, Florence, Galleria degli Uffizi

74 Adam Elsheimer, *The Exaltation of the True Cross*, Frankfurt, Städel Museum

(fig. 74) by Adam Elsheimer, another German artist of whom he was particularly fond.[37] Sixteen years later, Charles I (who was in the happy position of receiving gifts more often than making them) joked that Arundel's presenting a Holbein to the Grand Duke had constituted an authentic miracle.[38] By describing his 'foolish curiosity in enquiringe for the peeces of Holbien [sic]',[39] Arundel himself appears to have acknowledged that it was out of the ordinary. It can, however, be compared in intensity to another artistic passion that developed far beyond the dynastic motives that had originally inspired it: the cult of Dürer, promoted by Rudolf II, descendant of the much venerated Holy Roman Emperor Maximilian I, who had been among the artist's most ardent patrons. But enthusiasm for Dürer was very widespread – it was shared by Arundel and even, to a lesser extent, by the King – whereas the Holbeins to be seen in London were indicative of a real divergence between English and continental taste.

So, too, was the comparative dearth of modern Italian painting to be found in England. It is true that Charles I had tried to persuade at least one major Italian artist, Guercino, to move to England, but after this proved unsuccessful (because, Guercino explained, he could face neither the heretics nor the climate)[40] neither the King nor any of his courtiers showed any interest in getting pictures from him or from his contemporaries, let alone from the younger generation of Baroque artists who were transforming the churches and palaces of Rome. In reporting back to the Vatican about what kind of pictures would be most welcome at court as gifts that might serve to win concessions for Catholics, the Pope's agent in London said that although Guido Reni would be acceptable, in general old paintings were preferred.[41]

Had Buckingham survived longer the situation might have been different, for some of the first pictures that Gerbier had bought for him were by living Italian artists. Moreover, it seems to have been Buckingham who was responsible for bringing to England – but from Paris and not from Italy – the one Italian artist of stature to work in London, Orazio Gentileschi (1563–1639).[42] But Buckingham was murdered before being able to acquire much of his work. Gentileschi was then employed by the Crown, though his work was destined principally for the Queen's House in Greenwich: nine canvases by him, representing 'An Allegory of Peace Reigning over the Arts', were inserted into the ceiling of the Great Hall and three large religious paintings adorned its walls, including *The Finding of Moses* (fig. 75).[43]

The fact that London did contain some major and very beautiful paintings by Italian artists of the early seventeenth century was, once again, hardly the result of deliberate choice. Among the pictures bought en bloc from Mantua was the magnificent *The Death of the Virgin* by Caravaggio (fig. 76) and also four superb 'Labours of Hercules' by Guido Reni (fig. 77), the contemporary Italian artist who was most admired in England. The Gonzagas had also owned many fine pictures by their court painter, Domenico Fetti, and these now came to Whitehall. However, it was Buckingham who had managed to obtain a few years earlier the

75 Orazio Gentileschi, *The Finding of Moses*, London, National Gallery (on loan from a private collection)

set of little parables made for Isabella d'Este's grotto in Mantua (fig. 78)[44] that reveal the gifts of this most sensitive of Italian artists at their most attractive. It is not surprising that so keen a lover of Bassano would have appreciated them and, once again, this transaction suggests that Gerbier and he were following some genuine inclination rather than mere fashion in

76 Caravaggio, *The Death of the Virgin*, Paris, Musée du Louvre

77 Guido Reni, *Nessus Abducting Deianira*, Paris, Musée du Louvre

78 Domenico Fetti, *The Good Samaritan*,
New York, The Metropolitan Museum of Art

their purchases. It may have been the admiration aroused by pictures of this kind that, nearly ten years later, encouraged Hamilton to buy from a Venetian collector the most magical of all Fetti's paintings – to me, among the most magical of *all* pictures – *Hero and Leander* (fig. 79) and *Andromeda and Perseus* (fig. 80).[45]

It was, of course, contemporary Flemish rather than Italian art that made its mark on London. Peter Paul Rubens (1577–1640) had been in touch with English diplomats in the Low Countries since early in the second decade of the seventeenth century, at which time he

79 Domenico Fetti, *Hero and Leander*, Vienna, Kunsthistorisches Museum

80 Domenico Fetti, *Andromeda and Perseus*, Vienna, Kunsthistorisches Museum

81 Peter Paul Rubens, *Lady Arundel and her Retinue*, Munich, Alte Pinakothek

82 Peter Paul Rubens, *The Apotheosis of the Duke of Buckingham*, London, National Gallery

was already famous in Antwerp and Italy but had not yet 'conquered' Paris and Madrid. English patronage thus came to him relatively early in his international career. For Arundel he seems to have painted only portraits, including a striking one, *Lady Arundel and her Retinue* (fig. 81), but Buckingham, who certainly took advantage of this aspect of Rubens's genius, owned some thirty paintings by him of every kind, among which was an astonishing allegory – of which only the oil sketch now survives (fig. 82) – intended to be inserted in a ceiling in York House, depicting Buckingham himself being conducted by Minerva and Mercury to the Temple of Virtue while Envy tries to pull him down.[46] When Buckingham was murdered

83 Peter Paul Rubens, *Minerva protects Pax from Mars ('Peace and War')*, London, National Gallery

in 1628, his collection of Rubens's works must have been the greatest in the world, although by the time the Civil War broke out fourteen years later it was far surpassed in quantity and quality by the holdings of the King of Spain.

The most important English commission given to Rubens was for the canvases installed in the ceiling of the Banqueting House (examined in chapter 3), but the King also owned easel paintings by him, one presented by the artist himself, *Peace and War* (fig. 83), and one acquired from Rubens's own collection in Antwerp by Endymion Porter, *Landscape with Saint George and the Dragon* (fig. 84). Rubens died on 30 May 1640 and two or three weeks later, in reply to a tentative request from London, a list of the pictures remaining in his house and due to be sold was sent to Whitehall.[47] It is hardly surprising (though it must have pained

84　Peter Paul Rubens, *Landscape with Saint George and the Dragon*, Royal Collection Trust

him) that Charles's name is not to be found alongside those of the King of Spain, the Elector of Bavaria, Cardinal Richelieu and the Holy Roman Emperor who were able to enrich their collection in a decisive way as a result of the sale.

Twenty years earlier, when Rubens was painting Lady Arundel in Antwerp, her husband's Italian secretary had written to him in London that Rubens's pupil Anthony van Dyck (1599–1641), who was then aged only twenty-one, enjoyed a reputation nearly as great as that of his master, but that it was unlikely that he would want to leave Antwerp as he was already rich and stood to make a lot of money there.[48] Within a couple of months the impetuous and extravagant Buckingham clan had persuaded him to change his mind, but his first visit to London was very brief and it was not until 1632 that he returned to settle, with two short

85 Anthony van Dyck, *The Three Eldest Children of Charles I*, Turin, Galleria Sabauda

interruptions, until the end of his life.[49] The portraits that he painted in England quickly became, and have always remained, so famous that there is no need to do more than refer to them in passing, except to point out that they would also have been well known in foreign courts to which at least two of the most beautiful were sent: *Charles I (Le Roi à la chasse)* (fig. 86) was sent to France[50] and *The Three Eldest Children of Charles I* (fig. 85) to the Duchess of Savoy, the Queen's sister, in Turin. But although the evidence is extremely confusing, it seems to be almost certain that (despite the claims of his close friend Sir Kenelm Digby) van Dyck's genius for mythological and poetical subjects was almost wholly neglected by his vainglorious English patrons and, as we shall see later, met no response in France either.[51] It is

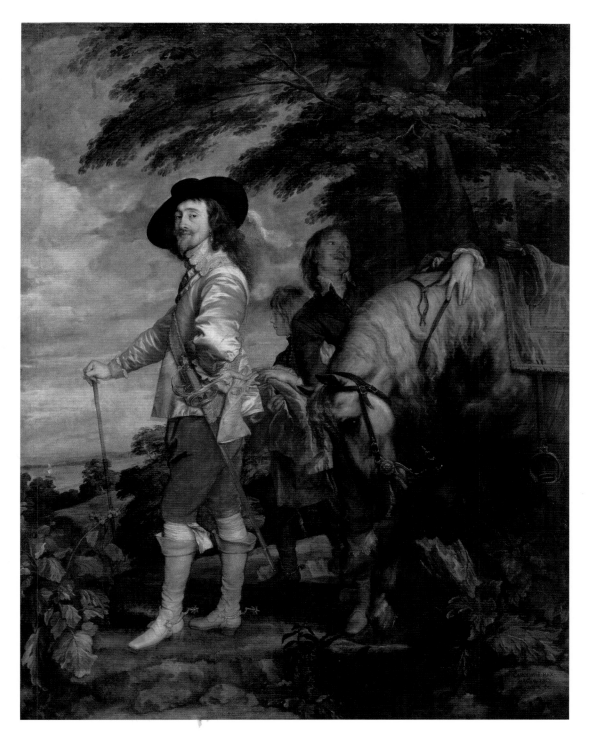

86 Anthony van Dyck, *Charles I (Le Roi à la chasse)*, Paris, Musée du Louvre

87 Anthony van Dyck, *Cupid and Psyche*, Royal Collection Trust

difficult to conceive how neither Charles, who (even before the artist settled in London) had acquired *Rinaldo and Armida* (fig. 12), nor any of the Titian-loving courtiers around him could have turned down the chance of commissioning such *poesie* – a failure of the imagination, soon to be mocked in the lines addressed by Richard Lovelace to Peter Lely in a similar situation:

> Now, my best Lilly, let's walk hand in hand,
> And smile at this un-understanding land;
> Let them their own dull counterfeits adore,
> Their Rainbow-cloaths admire, and no more.[52]

Towards the end of his life, the King did at last commission one mythology from van Dyck, a *Cupid and Psyche* (fig. 87), and received a masterpiece that was very different in character from the earlier scene from Tasso but equally beautiful.[53] It was almost certainly the last masterpiece that van Dyck painted for Charles, and it is not surprising to discover that it was to be particularly appreciated by Lely.[54]

In these two opening chapters, I have tried to convey an impression of some of the collectors and a few of the works of art that were to be seen in and around London when the King left for Hampton Court, and eventually for York, in January 1642, and of how they might have struck connoisseurs familiar with some of the principal collections on the Continent. But not everyone shared their enthusiasm and few of the pictures were to remain in England for long.

3

'SCANDALOUS MONUMENTS AND PICTURES'?[1]

IN 1637, WHEN CHARLES I'S COURT WAS AT ITS MOST SPLENDID, HIS WIFE, QUEEN HENRIETTA MARIA (1609–1669), COMMISSIONED FOR THE CEILING of her bedroom at Greenwich a large mythological picture from Guido Reni, who of all the Italian painters of the time was the one most admired in England.[2] The commission was transmitted from the papal agent in London to Cardinal Barberini in Rome, the nephew of Urban VIII, the reigning Pope, and the most important art patron of the day, and the Queen graciously asked him to choose a suitable subject for her.[3] The Cardinal at first decided on 'Cephalus and Aurora', and then changed his mind and asked Reni instead for 'Bacchus Finding Ariadne' (fig. 89).[4] The picture was not completed for more than three years, and when the Cardinal eventually saw it in August 1640 he got a shock and wrote to his agent in London in some dismay that

> both as regards the story and as regards the way in which the painter has chosen to depict it, the picture appears to me to be lascivious. I hesitate to send it for fear of further scandalizing these Heretics, especially since the subject of the work was chosen here in Rome. I will have a sketch made and sent to you, and if these things bother neither the Queen nor Father Philip [the Queen's confessor], we shall have to let it appear that Her Majesty ordered everything and that I was solicitously carrying out her commands.[5]

The Queen was unperturbed. She had heard only that the picture was exceptionally beautiful, and she was prepared to accept responsibility for any trouble that might be caused by its supposed indecency. Cardinal Barberini remained anxious – and well informed. 'The figures are not as well draped as I should like,' he wrote in February 1641, 'especially in these parliamentary times.'[6] Indeed, by now the Long Parliament had been in session for nearly three months, and the trial for treason of the Earl of Strafford was about to open. Correspondence

88 (*facing page*) Correggio, *Venus and Cupid with a Satyr ('Jupiter and Antiope')* (detail of fig. 156)

89 Giovanni Battista Bolognini, after Guido Reni, *Bacchus and his Companions Finding Ariadne
Abandoned on the Island of Naxos*, London, British Museum

continued as to whether the painting should be sent by land or sea, but it seems never to have reached England, for now the time for acquiring pictures was over.[7]

A supposedly indecent picture chosen by the Pope's nephew and sent from Rome: one understands why the shrewd Cardinal Barberini had his doubts about the whole enterprise. On the other hand, the Queen's lack of concern is also illuminating. Was she being merely insouciant, frivolous and obstinate, unaware of – or indifferent to – the challenge that was already threatening her position? Or was she being perfectly sensible in grasping the fact that whatever else might be arousing the hostility of Parliament, works of art were not of the slightest concern?

To try to answer these questions we must look once more – but now from a very different angle – at the whole nature of Stuart collections. I have been trying to indicate some of their splendour, but how far would that splendour have been apparent at the time and how far was it intended to impress? Two conflicting theories have been much debated in the literature on princely collecting in this period. It always used to be said that Charles I and certain other monarchs – conspicuous among them the Holy Roman Emperor Rudolf II – collected art and promoted extravagant court entertainments in order to 'escape reality' and take refuge in a dream world.[8] More recently, it has been asserted that the exact opposite is

true and that such activities formed part of a deliberate political policy to inspire awe in those invited to witness them.[9] The argument has been conducted at a somewhat abstract level, which is natural enough because very little specific evidence can be found in support of either view, but it is worth considering the stray facts that are available.

The idea that the prestige of a great art collection can be politically and socially important is expressed – or at least implied – quite frequently in the seventeenth century, but always (as far as I know) by non-English witnesses.[10] Thus a few years after Charles I's pictures had been disposed of in the manner examined below, the Venetian ambassador in London made an interesting comment that has not, I think, been noted by students of the sale. The new republican government had – so he claimed in 1656 – decided to keep prices low when selling off the King's sumptuous possessions so that as many people as possible would be able to participate and thus share in the anxiety that they might one day have to return to a restored monarchy what they had been able to secure for themselves.[11] This would give them a stake in the survival of the existing regime and would increase the aversion of the public to the domination of a king. Meanwhile, Cromwell himself was constantly raising his prodigious grandeur on the ruins of the royal house. There is no reason to believe that the sale was organized with such a Machiavellian purpose in mind, but the ambassador's suggestion is revealing for what it tells about the contrasting attitudes to art collecting in England and most of the rest of Europe, especially Spain, where Philip IV's ministers paid serious attention to the quality of the pictures to be seen in the sacristy of the Escorial because 'so many foreigners go there all year' including envoys of foreign princes.[12]

In England, matters were different. It is true that ambassadors and distinguished visitors were received in audience by the King at Whitehall and other palaces, and that at these audiences themselves, in the Banqueting House or in other less imposing chambers, and on their way through suites of rooms to get to them, they had to pass picture after picture of superb quality. Indeed, thanks to van der Doort's very thorough inventories, we know almost exactly what they would have seen in each one of these rooms. We also know, from the records of the Master of Ceremonies, a good deal about how audiences were conducted and even what was said at them.[13] Never is any reference made to Charles's eagerly acquired Titians and Raphaels, and the only visitor who is recorded as noticing van Dyck's most superb portrait of the King (fig. 155) was his embarrassing mother-in-law, Marie de' Medici,[14] even though the painting was placed at the end of a gallery in St James's Palace, along whose side walls were hung Titian's paintings of the Roman emperors (now, alas, destroyed and known only through copies: figs 150 and 151).[15] On the very rare occasions when works of art are mentioned, they are the ones to which we historians today pay the least attention. In April 1637, the King took the Spanish ambassador 'along with him and shewed him his statues as he passed through the Privy Garden [of St James's Palace]'.[16] But it was tapestries that

really mattered: for special occasions they would be brought up river from the Tower of London and, whatever foreign diplomats thought of them, these 'rich hangings' certainly made a great impact on the King's own officials.[17] I do not want to carry this line of thought too far. Quite large numbers of people obviously did have access to most of the collections of Charles I and his courtiers – and when Balthazar Gerbier wrote to Buckingham that, 'if Your Excellency will only give me time to mine quietly, I will fill Newhall with paintings so that foreigners will come there in procession', he clearly realized that this would be of benefit to the Duke.[18] To some extent he was obviously right: Rubens left testimony to how greatly impressed he was by Buckingham's collection as well as by the King's.[19] Moreover, the very fact that Mazarin, Philip IV of Spain and the Archduke Leopold Wilhelm were so quick to take advantage of the chaos caused by the Civil War in the hope of enriching their own galleries with expensive works of art from London (that they had never actually seen) provides telling evidence of the reputation abroad of the Stuart collections.

Within England itself, the evidence is vaguer. A sudden vogue for books on artistic techniques was one response, but it is not very revealing. Court poetry is rich in allusions to painting and even to actual painters, and these allusions must have been inspired by an awareness of the significance that they held for highly placed owners and patrons. It is, on the other hand, exceedingly rare to come across references to particular pictures that can be identified. The most eloquent admirer of the great paintings that had come to London was, rather improbably, Cromwell's chaplain, Peter Sterry (1613–1672). In a series of magnificent sermons preached under the Commonwealth, he frequently derives his imagery from pictures (which, one imagines, he had seen hanging in the saleroom rather than in a palace) and he refers to Titian and van Dyck (the King's favourites), though only in general terms.[20]

The scarcity of surviving documentation does not, of course, prove much about responses to the Stuart collections. But before I discuss what reasons there might – or might not – have been for hostility to them, I must point out that, unlike the popes, who sponsored handsomely illustrated publications of their possessions, the King of Spain or other rulers, Charles I did virtually nothing to let the world know of the masterpieces that he had been able to acquire. When the Duke of Mantua disposed of the Gonzaga pictures, he ensured that the whole transaction should take place in the utmost secrecy because he (rightly) foretold that his subjects would be very dismayed and indignant once they got to hear of it.[21] No such precautions were to be needed when the mansions of London threw open their doors to dealers, tradesmen and the agents of foreign governments.

But, of course, indifference did not amount to quiescence, and in different ways all the principal collections we have been looking at were dispersed as a result of parliamentary action. When, how and why did this occur? As far as I know, the first authorized moves were carried out towards the end of October 1642: nine months after the King left London,

parliamentary troops seized Windsor Castle amd removed the magnificent silver plate made by Christian van Vianen for the ceremonies of the Order of the Garter (the plate is lost and was presumably melted down).[22]

This at once raises the problem of how far objects of this kind would have been looked upon as private property. Sporadic iconoclasm, motivated by religious convictions, had taken place often enough in churches during the years of peace, and this intensified once conflict broke out. A month before the episode at Windsor, the parliamentary soldiers occupying Oxford had burnt 'Papist' books and pictures in the street and 'fired shots at the images of the Virgin with the infant Saviour in her arms' at the entrances of St Mary's Church and All Souls College.[23] A silver plate concealed in Christ Church was assumed to be a 'lawful prize', but the commander told the college that as long as they kept their plate 'in places fit for plate, the treasury or buttery', it 'should remain untouched'. In some ways, the only fundamental change that occurred was that expropriation and destruction were now carried out on a legal, or semi-legal, basis.

From early 1643 onwards, policies of this kind became far more systematic and began to encroach far more openly on what was acknowledged to be private property. When on 1 April the House of Commons appointed a committee for the destruction of 'superstitious and idolatrous monuments' of the Capuchin friars at Somerset House, they specifically recognized that this palace belonged to the Queen.[24] Nevertheless, they ordered that an inventory should be made of her 'hangings and household stuff', which were to be handed over to their own officials in return for a receipt, though it seems that some devastation was also inflicted without their authority (including, perhaps, the throwing into the Thames of an altarpiece by Rubens).[25] Instructions were given to deface 'superstitious' paintings in the chapel of St James's Palace, though it is not know whether or not these were carried out.[26] Similarly, we cannot be sure that – as was claimed in a royalist newssheet – after vandalizing Westminster Abbey, one of the parliamentary leaders 'proceeded in his visitation to his Majesty's gallery, which he reformed of all such pictures as displeased his eye, under pretence that they did favour too much of superstitious vanities'.[27] On the whole, however, although stained-glass windows were smashed and communion plates and other furnishings in royal chapels were seized – as, of course, was happening elsewhere – the King's picture collection was to survive the war relatively unscathed.[28] But this could not have been anticipated with any confidence, and meanwhile all the other aristocratic collections were put under threat.

In January 1643, government officials went to the Port of London to make a thorough search of the chests and trunks being shipped to Lord Arundel, who, with his wife, had recently moved to the Low Countries, from where he was to send substantial amounts of money to the King.[29] With a few exceptions, his pictures were allowed out, but two months later the jewels, which he had imprudently left behind, were sequestrated and ordered to be

sold for the benefit of the army.[30] Then, in May, the pictures belonging to Hamilton that had already been packed in readiness to be sent to him in Scotland (where in a very tortuous way he was acting on behalf of the King, who had secretly rewarded him with a dukedom and soon afterwards was to have him arrested) were detained in London and then handed over by the Commons to Lord Denbigh for safe-keeping.[31] There was an appropriate irony in this move. Denbigh (c.1608–1675) was Hamilton's brother-in-law, who as ambassador in Venice had, as we have seen, acquired all Hamilton's best pictures for him; but at the outset of the war he joined the parliamentary forces and at the battle of Edgehill found himself fighting against his own father, who had volunteered to serve under Prince Rupert and who was later killed in a skirmish.[32]

In January 1644, it was the turn of the Buckingham collection. The House of Commons decided that the pictures still hanging in York House should be seized and sold – also to raise money for the army, because the second Duke, though only fourteen years old, had served briefly under Prince Rupert at the outbreak of the war.[33] As we shall see, the fate of the collection he inherited was to be different, but the parliamentary discussions are revealing about the two principal and conflicting issues that were at stake in the reactions aroused by the Stuart collections. When it was explained to the Commons that if half the pictures at York House were sold, £6,000 could be made available to maintain the forces in Ireland, one MP protested that 'most of these paintings were either superstitious or lascivious, and that it was not fit to make a benefit of the superstitious ones, but rather to have them burnt'.[34] A special committee was appointed to look into the matter and, as a result, the Commons ordered that any pictures that showed God the Father, Christ, the Holy Ghost or the Virgin Mary should indeed be burnt, on the grounds that it would be wrong to make money by putting people's souls at risk.[35] Fortunately, this ferocious order was not put into effect, but the distinction made between 'lascivious' and 'superstitious' suggests that had Guido Reni's *Bacchus Finding Ariadne* actually reached England, it would not have suffered any damage at the hands of the Puritans; ironically enough, the picture was in fact to be mutilated a few years later, not in London but in Paris, by the Catholic widow of a French financier whose priorities were different and who was worried by the amount of nudity shown in it.[36]

We frequently come up against preoccupations of this kind with regard to pictures in private collections as well as to more publicly displayed images. Thus among the paintings recovered from a Spanish vessel that ran aground on the Sussex coast in 1644 were some which, it was claimed, contained

> most gross idolatry; upon one, the Trinity pictured in monstrous shapes like giants; upon another is painted the Virgin Mary as sitting in Heaven with her babe in her arms, underneath is the Pope, on whose left hand stands our King perfectly limmed [sic] and completely armed, with his cavaliers attending him; on the Pope's right hand stands the

90 *The Sussex Picture, or, An Answer to the Sea-Gull,*
London, British Library

Queen accompanied with her ladies, the King tenders his sceptre to the Queen, she accepts it not, but directs it to be delivered to the Pope. . . . I look upon this picture as an hieroglyphic of the causes and intents of our present troubles.[37]

I would dearly like to know what this can possibly have been and strongly suspect that the iconographer got something wrong somewhere. In fact, even at the time, there was considerable debate about the true meaning of the picture, which I have not succeeded in tracing. It was taken to London and exhibited at Westminster in an attempt to discredit the King, but a royalist pamphleteer then argued that the subject depicted was in fact a scene from the Martyrdom of Saint Ursula and that it was the work of a Flemish artist called 'Gerard de La Vallée', whose signature was clearly visible, and that it had nothing whatsoever to do with the English situation.[38] To refute him, a parliamentarian then published an extremely tendentious engraving of what he claimed to be a detail of the picture, showing the royal couple with the Pope (fig. 90).[39] Unfortunately, no other information has yet come to light about this extremely mysterious episode.

Idolatry and superstition were, however, fortunately protected from destruction by the need to make money out of them. It is constantly repeated that Charles's art collections

aroused anger because of the large sums he spent on them, especially at a time when he was engaged in levying taxes without summoning Parliament. This sounds plausible and may well have been the case, but there is almost no evidence for it.[40] I know of only one complaint about his extravagance in this area, and that was made when the King was trying to raise considerable sums for the simultaneous purchase of the Mantua pictures and statues and the (unsuccessful) relief of the Huguenots besieged in La Rochelle.[41] However, the reverse of the proposition is certainly true: Parliament quickly appreciated that selling art could make money, and this appreciation was to overrule all other considerations.

No case is more extraordinary, more difficult to substantiate and less edifying in this respect than that of Hubert Le Sueur's equestrian statue of Charles I (fig. 91).[42] This was commissioned by the King's Chancellor of the Exchequer, Richard Weston, later 1st Earl of Portland, who installed it not as a public monument in London but in the park of his private mansion at Roehampton. Nonetheless, in 1644 – nine years after his death – it was seized by Parliament and brought to Covent Garden to be auctioned on behalf of Portland's son in order to raise money towards the huge fine imposed on him because of his support for the King. It was bought by John Revet, the King's brazier, who after the execution of Charles was instructed to break it up – Parliament presumably feeling that having indirectly made a substantial sum out of the King's effigy, it could now regain its ideological purity by having it destroyed.[43] Revet must have been sorely tempted to comply with the order, as the bronze would have been extremely valuable for him. However, he kept the statue intact and concealed it, only to find that it was reclaimed after the Restoration by the second Lord Portland, whose mother eventually sold it to Charles II for £1,600.[44]

The threat to Le Sueur's statue was commercial and not ideological in origin. Until the end of his life, Charles was acknowledged to be King and coins with his effigy were the only ones in legal circulation, even in those parts of England under the control of his opponents. After his decapitation in January 1649, all this naturally began to change. Repeated orders were given for the removal of statues of him on or outside public buildings. But even in this area change was relatively slow. In July 1650, nearly eighteen months after his execution, the King's statue still stood alongside those of his ancestors in a niche above the gallery in the Exchange, and the Council of State decreed that it 'bee demolished by haveing yᵉ head taken off, and yᵉ Sceptʳ out of his hand' and a Latin inscription recording the end of tyranny be written on the base.[45] Six months later, we find the Council of State complaining to the Lord Mayor that 'in many churches and halls of companies in London, and other public meeting places, the arms and picture of the late King' were still visible.[46] As late as 1652, a Dutch visitor was startled to find that at Greenwich 'the Queen's name and coat of arms are still to be seen everywhere',[47] although in the 'rather nice village' of Brentford many of the inn signs were painted with the words 'Here *was* ye King's head' or 'Here *was* ye King's arms'.[48] Even

91 Hubert Le Sueur, *Charles I on Horseback*, London, Trafalgar Square

after all this it comes as a shock to learn – and in December 1651 this same Dutchman expressed his surprise – that in the Banqueting House of Whitehall Palace 'where there was nothing in the world now except three long deal tables . . . high up between the beams, there were still those beautiful Rubens paintings' (fig. 92).[49]

The discovery of documents about the themes to be celebrated on the Whitehall ceiling has made us more aware than ever before of the seriousness with which the iconography was

92 Peter Paul Rubens, the ceiling of the Banqueting House, London

93 Peter Paul Rubens, the ceiling of the Banqueting House, London: *The Union of England and Scotland*

94 Peter Paul Rubens, the ceiling of the Banqueting House, London:
The Benefits of James I's Government

discussed and planned;[50] and although the little child stomping the weapons of discord beneath his feet while extending his arms to personifications of England and Scotland (fig. 93) who, assisted by Minerva, are about to crown him, is now believed to represent the birth of the United Kingdom and not of Charles I, nonetheless the whole ceiling resonates with the triumphs of his dynasty.[51] One of the documents clearly states that 'the whole roofe of the Banqueting House [is] designed to the memory of King James, who was founder thereof';[52] but initial plans to introduce images very specific to him were abandoned. At one point, for instance, one of the squares was to portray 'the King w^th a Laurell wreath on his head, holding in one hand a booke open & in the other a penn' to express 'his learning, in w^ch he exceeded all the Kings of his tyme'.[53] Instead James is shown enthroned between Solomonic columns, stretching out his arms to protect Peace and Plenty and ordering Minerva and Mercury to crush the forces of evil (fig. 94), which may have had specific connotations such as the Gunpowder Plot but is more likely to have been thought of in general terms. After James I's death in 1625, renewed consideration was given to the ceiling and it was decided to transfer his Apotheosis to the large central oval, which depicts the King, with Religion and Faith on his right, being swept up by Justice to Heaven, where he is to be greeted by Victory and Minerva (fig. 95).

This – in barest outline, for the details were far more elaborate than I have suggested – was what was to be seen by Charles I's guests at special ceremonies in the Banqueting House and this, too, was the last work of art that he himself could have seen as he stepped out from one of the windows on to the raised scaffold. This was also what was to be seen by Cromwell and his visitors, as they in turn took part in grandiose ceremonies in the Banqueting House. Hours, weeks, months, perhaps years of planning had gone into the choice of images and their arrangement: extended quotations from the book of Isaiah were cited to justify the portrayal of children, animals and festoons to symbolize the 'public union'. To those involved in the design, no one more so than Rubens himself, their labours were of utmost importance; for that reason, above all, art historians of today must also take it seriously. But did anyone else care? Did Cromwell wonder for one moment what was going on above his head? Was he at all perturbed by an arrangement of figures, which however Protestant in intent was suspiciously similar to the imagery to be found in Catholic triumphs? The survival of the untouched Whitehall ceiling remains one of the most amazing (as well as the most fortunate) episodes of these times.

Privately owned portraits of the King and Queen were, of course, not in any danger. They hardly could be, in view of the fact that Parliament had decided to sell, rather than destroy, them: Bernini's marble bust of Charles I was valued at £800, higher than any other piece of sculpture in the royal collection, including antique sculpture. The next chapter will follow the fortunes of some of these portraits, but here it is worth pointing out that by at least a

95 Peter Paul Rubens, the ceiling of the Banqueting House, London: *The Apotheosis of James I*

96 The Music Room at Lamport Hall, Northamptonshire

few loyal subjects the King's portraits by van Dyck were not looked upon merely as beauti-
ful paintings: they embodied very obvious political connotations.[54]

Of no one was this more true than Sir Justinian Isham (1611–1675), a gentle bookish man
who had hoped to marry Dorothy Osborne and in 1651, at the age of forty-one, inherited
Lamport Hall, his father's Tudor house in Northamptonshire, which he set about renovating
with the professional assistance of John Webb.[55] When pictures were needed, Webb intro-
duced him to a dealer who sold him versions of two of van Dyck's grandest royal portraits,
made by pupils or copyists.[56] He refused to have reduced versions made and paid the large
sum of £250 for a full-scale copy of *Charles I with M. de Saint-Antoine*, which he hung in
the entrance hall (fig. 96), where it faced a copy of van Dyck's wonderful *Le Roi à la chasse*.
This defiant decoration was carried out in 1655, at a time when Sir Justinian was under

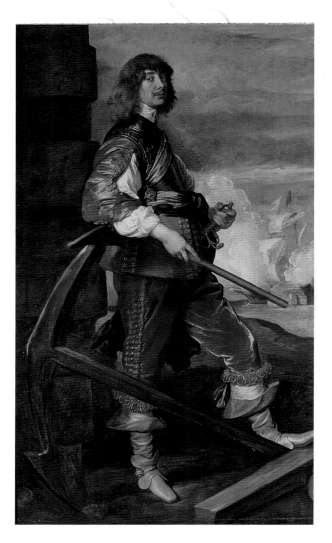

97 Anthony van Dyck, *Algernon Percy,*
10th Earl of Northumberland as Lord High Admiral,
Alnwick Castle, Collection of the Duke of Northumberland

constant police surveillance and occasionally subjected to arrest. Lamport Hall was searched
for weaponry and the authorities were well aware of Isham's extreme royalist sympathies, but
the pictures that so clearly proclaimed these sympathies emerged unscathed.

Isham acquired other van Dycks of less compromising subjects during the Interregnum
and it was probably at this period – but we cannot be sure – that he was able to buy a third
copy of a major picture for his entrance hall, where it hangs above the mantelpiece: that of

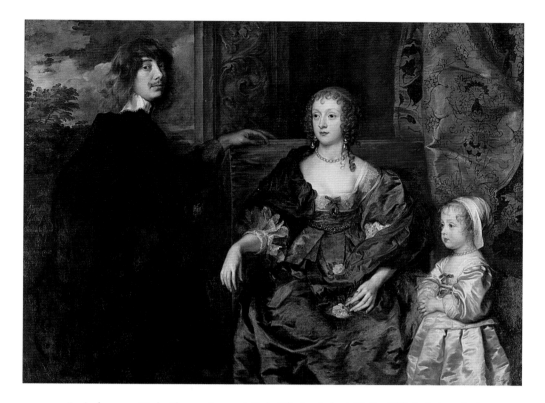

98 Anthony van Dyck, *Algernon Percy, 10th Earl of Northumberland, his First Wife, Lady Anne Cecil, and their Daughter, Lady Catherine Percy*, Petworth House, National Trust

Titian's *Cardinal Georges d'Armagnac and his Secretary*. As we saw, this famous painting had been acquired for the Duke of Buckingham by Gerbier some thirty years earlier and greatly excited Inigo Jones. Its transfer from one noble collection to another, that of Lord Northumberland, introduces us to the last of the great English collectors of this period.

Algernon Percy, the 10th Earl of Northumberland (1602–1668; fig. 97), was the 'proudest man in England' according to (the certainly biased) Clarendon: 'though his notions were not large or deep, yet his temper, and reservedness in discourse, and his unrashness in speaking got him the reputation of an able and wide man; which he made evident in the excellent government of his family, where no man was more absolutely obeyed' (fig. 98).[57] A more recent historian explains that he had 'the independent spirit of a feudal potentate'.[58]

Northumberland spent part of his childhood in the Tower of London, where his father, the 9th Earl, was imprisoned for sixteen years under suspicion of involvement in the Gunpowder Plot. Conditions were not arduous and the intellectual atmosphere was very stimu-

lating, but it was a strange start in life for the future owner of, among other properties, Syon House, Petworth House and Northumberland House, and the tenant of York House. Northumberland did not become one of Charles's intimates but he served the King loyally – though sometimes critically – in a number of high-ranking posts and he was a staunch patron of van Dyck. During the 1630s he bought pictures by other artists as well as tapestries and superb silverware, but not on the scale of Charles's courtiers.[59] His finances seem to have been in a constant state of upheaval, liable to sudden increases through inheritance and equally sudden reverses through the extensive building and rebuilding in which he was continually engaged;[60] at times we find him buying and selling almost simultaneously. What, however, makes Northumberland's career as a collector so distinctive is that it flourished at precisely the time when all his competitors (if that is how he would have seen them) were in trouble, that is to say when the Civil War was at its most intense.

As tensions increased during the Long Parliament, Northumberland found himself becoming more and more alienated from the King and 'prevailed upon not to do that which in honour and gratitude he was obliged to',[61] in the words of Clarendon – words interpreted by Clarendon's commentator as 'he had none of the superstitious veneration for royalty which had grown up in England since the Middle Ages'.[62] Thus, gradually, Northumberland became the most important of the peers to side with Parliament, but he was always a proponent of compromise and peace, and it was he who was chosen by Parliament to act as a guardian for the King's two youngest children. At least as far as his own interests were at stake, he maintained his independence against the pressure of Parliament and the army as stoutly as he had against the King.

In April 1645, Northumberland intervened decisively in the argument as to which of Buckingham's pictures should be sold off to increase the military strength of the army and which should be destroyed to increase the purity of its faith: he refused to allow any of them to be removed from the walls of York House. He was the tenant, and he did not intend to have it made 'very unuseful for [my] Habitation'.[63] Indeed, he reminded Parliament that it owed him £360 to refund the losses he had so far suffered for its cause, and he suggested that this should be paid in the form of 'some of the smaller pictures'.[64] How exactly he reconciled this proposal with his obligations to the landlady, the Duchess of Buckingham, and to her young son currently in exile, who was heir to the collections and whose interests he was supposed to be protecting, is not quite clear. But ethics were no more central to his concept of picture collecting than they were to those of his contemporaries. Parliament agreed, and so it was that Northumberland became the owner of Buckingham's *Cardinal Georges d'Armagnac and his Secretary, Guillaume Philandrier* by Titian (fig. 16). This picture can hardly be called 'small', although this adjective is appropriate for the 'eight little pictures in one Frame by Elshammer'[65] (figs 99 and 100), which was another and much more surprising choice but one that

99 Adam Elsheimer, *Eight Saints and Prophets*,
Petworth House, National Trust

100 Adam Elsheimer, *Tobias and the Angel*,
Petworth House, National Trust

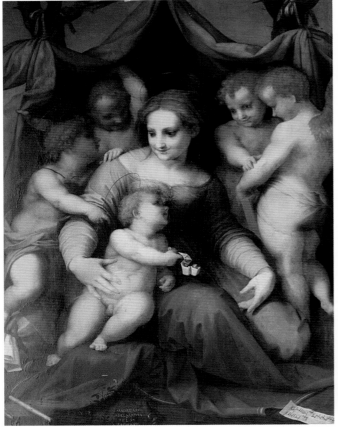

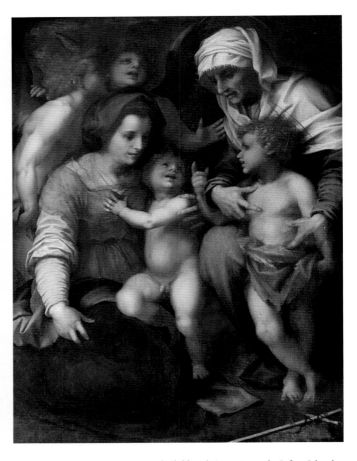

101 Andrea del Sarto, *Virgin and Child with the Infant John the Baptist and Three Angels*, Petworth House, Collection of Lord Egremont

102 Andrea del Sarto, *Virgin and Child with Saint Anne, the Infant John the Baptist and Two Angels*, Petworth House, Collection of Lord Egremont

must surely have been influenced by Lord Arundel's admiration for this artist. In addition, Northumberland demonstrated clearly enough that he at least had no qualms about 'superstitious' art, because he obtained two depictions by Andrea del Sarto of the Virgin and Child (figs 101 and 102), which ought certainly to have been consigned to the bonfire. To complete the deal, he went out of his way to select a 'lascivious' picture, Palma Vecchio's *A Venetian Woman* (fig. 103).

Northumberland was later to acquire some other works from the same source, but in this same year, 1645, it was to the estate of van Dyck that he now turned for what were the most splendid pictures ever to enter his collection. It seems quite likely that, many years earlier, van Dyck had advised him on the purchase of a Titian from Venice, and Northumberland would certainly have been familiar with the superb collection of Titians that van Dyck had

103 Palma Vecchio, *A Venetian Woman*, London, National Gallery

bought for himself in Italy and Flanders and then, in 1635, transported to London.[66] The artist had died in December 1641 and in his will had left his pictures to the wife he had married only a year earlier; she, however, remarried within a few months, and her second husband, and an exceedingly grasping host of relatives, set about laying their hands on van Dyck's great bequest and dispersing it for money as quickly as they possibly could. Many

97

104 Titian and workshop, *The Vendramin Family*, London, National Gallery

pictures were illegally smuggled out to Flanders, but some remained in London. Among these were two masterpieces by Titian, *The Vendramin Family* (fig. 104) and *Perseus and Andromeda* (fig. 105), and Lord Northumberland managed to buy them on 4 October 1645 for £200.[67] He quickly sold off the *Perseus and Andromeda*, and this seems to confirm what is suggested both by his acquisition of Titian's *Cardinal Georges d'Armagnac and his Secretary* from Buckingham and by the nature of his commissions to van Dyck: like most of the other English collectors, he was somewhat 'old-fashioned' in his taste, preferring portraits to mythologies. Indeed, long after van Dyck's death, he continued to buy portraits by him from other collections or from sitters and their families who had fallen on hard times, even when,

105 Titian, *Perseus and Andromeda*, London, Wallace Collection

106 Anthony van Dyck, *Olivia, Wife of Endymion Porter*,
Syon House, Collection of the Duke of Northumberland

as in the case of Mrs Endymion Porter (fig. 106), those sitters would surely have been uncongenial to him for their extreme royalist and Catholic beliefs. This suggests that however 'old-fashioned' his taste might be as regards to subject-matter, he had a real appreciation of aesthetic quality and, above all, of van Dyck.

107 Peter Lely, *Charles I and James, Duke of York*, Syon House, Collection of the Duke of Northumberland

108 Polidoro da Caravaggio, *Psyche Abandoned on a Rock*, Royal Collection Trust

In 1645, he, too, acquired – in exchange for a miscellaneous group of still lives and other pictures – a reduced, unfinished version of *Charles I with M. de Saint-Antoine*, which so appealed to the royalist Sir Justinian Isham, and not long afterwards he commissioned from Lely a portrait of Charles with his second son, the Duke of York (fig. 107). Although Northumberland was always hoping for reconciliation between the two sides, his parliamentary allegiance never seems to have been in serious doubt. He did not, however, vote for the execution of the King, and for a number of years he abstained from buying any of the works from the royal collection being sold off by the government following the collapse of the monarchy. By 1657 he seems to have found it pointless to be over-scrupulous – and his financial situation probably improved at the same time. He bought from one of the King's creditors three pictures that had hung in Whitehall, where he must often have seen them: a *Saint John* believed to be an original by Correggio, which Charles had bought in Madrid when he had gone there as Prince of Wales, as well as *Psyche Abandoned on a Rock* by Polidoro (fig. 108) and Giulio Romano's *Sacrifice of a Goat to Jupiter* (fig. 109). The following year, he also bought a sizeable group of antique statues to adorn Northumberland House. He did not have long to enjoy these because he was compelled to return them to the royal collection when the monarchy was restored three years later.

Northumberland's collection was now the finest in England, but despite his superb Titians and van Dycks, which made it so similar in character to those of Charles I and his courtiers, it never really compared with them in scale. It is true that he had begun buying in the 1630s

109 Workshop of Giulio Romano, *Sacrifice of a Goat to Jupiter*, Royal Collection Trust

but his purchases had not then been very significant and it was only with the disintegration of the *ancien régime* that he came into his own, fortified by the examples (and, above all, by the pictures) of Buckingham, van Dyck and the King. But although it was a cautious English nobleman of ancient lineage, a friend and neighbour of the King, who was among the first collectors to be able to take advantage of the earliest, menacing drops to fall on that regime, we shall see that once the storm raged in full force the pictures still remaining in the palaces of Whitehall and the Strand would be swept away to the remoter regions of Europe, as well as of England, by collectors of a very different kind from any that we have yet come across.

4

EXILES AND EXPORTS

THE ARUNDEL, BUCKINGHAM, HAMILTON AND ROYAL COLLECTIONS WERE FORMED IN RIVALRY; THEY WERE NOW TO BE DISPERSED IN RIVALRY. THE 1640s were a bad time for most of western Europe, as international wars combined with civil strife to threaten central governments or, at the very least, to cut their revenues in the most drastic way. The almost simultaneous dumping – or predicted dumping – on to the art market of four such outstanding collections posed difficult problems for even the most avid rivals of the amateurs who had built them up. It poses a difficult problem for the historian as well. The complicated sales that will be examined in the coming chapters would become wholly incomprehensible if treated in chronological order rather than by the individuals who were driven to them: it is essential to remember that much of what will be described in sequence was in fact happening simultaneously.

In February 1642, Charles I, who had already left London, instructed Lord Arundel to escort the Queen and their daughter Princess Mary to the Low Countries to join William of Orange, whom Mary had recently married. Although Arundel's presence was intended to be purely formal, he never returned; it seems very likely that he and Lady Arundel had for some time been thinking of leaving England for good. His health was now very bad, their finances were in a desperate way, and as the situation in London grew ever more tense there were rumours that Arundel House was to be attacked by a riotous mob. Already, the year before, he had made his will, leaving everything to Lady Arundel, and she had had an inventory drawn up of the household stuffs and goods in her own London residence just outside St James's Park.[1] They made arrangements for their possessions to be sent to them in the Low Countries and the great majority of their pictures seem to have reached them by 1643. So, too, did much of their library, though not the marbles and probably not all the drawings. It is possible that they hoped to bring these over also, but Arundel's refusal to return to England when ordered and the royalist propaganda disseminated by his Catholic wife led to the sequestration by Parliament of all the possessions they had left behind. Nonetheless, this first great arrival of art from England, which included both fine originals such as Holbein's

III Hans Holbein the Younger, *Dr Chambers*,
Vienna, Kunsthistorisches Museum

Dr Chambers (fig. III) and studio versions of celebrated masterpieces such as Titian's *Three Ages of Man* (to choose his two favourite artists), must have made quite an impact even in Antwerp, where the flourishing picture trade had made connoisseurs familiar with works of outstanding quality over the years.

Towards the middle of 1645, Arundel left Antwerp for Italy and at about the same time as Lady Arundel moved to the Low countries. This ordering of priorities will not come as too much of a surprise to anyone who has studied the Earl of Arundel's career; he always seems to have preferred Italy to his wife. In Italy, he spent about eighteen months in comparative poverty. He lived mostly in Padua, but he revisited many cities in the north and he remained as enthusiastic about art as he had ever been. In Parma, he made a great impression on the artist in charge of the Duke of Modena's picture collection, both because of his skill at distinguishing the styles of different masters and because of his extraordinary visual memory, especially in regard to Holbein.[2] But he also complained bitterly about the forced disbanding of his own collection. He produced much the same effect on John Evelyn, whom he met

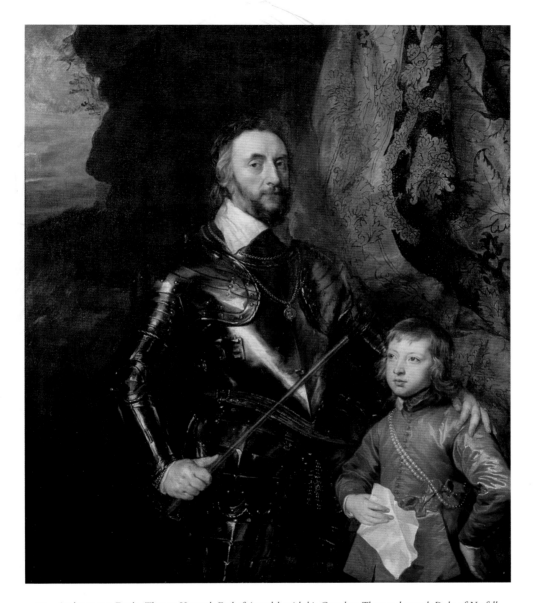

112 Anthony van Dyck, *Thomas Howard, Earl of Arundel, with his Grandson Thomas, later 5th Duke of Norfolk,*
Arundel Castle, Collection of the Duke of Norfolk

in Padua not long before his death and for whom he wrote out an itinerary describing the places most worth visiting in Italy.[3] But he was in a depressed state of mind because his eldest grandson, with whom he had had himself painted ten years earlier by van Dyck (fig. 112) and in whom he had placed high hopes, was now a lunatic. Another grandson had, to his extreme

distress, become a Dominican monk, and he grumbled that his wife had already 'scatter'd and squander'd' – the words used by Evelyn some forty years later – part of the 'very rich collection as well of medals as of other intaglios' that he had entrusted to her care.[4] Lady Arundel, whose passion for art seems to have rivalled that of her husband, was hardly to blame. She too was reduced to poverty by the seizure of her property in England; we know that she took the utmost care of the Arundel library whenever she changed her residence in the Low Countries, and it seems unlikely that she sold any of his pictures before his death in September 1646. Lady Arundel undoubtedly played a part in designing the memorial print dedicated to herself, which was etched by Hollar in 1650 from a preliminary drawing by Cornelis Schut to commemorate this 'patron of artists and restorer of the fine arts' (fig. 113):[5] Arundel is shown – just as, in his will, he had asked to be represented in bronze or marble – 'looking upwards . . . leaning upon a Lyon holding an Escochion'.[6] While a skeletal Death and the figure of Time try to pull him away with them, Fame proclaims his eternal glory. Scattered throughout the print are important items from his collection: Holbein's *Duke of Norfolk*, coins and medals, in a niche the statue of Venus that had already been depicted in Mytens's portrait of him in his gallery, painted some thirty-five years earlier (fig. 61), a drawing signed by Raphael and much else.

After Arundel's death, we know that some of his pictures began to be dispersed, but at first these seem to have been ones left behind in England and not taken to the Low Countries. A number of these are recorded in the possession of various members of the family. In 1653, for instance, in the 'closet' of his granddaughter-in-law, Lady Anne Mary Howard, who appears to have been living in Arundel House, were to be seen a *Madonna* by Raphael, portraits by Dürer and Holbein, as well as *An Allegory of Passion* by the latter artist (fig. 114), recorded very precisely on the painting itself as 'a fellow on horseback flying almost, with this cosi. desio me mena.' – a Petrarchan allegory of desire that had belonged to the King and had almost certainly been given by him to Lord Arundel.[7] A year later, the French ambassador gleefully reported that Arundel's sons, who were 'Catholic and in debt',[8] were trying to sell pictures from what remained of the collection in England.[9] Theoretically, it was not theirs to sell because Arundel had left all his possessions to his widow, who was still alive in Amsterdam, but it is, of course, possible that they were acting on her behalf. In any case, the deal came to nothing when the ambassador discovered that all the best items had been sent to Flanders 'to prevent their being looted'.[10] The Spanish ambassador in London was much more enterprising: he had heard that the Arundel family possessed one of the most famous masterpieces of the sixteenth century, Raphael's *Pope Leo X with Cardinals Giulio de' Medici and Luigi de' Rossi* (fig. 115). This was known to have been copied by Andrea del Sarto – so well, according to Vasari, that Raphael's own pupil Giulio Romano had not been able to distinguish between the two versions.[11] As the copy was made for the dukes of Mantua, whose

113 Wenceslaus Hollar, after Cornelis Schut, *Allegory on the Death of Thomas Howard, Earl of Arundel*,
London, British Museum

114 Hans Holbein the Younger, *An Allegory of Passion*, Los Angeles, The J. Paul Getty Museum

collection had come en bloc to England, it was reasonable to assume that it was this that belonged to the Arundels. Strongly encouraged by the authorities in Madrid, the ambassador bought the picture and sent it to Spain, where its arrival was awaited with great excitement. This, however, changed to disappointment when the connoisseurs were able to see it for themselves. As was pointed out by Velázquez, who had recently returned from Italy, this could not be the del Sarto version – let alone the original Raphael – as the cardinal in the background differed radically from Cardinal Luigi de' Rossi.[12] It is now recognized that

115 Raphael, *Pope Leo X with Cardinals Giulio de' Medici and Luigi de' Rossi*, Florence, Galleria degli Uffizi

116 Giuliano Bugiardini, *Pope Leo X with Cardinals Giulio de' Medici and Innocenzo Cibo*, Rome, Galleria Corsini

it is, in fact, a third version of Raphael's composition, painted by Giuliano Bugiardini for Cardinal Cibo who wanted his own portrait to be substituted for that of de' Rossi (fig. 116).[13]

In 1654, Lady Arundel died in Amsterdam, just two years after her eldest son, Lord Maltravers (1608–1652). Both of them had made valuable contributions to the collection, but their relationship was disastrous. Lord Maltravers had spent years trying to contest his father's will and he had accused his mother of wasting what would eventually become his inheritance by such unnecessary expenses as going to Rome 'to kiss the Pope's great toe'.[14] She in turn prayed God 'to forgive him for his unnaturall carriage towards her' and left the collection to her younger son, Lord Stafford (1612–1680).[15] Like her, he was a Catholic but he had no difficulty in moving between England and the Continent during the Commonwealth, and

he appears to have begun selling his inheritance as quickly as he could after his mother's death.[16] Among the first pictures to go was the magnificent *Christ and the Centurion* by Veronese (fig. 43), which was bought for Spain by Philip IV's former ambassador Alonso de Cárdenas, who had been expelled from his country's embassy in London in 1655, at the very moment when the Arundel pictures began coming on the market in the Low Countries, to which Cárdenas now moved.[17] However, at this stage Lady Arundel's own will was contested – by the son of her elder son (the one who had tried so hard to prevent her getting the pictures in the first place).[18] Eventually Lord Stafford and his nephew reached a settlement and her possessions were divided between them. Some of the Arundel pictures were brought back to England by the competing branches of the family: family portraits, certainly, but also at least one of the Holbeins, the *Erasmus* (fig. 117). We also know that John Evelyn persuaded Henry Howard, Lord Arundel's grandson, who became 6th Duke of Norfolk, to present to Oxford University some of the famous marble inscriptions from the eastern Mediterranean, which now lay battered and neglected in the grounds of Arundel House, and to the Royal Society many of the most learned manuscripts.[19]

Many years later, the indefatigable Evelyn approached Lord Howard once again to know

whither he would part with any of his Cartoones & other Drawings of Raphael & the greate masters. He answered me, he would part with and sell anything for mony, but his Wife (the Dutchesse &c) who stood neere him; & I thought with my selfe, That if I were in his condition, it should be the first thing I would be glad to part with: In conclusion he told me, if he might sell them altogether, he would; but that the late Sir Peter Lely (our famous painter) had gotten some of his best.[20]

Evelyn's scathing tone is understandable enough, for he had deeply admired Henry's grandfather, Lord Arundel, and had seen for himself the love that had gone into building up his great collection, which was now being dissipated by 'Lely, Wright, and the rest of the Painters, Panders, and Misses'.[21]

Over the next few generations, various private purchases and public sales were made in London and in the provinces of works of art that had belonged to Lord Arundel, but – with very rare exceptions – the only items of real quality to emerge from these were pieces of furniture and, above all, drawings, which had almost certainly never been removed from the various residences belonging to him and his wife. Most of Arundel's pictures, therefore, remained in Amsterdam for the next thirty years, until they were finally dispersed by auction in 1684. Long before that, however, the finest examples had been drifting off to different parts of Europe. One gets the impression of a sort of incredible emporium, owned by absentee shareholders, which, over the years, was dipped into by purchasers of all kinds, who presumably paid their bills of exchange into the accounts of the various family members who

117 Hans Holbein the Younger, *Erasmus*,
London, National Gallery (on loan from the Longford Castle Collection)

118 Charles Le Brun, *The Family of Everhard Jabach* (destroyed 1945)

had a stake in what remained. The name of Arundel provided a plausible guarantee of quality and authenticity, but who made the arrangements and who determined the price is not at all clear. When in 1674 the government of the United Provinces was looking for a suitable present to give to Lord Arlington, Charles II's minister, who was on a diplomatic mission to The Hague, it was to this depot (if one can call it that) that they turned, and there they chose for him a so-called 'Raphael' that had been particularly close to Lord Arundel's heart (fig. 20).[22] And we know of at least one Englishman who sold off in London 'several valuable paintings, collected abroad . . . formerly belonging to the Arundel collection'.[23]

But by far the most spectacular purchases were made by three members of a single family. We shall come across Everhard Jabach (1607–1695) in chapter 5 because he was one of the most lavish purchasers at the royal sale. He was born in Cologne and then moved to Paris, where he became director of the highly profitable East India Company and banker to Mazarin (fig. 118). In his handsome palace, he built up a collection of paintings and especially drawings, which within a few years was to become the finest in Europe.[24] Unsated by his spoils from Charles I's collection, he turned his attention to the Arundel storehouse. From it he bought a few Italian pictures that may just possibly have included Titian's *Concert*

119 Hans Holbein the Younger, *Thomas Godsalve and his Son, John*,
Dresden, Staatliche Kunstsammlungen, Gemäldegalerie Alte Meister

champêtre by Titian (Paris, Musée du Louvre), although we cannot be sure. It was above all
the Holbeins that tempted him, and among the many fine portraits that he acquired are four
now in the Louvre, including *Nicholas Kratzer* (fig. 120) and *Anne of Cleves* (fig. 121).[25] Finan-
cial problems forced him to sell much of his collection to Louis XIV in 1671, but he soon
recovered his fortune and in subsequent inventories we come across further Holbeins
that had once belonged to Arundel, including *Thomas Godsalve and his Son, John* (fig. 119).
Splendid as these are, they were surpassed in scope and importance by those that were bought
in the same period by two of his nephews, the brothers Franz Gerhard and Bernhard Albert

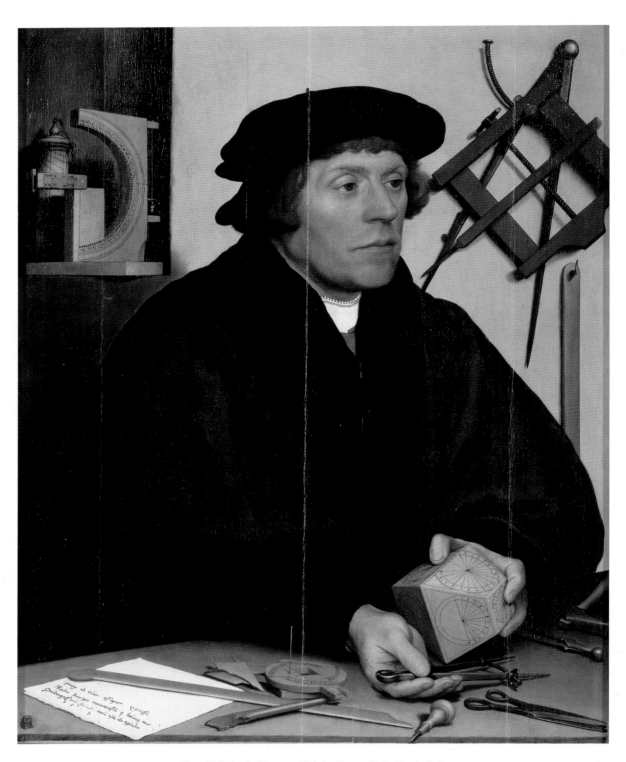

120 Hans Holbein the Younger, *Nicholas Kratzer*, Paris, Musée du Louvre

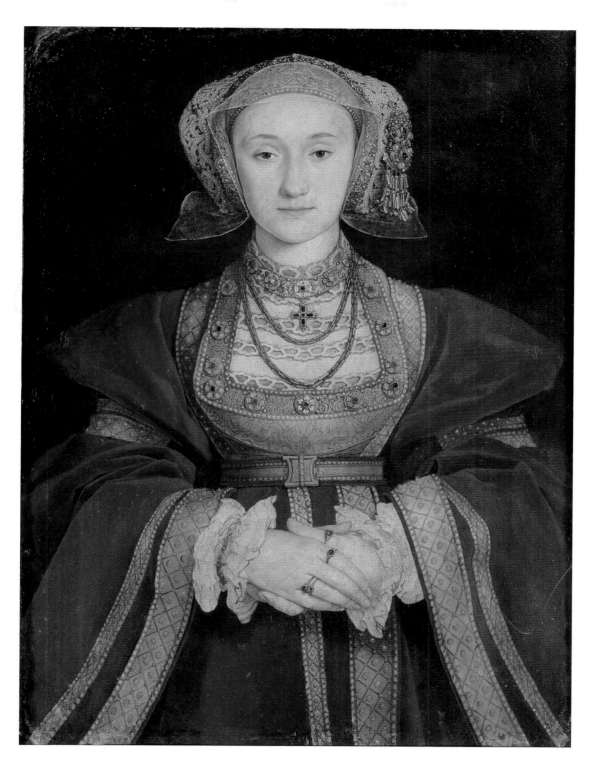

121 Hans Holbein the Younger, *Anne of Cleves*, Paris, Musée du Louvre

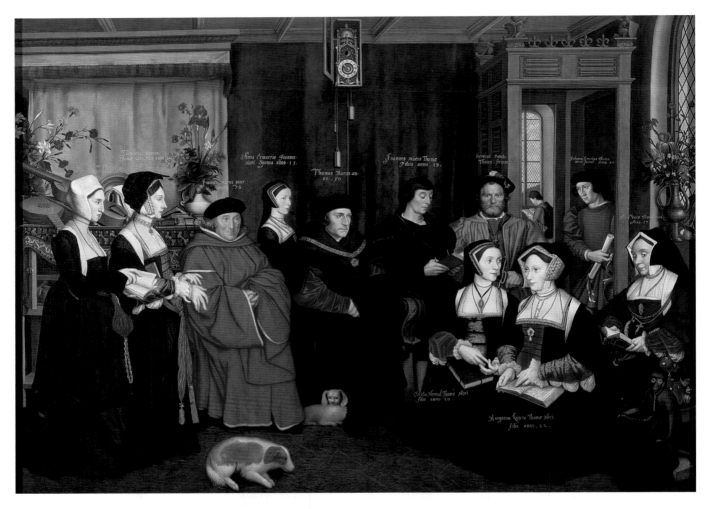

122 Rowland Lockey, after Hans Holbein the Younger, *The Family of Sir Thomas More*,
Nostell Priory, National Trust

von Imstenraedt who remained in Cologne – the city that Jabach himself had left for Paris
– where they formed a marvellous collection.[26] They bought about twenty Arundel pictures
of superb quality, including the three grandest Holbeins he had owned (all alas now destroyed,
although their appearance is known from copies), *The Triumph of Riches* and *The Triumph
of Poverty* (figs 70 and 71) and *The Family of Sir Thomas More* (fig. 122). Their Arundel Dürers
included the portrait of Katharina Fürlegerin (fig. 123) and among their Italian acquisitions
were Antonello da Messina's *Saint Sebastian* (fig. 124) and four Titians. Three of these have
disappeared, but the fourth has not, and it has won increasing recognition as one of the

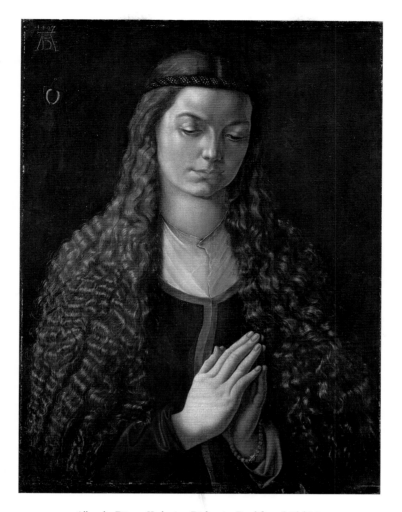

123 Albrecht Dürer, *Katharina Fürlegerin*, Frankfurt, Städel Museum

supreme masterpieces of art, *The Flaying of Marsyas* (fig. 125) – a picture not apparently recorded before being 'discovered' by Lady Arundel and one in which pagan mythology takes on a tragic intensity unprecedented in painting.[27]

It was therefore to Cologne, and not to London, that a well-informed traveller would have had to go in the decade after Lady Arundel's death to gain an impression of the core of her husband's collection, one so neglected by the squabbling son and grandson to whom she had bequeathed it. Even Charles I could have been seen there more poignantly and more vividly than anywhere else because, through a somewhat circuitous route, the Imstenraedt brothers

124 Antonello da Messina, *Saint Sebastian*,
Dresden, Staatliche Kunstsammlungen, Gemäldegalerie Alte Meister

125 Titian, *The Flaying of Marsyas*, Kroměříž, The Archbishop's Gallery

126 Anthony van Dyck, *Charles I and Henrietta Maria*, Kroměříž, The Archbishop's Gallery

had managed to buy from the dispersed royal collection van Dyck's beautiful double portrait *Charles I and Henrietta Maria* (fig. 126). But none of these masterpieces was to remain in Cologne for long.

In 1667, the Imstenraedt brothers, having written a lengthy catalogue of their collection in Latin verse,[28] tried to sell their pictures to Leopold I, the Holy Roman Emperor, who five years earlier had been bequeathed the paintings of his uncle, Archduke Leopold Wilhelm, so many of which, as we shall see, had come from England. The Emperor turned down the collection as too expensive, and the brothers next planned to sell it by lottery, but this too fell through because no one seems to have bought tickets.[29] Eventually they were forced to dispose of it cheaply to Karl von Liechtenstein, the Bishop of Olomouc in Moravia, one of those aristocratic, landowning prelates who dominated so much of central Europe in the seventeenth century. He divided the pictures between his two residences of Olomucz and Kroměříž – which is why the Titian ended up in so remote a place, utterly unknown even to scholars until the middle of the 1920s and to the world at large until only a few decades ago.[30]

127 Anthony van Dyck, *George Villiers, 2nd Duke of Buckingham, and Lord Francis Villiers,*
Royal Collection Trust

We must now go back to the middle of the 1640s, when the Civil War was still in progress and Lord Arundel had left for Italy while, in the Low Countries, his wife was gradually beginning to 'scatter and squander' some of their smaller and more movable possessions. This was the time when, in London, proposals were being made to confiscate and sell the paintings inherited from his father by the 2nd Duke of Buckingham (fig. 127), who was still only sixteen

but who had already committed himself briefly to the King's cause before being sent off to the Continent out of harm's way. The news of a possible sale was reported to Madrid by the Spanish ambassador and it caused considerable excitement: Philip IV was keen to take advantage of any transaction (provided that his involvement could be kept secret), especially as it was rumoured that Charles I's goods would shortly suffer the same fate.[31] In the end, Lord Northumberland (Buckingham's guardian and tenant) took some of the York House pictures for himself and quickly put an end to any plans to get rid of the rest. Northumberland and some of his political allies among the more moderate peers were working cautiously, but with great determination, for a reconciliation between Parliament and the young Duke. The House of Lords began to put pressure on the Commons to revoke the sequestration of his goods, and a year later this was agreed by both Houses.

But although Buckingham now had his property and his possessions safely back, he seems to have started almost immediately to make plans for the removal to the Low Countries of his pictures and jewels. Many other magnates were taking similar precautions, including Lord Northumberland himself, but Buckingham had an additional reason for trying to raise money: he was determined to renege on his obligations and, once again, to mount a campaign in support of Charles I, who was under a form of house arrest. In February 1648, Buckingham was granted permission to export to the United Provinces sixteen chests of pictures, free of customs duty, provided that they remained sealed and were not sold abroad; they could, however, be re-imported into any part of England that the Duke chose.[32] The Dutch authorities countersigned this authority. Despite the restrictions imposed upon him, Buckingham had firm plans to sell part of his collection abroad in order to raise funds. On the strength of such prospects of wealth and support, he was able in June and July to take part in the Second Civil War. It was not a successful episode. His younger brother was killed, he himself was declared a traitor by the Commons, his possessions were once again sequestrated and he had to flee to the Low Countries. But the bulk of his picture collection had arrived there safely in May, and it seems that a faithful servant gradually smuggled out much more over the following months.

However, his advisers suggested to him that Amsterdam was not the best place for disposing of his pictures. They may have recalled that the future of the Arundel pictures was still very uncertain and that the market would not be able to stand too great an influx at the same time. In any case, for reasons that will be explained shortly, most of them were taken to Antwerp, where they were temporarily stored in the house of a merchant.[33]

The problem of how to dispose of Buckingham's goods to his best advantage was very thorny. His financial advisers reckoned that, although his precious stones gained greatly in impact by being seen all together, to put them all up for sale in a single batch might either make them prohibitively expensive or, if carried out with too much speed, drastically depress

the market. Furthermore, many of his paintings had been pawned in the province of Zeeland to raise money to ease his immediate plight and could not be redeemed until he had raised the necessary cash. Thus, at one stage during the complicated transactions that ensued, the Duke found himself in the position of having sold pictures that could not be supplied to their new owners.

Not everything was sold. Family portraits and many minor pictures remained in London, and the Duke gave some items to his friends. Of these, by far the most significant was a portrait by Rubens of Anne of Austria, the Queen of France, with whom the first Duke had conducted such a blatant flirtation a quarter century earlier.[34] Nevertheless, it would seem that most of the more splendid pictures inherited by that duke's son were sold off in 1649 and 1650.[35]

At first, they were distributed quite widely. A canon of Antwerp cathedral is believed to have bought the most famous of all, Titian's *Ecce Homo* (fig. 26), and many more were purchased by dealers, especially the family firm of the Duartes, one of whom had been jeweller to Charles I.[36] They were of Portuguese–Jewish origin – nominally converted to Catholicism – and at various times they owned pictures that had belonged to Arundel as well as Buckingham, some of which drifted back to English private collections many years later, such as *Nature Adorned by the Three Graces* by Rubens (fig. 128), sold by Buckingham and in 1716 found by the artist James Thornhill in Paris.[37] The pictures that had been pawned in Brussels and Holland were eventually redeemed and purchased for £1,000 by another dealer. So satisfied was the Duke of Buckingham with the results of his transactions that he made vigorous attempts to have sent over from England his remaining tapestries, statues and other goods, if necessary through the agency of diplomatic channels, such as the Spanish embassy, or through foreign merchants. Smuggled out might be a better phrase as his goods remained under sequestration, although, through his contacts with Lord Northumberland, his links with the parliamentarians were not altogether severed even now. The statues certainly remained at York House, however, for we next hear of them in 1651, when Buckingham was in Perth, where, four months before the utter defeat by Cromwell of the young Charles II at the battle of Worcester, he took time off to sign a statement that he gave 'full power and Authority to Sir C^hal Cottrill [Cotterell] K^t to sell for My use My statues. And to deliver the same or to cause them to be delivered to such as shall buy them who shall as peaceably Enjoy the same without any further Clayme of mine as if they had been sold Immediately by My Self.'[38] It is not clear how successful he was in disposing of the sculptures; but certainly the most important piece in the collection, Giambologna's *Samson and the Philistine* (fig. 65), remained in England in the hands of his immediate descendants.

However, the destiny of the Buckingham pictures was to be very different from anything that I have suggested so far. The main reason why Antwerp was recommended as the most

128 Peter Paul Rubens and Jan Brueghel the Elder, *Nature Adorned by the Three Graces*,
Glasgow, Kelvingrove Art Gallery and Museum

129 David Teniers the Younger, *Archduke Leopold Wilhelm*,
Vienna, Kunsthistorisches Museum

suitable place for selling them was the arrival in nearby Brussels in 1647 of an astonishing new luminary in the world of international art collecting, Archduke Leopold Wilhelm (1614–1662), second son of the Holy Roman Emperor Ferdinand II and governor of the Spanish Netherlands (fig. 129).[39] Within two years, Buckingham's advisers were already suggesting that Leopold's 'good success in Flandre [*sic*] will make him prodigal in these curiosities'.[40] The success in question was his recent campaign against the French, and indeed much of his time was spent in warfare. Nonetheless, in ten years or so he built up one of the greatest art

127

130 Orazio Gentileschi, *The Rest on the Flight into Egypt*,
Vienna, Kunsthistorisches Museum

collections in Europe, and among his first important acquisitions were the finest of the Buckingham pictures, which cost him £5,000. Among these were Titian's *Ecce Homo* (fig. 26), quickly ceded by the cleric who had bought it, and Gentileschi's *The Rest on the Flight into Egypt* (fig. 130). Yet he did not keep a single one of these paintings for himself, but sent them all to his elder brother, the Holy Roman Emperor Ferdinand III, in Vienna, where they still remain.

The reason for this self-denying abstinence is not clear but it is likely that it was prompted in part by an ambition to compensate for the loss of the pictures assembled by his great-grandfather Rudolf II in the imperial capital of Prague and recently looted by the Swedes.[41] Still more decisive, however, must surely have been the sudden availability, at almost exactly the same time, of an even more remarkable collection than Buckingham's, that of the Duke of Hamilton. I hoped against hope that I would be able to clear up the mystery of a transaction that is universally agreed to have transformed the nature of one of the world's great museums. But I have not yet been successful and can do no more than lay the evidence before you.

As civil war loomed and Hamilton became more and more involved in Scottish affairs, he (very sensibly) took steps to have his pictures transferred from London to Scotland. In a few

131 Peter Paul Rubens, *Daniel in the Lions' Den*, Washington, D.C., National Gallery of Art

cases he was successful: *Daniel in the Lions' Den* (fig. 131), a large early Rubens given to him by Charles I, was taken north and so (either then or at a later stage) were a number of family portraits. Not long after hostilities broke out, Parliament refused to allow the removal of any more of his possessions, even though the pictures were already in packing cases waiting to be shipped. Indeed Hamilton's request for permission may have been a mistake, for on 23 May 1643, within three days of its being made, the Commons ordered all his property to be handed over to his brother-in-law, Lord Denbigh, the very man who as ambassador to Venice had acquired the pictures for him. Denbigh espoused the parliamentary cause (though he was later to drift back into royalism), and in accepting custody of Hamilton's pictures he engaged his honour 'that they shall be forthcoming, to be disposed of when this House shall

require'.[42] Within a few months, pressure was building up in Parliament for the sale of the pictures to cover some of the expenses of the army, but (as happened with Buckingham) the matter was soon dropped.[43]

The purpose of this study is not to explore Hamilton's convoluted behaviour over the next few years – partly spent as the King's closest friend, partly as his prisoner – except to say that by July 1647 it had led to the Commissioners for the Scottish Parliament pressing the House of Commons in London to have his pictures and other possessions restored to him.[44] Eventually, on 8 January 1648, the Commons agreed with the Lords 'that as well as the Pictures as other Goods of the Duke [of] Hamilton's, in the custody of the Earl of Denbigh, or others, be restored, as is desired'.[45] However, the decision came too late and it is virtually certain that Hamilton never saw his pictures again. Within only months of formal restitution being agreed, the whole situation had changed out of all recognition. Hamilton had been made Commander in Chief of the Scottish army, which he was leading into England in support of the King; within a few months his troops were routed and on 9 March 1649, only weeks after Charles, he too was beheaded.

In his will, Hamilton, who was a widower and had no sons, bequeathed 'his jewels, plate, and pictures (which were of great value)' to his younger brother William (1616–1651), who now became the second Duke.[46] William had sailed to the Low Countries and it was there that he heard of the deaths of the King and of his brother. He at once tried desperately to raise money on behalf of the man he now acknowledged as his legitimate King, Charles II. In March 1650, he made a will in The Hague; in it he left all his 'jewels, silver, plate, hangings, pictures, beds and whatsoever goods else are mine' to Anne, the daughter of his executed brother, and hence his own niece, but he gives no indication of what these pictures were or whether they were of any significance.[47] A few months later, he returned to Scotland. On 3 September 1651, he was wounded and taken prisoner at the battle of Worcester, and within ten days he was dead.

In this same year, 1651, David Teniers (1610–1690), court painter of the Archduke Leopold Wilhelm in Brussels, signed and dated a picture that portrayed himself showing a drawing to the Archduke in his picture gallery, in the company of two courtiers (fig. 132).[48] Most of the pictures shown in this painting (in a wholly fanciful arrangement) are identifiable, and the quality of those depicted in this and in similar views is remarkable, but only a few are of immediate interest to us. On the top row, second from the right, is Saraceni's *Judith with the Head of Holofernes* (fig. 133), which came from the Hamilton collection. So, too, did *The Death of Actaeon* next to it, Titian's painting now in the National Gallery, London (fig. 134).[49] In the row below, the second picture from the left is Giorgione's *Three Philosophers* (fig. 32), which had also previously hung in Wallingford House. Below it is a *Saint Margaret* (fig. 31), attributed to Raphael and acquired by Hamilton against bitter opposition from Arundel.[50]

132 David Teniers the Younger, *The Gallery of Archduke Leopold Wilhelm*,
Brussels, Musées Royaux des Beaux-Arts, Musée d'Art Ancien

Leopold Wilhelm shared their enthusiasm, and *Saint Margaret* is not only given a place of honour but is also provided with a curtain. On the other side of the arcade is Veronese's *The Adoration of the Magi* (fig. 135), which had belonged to Hamilton, as had *Christ Healing a Woman with an Issue of Blood* (fig. 136) to its right. On the ground floor, just to the right of the table, is *Saint Dominic and Saint Ursula*, the fragment of an altarpiece by Antonello da Messina, which had been sawn up into five pieces (fig. 33): this too had been owned by Hamilton. It would be perfectly easy to go through other views of the Archduke's gallery and to pick out other paintings from the same astonishing source but I have already shown enough

133 Carlo Saraceni, *Judith with the Head of Holofernes*, Vienna, Kunsthistorisches Museum

134 Titian, *The Death of Actaeon*, London, National Gallery

135 Paolo Veronese, *The Adoration of the Magi*, Vienna, Kunsthistorisches Museum

to indicate how significant a place Hamilton's pictures held in the Archduke's collection. As he later bequeathed this collection to his nephew, the Holy Roman Emperor Leopold I, these pictures joined those that had belonged to Buckingham and now form one of the most important nuclei of the Kunsthistorisches Museum in Vienna.

But how and when precisely did the paintings change hands? There is no record in official papers, and the transaction must have been a private one. Who was responsible for it? On Leopold Wilhelm's side, David Teniers himself was probably involved: we know that he was in London in 1651 buying pictures for the King of Spain. And who was acting on behalf of the Hamilton family? Had the second Duke sold them when he, like so many royalists, was trying to raise money for the royal cause? Was Lord Denbigh, who had been put in charge of the pictures, somehow implicated? It seems impossible to me that archival research will not, one day, answer these questions. But almost as interesting as what we may discover

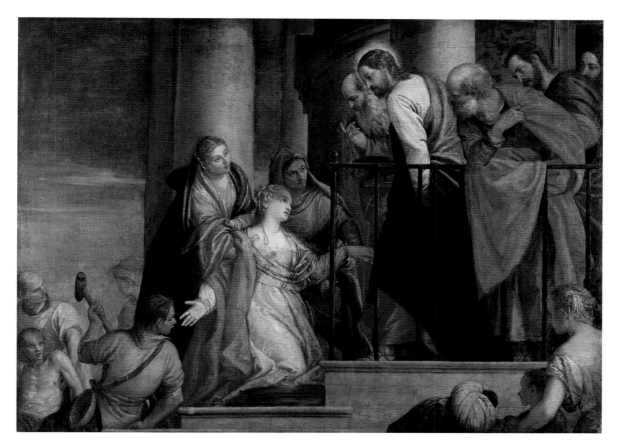

136 Paolo Veronese, *Christ Healing a Woman with an Issue of Blood*,
Vienna, Kunsthistorisches Museum

in the future is what we have failed to discover in the past. The absolute silence that followed
the removal from London of one of the most beautiful collections of Venetian paintings ever
put together is surely revealing about the wider response – or rather lack of response – to the
achievements of a very small group of Stuart courtiers who could by now rival collectors any-
where in Europe. We must bear this in mind when considering the fate of the most famous
collection of all – that of Charles I.

DAVID · TENIERS · Fec

5

THE ROYAL SALE

Charles I was beheaded on 30 January 1649, and two days later the Commons appointed a special committee to take care of his possessions and to have them locked up (fig. 138). A few weeks later, Parliament authorized the Council of State to sell them to pay off the King's debts, reserving only what was necessary for the State, though this was not to exceed £10,000 in value.[1] Commissioners with very extensive powers were appointed to draw up full inventories and to put a valuation on individual items so that these could be sold, and it was acknowledged from the first that prices would be much higher if works of art were sold abroad.[2] The first £30,000 to be raised from these sales was to be lent to the navy, which would have to pay that sum back within about eighteen months. The remaining profits were to be used to settle the debts owed to the King's servants, which of course involved a far wider group of people than would be implied by the use of that term today.[3] The actual sales were to be conducted in the great hall of Somerset House, which had been one of the royal palaces. Contrary to what is often believed, there was never any question of an auction. Many of the inventories seem to have been completed within nine months, though a few dragged on for another year or so.

Whatever one feels about the nature of the undertaking in general, it is hard to exaggerate the skill with which the Commissioners tackled the formidable difficulties facing them. We are essentially interested in the paintings and statues, but they had to compile identifiable, and sometimes very detailed, records of everything found in the royal palaces – tapestries, above all, which were looked upon as the most valuable of all possessions, but also furniture and furnishings of all kinds: beds, carpets, greyhound collars, comb cases, chairs, cushions, even 'close-stools' adorned with red velvet. All these were scattered through a whole series of residences that had belonged to the King and his family.

Despite some complaints at the time and much ridicule ever since, the prices assigned by the Commissioners to the huge numbers of works of art they had to dispose of were not intrinsically unreasonable and certainly not incoherent. Officials must have had access to

137 (*facing page*) David Teniers the Younger, *Archduke Leopold Wilhelm in his Picture Gallery in Brussels* (detail of fig. 161)

138 *The Execution of Charles I*, Edinburgh, Scottish National Portrait Gallery
(on loan from the Collection of Lord Dalmeny)

earlier inventories[4] and probably also to records of some of the prices paid by the King for his pictures, not to mention advice from the ubiquitous Balthazar Gerbier, whom we have come across before and shall again, and who now joined their number and doubtless made sure that his own interests (whatever they happened to be at that given moment) would not suffer. No sale of this kind had ever been held before, nor had market conditions ever been so unsettled.

Before we turn to that market, it is worth attending briefly to some of the principal works that, at different moments during the course of the sale, were reserved for Cromwell by the State, even though it is very difficult to discern any taste or guiding principle at work in the making of these choices. As I have already mentioned, £10,000 was set aside for this purpose from the very first, and a further £10,000 was soon added. It is not surprising that a high proportion of this sum was spent on furnishings of various kinds, for the royal palaces were taken over as government offices and needed decorating; indeed, Cromwell himself was later to live in royal splendour at Whitehall.[5] Tapestries, especially, were acquired, and it is under the category of designs for tapestry that we must include the two most famous sets of paintings that were to remain in England and that are still here today: the cartoons by Raphael (figs 55 and 56), valued at £300 the lot, and – much more expensive at £1,000 – *The Triumphs of Caesar* by Mantegna (figs 141 and 142), whose reserve was the result of a last-minute change of mind after they had already been sent to the saleroom.[6] In fact, so great

139 Workshop of Giulio Romano, *The Omen of Claudius's Imperial Power*, Royal Collection Trust

140 Workshop of Giulio Romano, *Nero Playing while Rome Burns*, Royal Collection Trust

was the need for tapestries that some that had already been sold to private purchasers were later to be bought back by the State.[7] It is significant that in 1654 the Dutch ambassadors recorded that the Banqueting House (in the ceiling of which Rubens's glorification of James I was still to be seen) 'was hung with extraordinary rich hangings',[8] as it had been during the reign of Charles I, but then only on very special occasions.

Royalists and indeed parliamentarians, already alarmed by Cromwell's ambitions, may have feared that their suspicions were confirmed when they learned that he had reserved for himself two pictures by Giulio Romano and his workshop, one then believed to be of Julius Caesar and the other of Nero fiddling while Rome burns (figs 92 and 93), and there must certainly have been political reasons for his acquisition of portraits of the King and Queen of France and the French ambassador, acquisitions that are particularly striking in view of the fact that the only other portrait bought from Charles's collection was of one of the royal jesters.[9] But other pictures reserved for Cromwell are often surprising and sometimes inexplicable;

141 Andrea Mantegna, *The Triumphs of Caesar: The Musicians*, Royal Collection Trust

142 Andrea Mantegna, *The Triumphs of Caesar: The Corselet Bearers*, Royal Collection Trust

143 Titian, *Salome with the Head of Saint John the Baptist*, Madrid, Museo del Prado

indeed, in some cases, Cromwell seems to have decided not to keep a painting, despite the fact that the Commissioners had retained it for him. This appears to have been the case with the single most expensively valued painting chosen, a version of Titian's *Salome with the Head of Saint John the Baptist* (fig. 143).[10] What is so astonishing about the pictures that Cromwell did keep is not so much the fact that, with the exception of portraits by the Dutchman Paul

144 Luca Cambiaso, *The Assumption of the Virgin* (fragment), Royal Collection Trust

van Somer and one seascape by Jan Porcellis, every single one of them is by an Italian artist, but that so many are of subjects that one would have thought of as dangerously provocative. Sometimes, no doubt, the implications could be evaded. Thus the *Infant Christ and Saint John Embracing*, a rather disagreeable religious picture then attributed to Parmigianino, was described merely as 'two naked boys';[11] we must remember in this connection how many proposals had been made to destroy any picture depicting the 'second person of the Trinity'.[12] But Cambiaso's *The Assumption of the Virgin* (fig. 144) was acquired by Cromwell under its correct title of 'Mary Ascention w^{th} y^{e} Apostles looking on', though the fact that the next time we hear of the painting, after the Restoration, it is described (in its present

state) as 'part of the Assumption of the B. Virgin and the Apostles standing by about the Tombe' suggests that the more offensive upper half with the Assumption itself was probably removed while it actually belonged to Cromwell.[13] Nonetheless, it was an odd choice for him in the first place, as too were such pictures (now untraced) as 'Mary, Elizabeth and the Child' by Schiavone or a 'Madonna with many angels and one with a scourge'.[14]

Although sales to the public began in October 1649, well before then hopes had been high in different parts of Europe that rich pickings would become available as a result of the troubles in England. As early as the summer of 1645, encouraging rumours reached Madrid that Charles I's collection was likely to come onto the market,[15] and at much the same time Mazarin, who was deeply involved in Anglo–Scottish intrigues, told his special envoy that he should keep a look out for good-quality tapestries.[16] However, a little time was to pass before either France or Spain would be able to take full advantage of the situation.

Although we have quite complete records of the items that were put into the sale and of the prices asked for them – and also of the prices that were actually paid – it is difficult to reconstruct the exact management of affairs. Paintings, furnishings and other goods seem to have been transported in large consignments to Somerset House, which was then replenished with further supplies as stocks ran low. At any given moment, a great deal of space must have been needed, because we know that in May 1650 some 250 paintings and 150 tapestries were available to shoppers visiting the palace.[17] Statues, antique and modern alike, often badly damaged, were displayed downstairs, alongside furniture. Tapestries were hung on the walls, but the pictures, which may have been numbered and arranged in sections labelled in alphabetical sequence, were placed in galleries running around the room at a high level. This made it difficult to see them properly, especially as they tended to be very dusty and badly cared for.[18] It is worth reflecting for a moment on the possible significance of the spectacle. This was certainly the first time in England that what we can, for shorthand, call 'ordinary people' – not the populace, of course, but soldiers and lawyers, clergymen and doctors – could have had the chance to see Titians and Rubenses, Guido Renis and van Dycks, dusty though they may have been. How did they respond to the experience? We cannot answer, although (as mentioned previously) it seems to me likely that it was in this emporium, rather than at Whitehall or St James's, that the aesthetic imagination of the Puritan chaplain Peter Sterry was so powerfully stirred.

It was money that mattered most. Opinions differed about the valuations drawn up. A Dutch visitor found the prices reasonable, but the Swedish ambassador thought they were excessive.[19] Whatever views were held on the matter, all goods purchased at the sale had to be paid for in cash, for which a very carefully worded receipt was provided by the organizers, ensuring that the object bought would remain the new owner's 'for ever, to all intents and purposes whatsoever'.[20]

But how would the average visitor have known what he was looking at? Although no catalogue has apparently survived, we can find scattered but very unclear references to the probable existence of what may have been printed lists, recording each picture, by artist, subject and price. For an inexperienced public, the value of this information cannot have been easy to gauge. A month after the sale opened, Lady Kerr wrote from London to her brother, Lord Lothian, a keen and much-travelled art collector living in Scotland, on behalf of 'a friend of mine being desirous to make purchase of some of . . . the late King's [pictures]'.[21] She enclosed a list and asked him whether he was familiar with the originals. Unfortunately, we do not have his reply.

Whatever the reason, initial responses to the sale were disappointing: in the first months, thirty-eight individuals, it is true, bought 375 pictures between them, but mostly at the lower end of the market so that by May 1650 only £7,750 had been raised from this source, although the furnishings did rather better.[22] The plight of those of the King's servants – civil servants, although anachronistic, is probably a better term – who had remained unpaid in parliamentary London during the Civil War was now even more serious, and as they (as well as the navy) were to be the beneficiaries of the sale, Parliament decided on new measures. A list was drawn up of those most in need, to be paid in cash if absolutely essential but, as far as possible, in goods from Charles's estate, that is, in furnishings or pictures. As the pictures had already been valued when it was hoped to sell them all directly, a royal plumber who was owed £903 for repairs to various palaces and the Tower of London found himself being given £400 in cash and then allowed to choose up to £500 worth of pictures, including Titian's *Saint Margaret Triumphing over the Devil* (fig. 145).[23] From the government's point of view, the plan had obvious attractions, but for a plumber (even if by that we mean some sort of entrepreneur rather than the man who would actually come to repair the drains) with a family to feed, a Titian naturally served only one purpose: that of being transformed into currency as soon as possible. Among the so-called 'First List' of the King's creditors – those whose needs were especially urgent – we find not only his plumber but also his silkman, his cutler, his linen-draper and so on. One name is of particular interest: Balthazar Gerbier, the artist, dealer and secret agent, who had been largely responsible for building up the collection of the Duke of Buckingham and who had frequently acted as an intermediary between Rubens and the royal family. Gerbier certainly knew what he was about and accepted in settlement of what was owed to him the splendid portrait of the Emperor Charles V by Titian (fig. 146) – given to the King when he was still Prince of Wales by Philip IV of Spain – and van Dyck's equestrian portrait of Charles I (fig. 147). He was soon attempting to raise money by proposing to paint, in conjunction with Peter Lely, a series of pictures to be placed in the Palace of Whitehall representing all the memorable achievements since the first sitting of the Long Parliament: major battles and sieges, the principal commanders, group portraits of Parliament

and the Council of State and so on.[24] That particular project came to nothing and not long afterwards he settled for a time in the Low Countries and wrote in fulsome terms to defend the late King against detractors.[25]

After the most urgent cases had been dealt with, a Second List of the King's creditors was drawn up. Even more than with the First List, debts were to be settled not in cash, but through the handing over of furnishings and works of art that had originally been valued for purposes of sale. Because of this, most of the creditors organized themselves into syndicates (which were called Dividends), under the leadership of one named individual, who, in collaboration with the Trustees for the Sale, chose what to acquire up to a limit of about £5,000 in the interest of his group.[26] Within each syndicate, the objects were divided among members through the casting of votes; thus, in theory, each member became the owner of some painting or item of furniture, and could do what he liked with it. In practice, most members recognized that it was not all that easy to turn a Correggio or even a 'faire Looke-ing Glasse in an Eboney Frame with an Antique Border of silver, and brasse'[27] into ready cash, and therefore tended to leave such items with the head of the syndicate and ask him to arrange for its sale on their behalf, presumably on the basis of a commission. It is not therefore surprising that we tend to find at the head of the fourteen syndicates men who would be likely to have some experience of the luxury market: among them the King's jew-eller, tailor, draper and upholsterer, as well as a number of painters and also a lawyer. These syndicates managed to acquire some of the masterpieces of the royal collection, partly, one presumes, because such items were too expensive for all but extremely few individuals to buy on their own. For instance, the one led by Thomas Bagley, the King's glazier, obtained not only rich saddles to the value of £2,000 and twenty-two antique statues but also *The Education of Cupid* by Correggio (fig. 153), valued at £800.[28] The syndicate presided over by Edward Bass, who had been a minor official under the Great Seal of the Realm, was allocated Raphael's *Holy Family (La Perla)* (fig. 58) at £2,000, the most expensive single item belonging to the King, as well as his other famous Raphael, *Saint George and the Dragon* (fig. 57). The eleventh Dividend was led by Edmund Harrison, who had been Embroiderer to James I and Charles I (and was later to hold the same post under Charles II) providing uni-forms for the court. He and his colleagues were awarded, among many other highly desir-able items, Titian's *Pope Alexander VI Presenting Jacopo Pesaro to Saint Peter* (fig. 148) and Rubens's *Peace and War* (fig. 83). The second syndicate, presided over by David Murray, the King's tailor, acquired not only a great many furnishings, as one might expect, but also Cor-reggio's *Venus and Cupid with a Satyr* (fig. 156) and Dürer's *Self-portrait* (fig. 159).

I have, I hope, said enough to indicate that we have been witnessing what is perhaps the single most extraordinary episode in the history of English art collecting, or indeed that of any other nation. Great masterpieces painted by Correggio and Titian, by Raphael and

145 Titian, *Saint Margaret Triumphing over the Devil*, Switzerland, private collection

146 Titian, *Emperor Charles V on Horseback*, Madrid, Museo del Prado

147 Anthony van Dyck, *Charles I on Horseback*, London, National Gallery

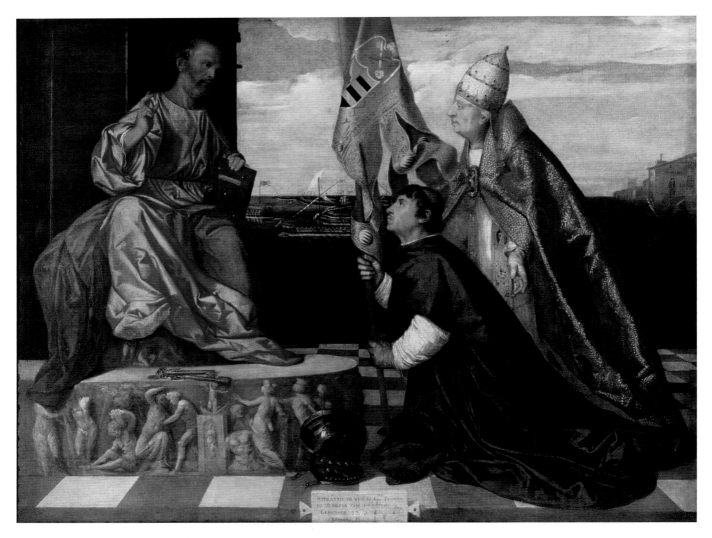

148 Titian, *Pope Alexander VI Presenting Jacopo Pesaro to Saint Peter*,
Antwerp, Koninklijk Museum voor Schone Kunsten

Holbein, by Rubens and van Dyck, for kings and princes, cardinals and courtiers were now to be found in small houses scattered through London and the countryside belonging to haberdashers and glaziers, cutlers, musicians and painters. It is hard not to be reminded of the surprise felt in these very years by English travellers when they saw how widespread was the distribution of pictures in Holland (pictures admittedly of a very different kind): 'All in generall striving to adorne their houses, especially the outer or street rooms, with costly

peeces, Butchers and bakers not much inferiour in their shoppes, which are Fairely sett Forth, yea many tymes blacksmithes, Cobblers, etts. will have some picture or other by their Forge and in their stalle.'[29] The English market was not so democratic but neither was it aristocratic, or even oligarchic. It did not, however, last for long.

Among the first men to visit Somerset House in October and November 1649, when the royal sale got under way, were two army officers with bulging purses, Colonel William Webb and Colonel William Wetton. Colonel Webb came, as it were, straight from the battlefield, for he had played an active part in the Civil War. Colonel Wetton was a Leveller and, a year earlier, he had been chosen as one of their delegates in discussions with the army High Command. Each man disbursed several hundred pounds and, among much else, Webb acquired a *Tarquin and Lucretia* attributed to Titian (now in Vienna, Kunsthistorisches Museum) while Wetton chose Andrea del Sarto's *Virgin and Child with Saint Matthew and an Angel* (fig. 149).[30] Improbable purchases for military men, one might think, but for the fact that, within a few hours of getting hold of it, Wetton had sold his 'superstitious' masterpiece, while Webb waited only four weeks before disposing of his 'lascivious' canvas. Both were bought by the same customer, Alonso de Cárdenas, the Spanish ambassador in London.[31]

Cárdenas had first come to England eleven years earlier in 1638, when the country was still at peace, but he and Charles I got on extremely badly, and the King refused to welcome him in his palace at Whitehall.[32] One effect of this was that when the Civil War broke out Cárdenas cultivated excellent contacts with the army and parliamentary leaders, to whom he frequently offered lavish presents of wine and fine cloths.[33] This helps to explain how, after the execution of Charles I, Cárdenas was in very good position to employ – this is the only word I can think of – leading army officers to buy pictures that he would then purchase from them. Here I must mention one puzzling aspect of the royal sale: although it was recognized by the authorities (indeed, welcomed by them) that expensive items would quickly be sold abroad, I do not know of any occasion when foreigners bought directly at the sale itself. In every case, whether they were private citizens or government representatives, their goods came to them at one remove through English intermediaries, though sometimes these intermediaries did not even bother to take their pictures home from Somerset House.

Cárdenas was faced with two great difficulties. In the first place, although Philip IV was extremely keen to acquire pictures from the sale of the collection of Charles I, he was short of money and was reluctant to pay even his ambassador's salary, let alone give him extra funds for the purchase of works of art. In the second place, the English republic now demanded that foreign ambassadors in London should grant full diplomatic recognition to the new regime and threatened to expel those who maintained that they were still accredited to the former King. Philip IV, who had every reason to hate rebels of all kinds, refused to go as far

149 Andrea del Sarto, *Virgin and Child with Saint Matthew and an Angel* (*Madonna della Scala*),
Madrid, Museo del Prado

as this, although he encouraged Cárdenas to engage in secret negotiations with the English authorities.[34]

Thus Cárdenas, who was heavily in debt, could at first afford to buy only relatively minor pictures at the royal sale, as well as a few beds and tapestries, and he was just preparing to pack these up to take them to his own residence in Madrid when at last in October 1650 Philip IV decided to recognize the English government. At exactly the same time, the French embassy was closed down because Mazarin refused to take the same step.

This was the opportunity that Cárdenas had been waiting for. He sent regular reports back to Spain about the finest pictures available in London and about his chances of being able to buy them at reduced prices, for he proved to be an extremely shrewd negotiator. He would offer sums of money to the indebted English owners of the main pictures and would suddenly withdraw the offer until they agreed to settle for less. He could do this with impunity because, with the French out of the way, he had no rivals.

Philip IV also faced severe financial difficulties. Moreover, it would have been indecent for him to buy directly from the collection of the 'murdered' King of England, who had almost become his brother-in-law.[35] So a very ingenious solution was worked out. Philip IV left all the purchases to Luis de Haro who, in 1643, succeeded his uncle, the Count-Duke of Olivares, as Chief Minister. Haro would then present the best pictures to the King and keep the remainder for his own private collection.[36] In this way, Philip IV paid nothing and was not compromised in any way, but acquired some of the greatest masterpieces both from Charles I's collection and from those of other leading families whose fortunes had collapsed along with the *ancien régime*. Luis de Haro gave instructions as to what was to be specially looked out for: as few religious works as possible, he insisted, except for ones that would be suitable for adorning the Escorial.[37] Among the most famous paintings that soon arrived in Madrid were Titian's *Roman Emperors*, which, alas, are now known only through poor engravings (figs 150 and 151).

By 1651, many important works of art were reaching Madrid from London, and because Cárdenas was now a fully accredited diplomat he did not have to pay the usual export duty to remove them from England.[38] Haro would write back urging to buy ever more, especially Titian, Tintoretto, Veronese and, of course, Raphael, and Cárdenas did what he could to satisfy him. In the spring of 1652, for instance, he bought from the former King's royal embroiderer, Edmund Harrison, eight pictures that a few months earlier had been turned over to Harrison and his syndicate in settlement of unpaid salaries. Among these was *The Allocution of Alfonso d'Avalos, Marchese del Vasto* by Titian (fig. 152). From the head of one of the other syndicates, Robert Houghton, who had been the King's brewer, he acquired Tintoretto's *Christ Washing the Feet of His Disciples* (fig. 47).[39] As soon as the pictures arrived, they were shown to Don Luis de Haro, who was an enthusiast but not an authority, and he

in turn would seek the advice of his experts about the quality. The most influential of these experts was Diego Velázquez, who was naturally full of admiration for the Tintoretto, which Haro immediately gave to the King. Even more important, in the eyes of everyone, was the picture valued more highly than any other in the inventory drawn up of Charles I's collections, Raphael's *Holy Family (La Perla)* (fig. 58). Cárdenas considered the extremely difficult purchase of this, 'the best picture in the world',[40] at less than the price he had expected to have to pay, as one of his greatest triumphs. Both Velázquez and Don Luis de Haro were overwhelmed by the painting and Don Luis placed it as a surprise for the King in his apartment at the Escorial, whereupon Philip is said to have exclaimed 'This is the pearl of my collection!'[41]

Not everything was so successful. Among the pictures Cárdenas was very pleased to have bought was Correggio's *The Education of Cupid* (fig. 153), valued at £800, one of the most

150 Aegidius Sadeler II after Titian, *D. Oct. Augustus*, London, British Museum

151 Aegidius Sadeler II after Titian, *C. Caesar Caligula*, London, British Museum

152 Titian, *The Allocution of Alfonso d'Avalos, Marchese del Vasto*, Madrid, Museo del Prado

153 Correggio, *Venus with Mercury and Cupid ('The Education of Cupid')*, London, National Gallery

154 Anthony van Dyck, *Everhard Jabach*,
St Petersburg, State Hermitage Museum

expensive items in the royal collection. However, when Velázquez saw it, he said that it could not be an original Correggio and Don Luis de Haro decided to keep it for himself, saying that for him 'it would certainly be an original'.[42] This was a wise decision: Velázquez was wrong and it is because of his mistake that this fine work eventually found its way to the National Gallery in London rather than to the Prado.

Some of Cárdenas's most spectacular purchases were relatively cheap – as he enjoyed boasting – because he had few, if any, serious rivals. The French, however, had not been wholly inactive and, at an early stage in the sale, a very rich collector living in Paris, Everard Jabach, had become involved. I have already mentioned this financier from Cologne. He knew the English collections very well – as we have seen, he was to buy some splendid Holbeins that had belonged to Lord Arundel – because he had come to London in the mid-1630s and had

friends among many of the artists and connoisseurs employed by Charles I, including van Dyck, who painted his portrait (fig. 154). I do not think that he returned to London at the time of the sale, but he must have had excellent agents working for him because he was able to get hold of a number of outstanding pictures from the King's creditors, both modern, such as Caravaggio's *The Death of the Virgin* (fig. 76) and Guido Reni's *Nessus Abducting Deianeira* (fig. 77), and older, including Titian's *The Entombment* (fig. 36).[43]

Various other French agents were scouring the London market but it was Mazarin's decision, in December 1652, to grant official recognition to the Commonwealth that brought about a radical change in the situation. Mazarin was himself a passionate collector and the ambassador he sent to London, Antoine de Bordeaux, acted on his behalf with as much diligence (though not as much acumen) as Cárdenas did for Luis de Haro, and thus for the King of Spain.[44] This element of competition naturally suited the English very well indeed and, from then on, we often find them playing off one ambassador against the other and demanding stiff prices for pictures that they themselves had been able to acquire at comparatively low estimates.[45] Sometimes they went too far. Thus Robert Houghton and his syndicate had been allotted van Dyck's *Cupid and Psyche* (fig. 87) at a valuation of £110. He offered it to M. de Bordeaux for £1,000, which would constitute quite a steep profit even by the inflated standards of today; not surprisingly the offer was turned down. M. de Bordeaux also refused to pay £100 for van Dyck's *Three Eldest Children of Charles I* (fig. 85), which Colonel Webb had bought for £60; but this surprising decision was probably owing to the fact that he was already negotiating for seven other van Dycks at the same time.[46] In the end, both the *Cupid and Psyche* and the *Three Eldest Children* were bought by Peter Lely and consequently remained in England, but we do not know whether he was able to bring the price down.

Mazarin was particularly keen to buy paintings by van Dyck, partly because he thought they would be cheap in England, though, like the English, he admired the portraits and not the figure paintings. Above all, he insisted, it was portraits of 'gens de condition' that should be sought.[47] This renders all the more surprising the fate met with by one of the most splendid of all van Dyck's portraits, representing sitters who could scarcely be said to lack 'condition': *Charles I with M. de Saint-Antoine* (fig. 155) was bought – at one remove – by Remigius van Leemput, a Flemish painter who had settled in London in 1635 and was much employed in copying van Dyck and other artists. Having presumably failed to sell this large masterpiece in London, van Leemput took it to Antwerp to see if it could be sold there. But his enterprise was unsuccessful, and he was forced to bring the picture back to England.[48]

When M. de Bordeaux arrived in London, two or three years after the Spanish ambassador and Jabach had had access to some of the most attractive pickings, he came to the conclusion that the three most desirable pictures still remaining were a Raphael and two

155 Anthony van Dyck, *Charles I with M. de Saint-Antoine*, Royal Collection Trust

Correggios. He had tried to buy Raphael's *Holy Family* (*La Perla*) (fig. 58) but Mazarin had turned it down as being too expensive. So he fell back on the Correggios.[49] The one that particularly appealed to him was *Venus and Cupid with a Satyr* (fig. 156). Although the Spanish ambassador had doubts about the reception that so indelicate a picture might receive in Madrid, he had got in first – for each man was almost as eager to do down his rival as to enrich his master's collection, a sentiment that was fully shared by the masters themselves – and had offered £4,000 to the syndicate presided over by David Murray, the royal tailor.[50] This was four times the valuation placed on the picture when it was allocated to them but it was still not enough, for the owners were asking for £6,000. When M. de Bordeaux showed an interest, he was told that he could have it for £5,000 and, as he was lodging in David Murray's house, he felt confident that he would be able to get it, provided that Mazarin was prepared to pay. After a couple of months of fairly tough negotiating, he succeeded in buying it for £4,300. M. de Bordeaux also succeeded in buying the other item on his list of desiderata, Correggio's *Allegory of Vice* (fig. 157), the much more attractive pendant to the *Allegory of Virtue* (fig. 158), which had earlier been bought by Jabach, both pictures having been originally painted for Isabella d'Este's grotto in Mantua.[51]

Oddly enough, these excellent purchases met with exactly the same lack of recognition in Paris as had the *Education of Cupid* in Madrid. Mazarin believed that neither the *Satyr* nor the *Allegory of Vice* was by Correggio himself. M. de Bordeaux had to write back forcefully that all the connoisseurs in England were convinced that both were perfectly genuine, and he clinched his case with the decisive argument that the Spanish ambassador had been ready to pay £300 more for the *Allegory of Vice* than he himself had had to do.[52]

The rivalry between the two nations extended to almost every purchase. M. de Bordeaux acknowledged frankly to Mazarin that he had no expertise in the field and, looked at from our perspective, it would certainly appear that Cárdenas had a more imaginative approach.[53] The marvellous Dürer *Self-portrait* (fig. 159) and Mantegna's *The Dormition of the Virgin* (fig. 160), for instance, the first notable pictures by these masters to arrive in Madrid, provide telling indications of his flair and opportunity.

But how far was he alone responsible for these choices? It so happens that for at least part of the time that Cárdenas was ordering pictures for Don Luis de Haro, another artistic agent acting indirectly on behalf of the King of Spain was in London: the painter David Teniers, who proved to be a connoisseur of exceptional ability. Teniers had been sent to take advantage of the English troubles by the Count of Fuensaldaña, one of Philip IV's most trusted advisers and principal aide to Archduke Leopold Wilhelm, Governor of the Spanish Netherlands, whom we have already met (fig. 161).[54] His main target was the picture gallery of the 5th Earl of Pembroke. It had been inherited from his father, a close friend and intimate courtier of Charles I with whom he had sometimes exchanged important works of art.[55] He

156 Correggio, *Venus and Cupid with a Satyr ('Jupiter and Antiope')*, Paris, Musée du Louvre

157 Correggio, *Allegory of Vice*, Paris, Musée du Louvre

158 Correggio, *Allegory of Virtue*, Paris, Musée du Louvre

159 Albrecht Dürer, *Self-portrait*, Madrid, Museo del Prado

160 Andrea Mantegna, *The Dormition of the Virgin*, Madrid, Museo del Prado

161 David Teniers the Younger, *Archduke Leopold Wilhelm in his Picture Gallery in Brussels*,
Madrid, Museo del Prado

162 Anthony van Dyck, *Philip Herbert, 4th Earl of Pembroke and his Family*,
Wilton House, Collection of the Earl of Pembroke

had bought a number of paintings attributed to famous masters – Titian above all – but was chiefly celebrated for his unrivalled set of van Dyck portraits, including *Philip Herbert, 4th Earl of Pembroke and his Family* (fig. 162), which hung in Durham House, the mansion he leased in the Strand.[56] During the Civil War, Pembroke had deserted the King's cause and after Charles's execution had given ostentatious support to the new regime. Within less than a year he himself was dead, and it was because of his enormous debts that part of the collection had to be sold by his son. Teniers bought some of the pictures but not, so it would seem, anything of major importance, and he also acquired others that had been in Charles I's collection, including perhaps Titian's *Venus and Cupid with an Organ Player* (fig. 163).[57] Teniers rather irritated Cárdenas, but it seems very reasonable to suppose that he suggested

163 Titian, *Venus and Cupid with an Organ Player*, Madrid, Museo del Prado

to him some of the royal pictures most worth trying to get. Meanwhile his own acquisitions were sent to Fuensaldaña in Brussels, who in turn passed them on to various Spanish collectors, including Philip IV. Fuensaldaña also bought pictures in Antwerp, of which by far the most exciting was almost certainly one that Buckingham had recently brought over from England, van Dyck's *The Continence of Scipio* (fig. 164), the first, largest and most important painting made for his father, the first Duke. Archduke Leopold Wilhelm was by now probably sated by his acquisition of the Hamilton pictures and the painting ended up in the collection of the King of Spain.[58]

On 16 December 1653, Cromwell was made Lord Protector and Whitehall, St James's and the other royal palaces were vested in him. A fortnight later, M. de Bordeaux wrote the first of a series of reports to Mazarin informing him that no further goods from these sources were likely to come on to the market.[59] Nor did they. Pictures already in private hands still drifted out of England but to all intents and purposes the sale was at an end.

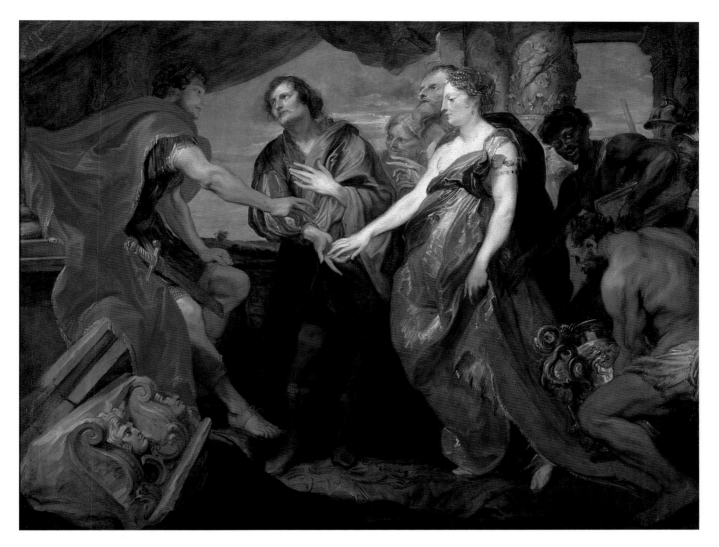

164 Anthony van Dyck, *The Continence of Scipio*, Oxford, Christ Church Picture Gallery

What had been its consequences? This chapter has highlighted the benefits gleaned from it by collectors in Paris, Madrid and elsewhere on the Continent. The next and final chapter will examine some of the more surprising results of the sale within England itself, and the attempts made after 1660 to reverse them.

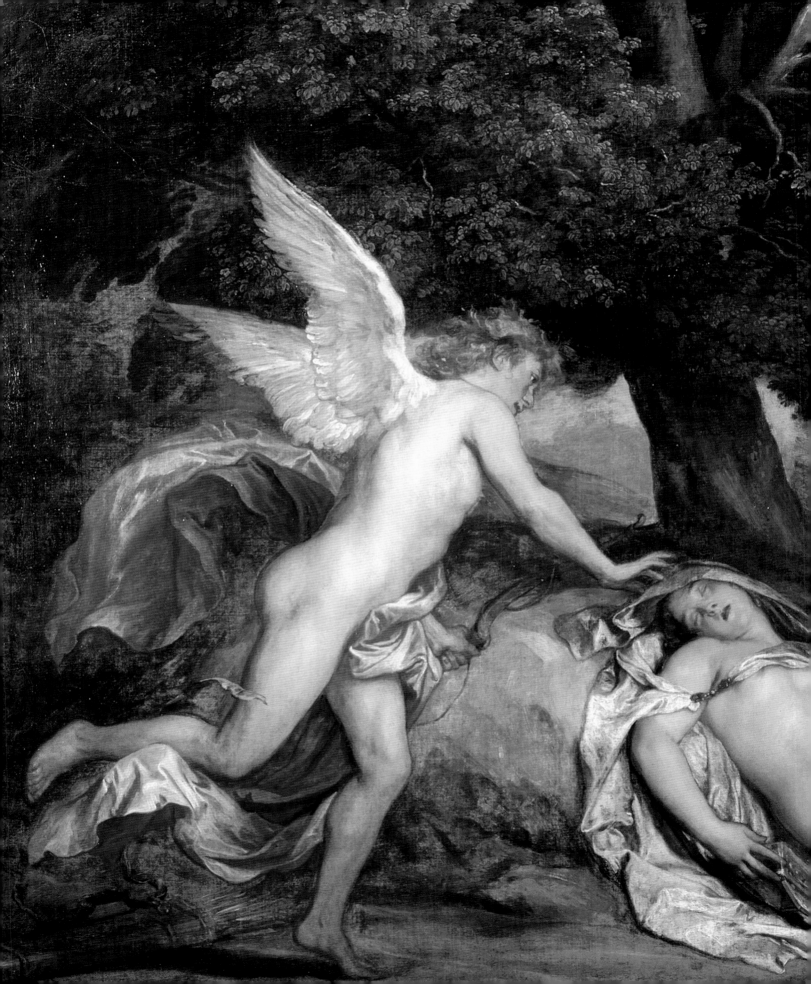

6

FINAL DEPARTURES AND FIRST RETURNS

O N 9 MAY 1660, THE DAY AFTER THE RESTORATION OF THE MONARCHY WAS OFFICIALLY DECLARED IN ENGLAND, BUT THREE WEEKS BEFORE the final return of Charles II (1630–1685) to London, it was moved in the House of Lords that a Committee be set up to 'consider and receive Information where any of the King's Goods, Jewels, or Pictures are; and to advise of some Course how the same may be restored to His Majesty'.[1] This was followed by a series of enactments to the same effect, delivered in increasingly threatening tones. At almost exactly the same time in Madrid, the Spanish Council of State issued instructions to the 'person who is to serve in England' that

> if any proposals are made there about the restitution of pictures and tapestries that some ministers bought, you should excuse yourself with the statement that you know nothing about this matter. If nonetheless they insist that you report this back, you can say that you will send a dispatch to Spain passing on the suggestion – but without entering into any further discussion or giving any guarantees – and that you will report to them what the outcome is.[2]

These are the parameters within which, as it were, plans had to be conceived to undo some of the artistic consequences of the Civil War.

It will be most convenient to begin with the situation in Spain because, for obvious reasons, there was little enough that could be done about it, even though, when pressed about the denials put in his mouth by the authorities in Madrid, the ambassador must have felt somewhat embarrassed. It is not just that it was well known in London that 'some ministers' had indeed bought pictures and tapestries from Charles I's collection, it was also known that these ministers had been acting on behalf of Philip IV because this had been proclaimed to the world three years earlier in a widely distributed, well-informed and handsomely illustrated guidebook to the Escorial published in Madrid. In it the author writes quite openly about the fate of the pictures that had belonged to 'King Charles Stuart . . . that great prince, worthy

of a happier future'[3] and describes how the best of them had been sent by the Spanish ambassador in London to Don Luis de Haro, 'who laid them at the feet of the King our master, whose greatly superior understanding [in such matters] judged them to be worthy of this wonderful place [the Escorial]'.[4] For it was in the sacristy of the Escorial that Velázquez had installed a selection of some of Charles I's masterpieces, including Andrea del Sarto's *Madonna and Child with Saint Matthew and an Angel* (fig. 149) and Tintoretto's *Christ Washing the Feet of His Disciples* (fig. 47). The sacristy was perfectly accessible to well-connected visitors, including the English ambassador who was trying to get the pictures returned to London. Efforts to this effect were still continuing in a rather desultory way as late as 1668, and it was only then, when the Spanish authorities 'told me it was under consideration', that the ambassador evidently decided that it would not be worth wasting any more time on the matter.[5]

Whether or not representations were also made to the French, I do not know. Mazarin's attachment to his pictures was legendary – he was heartbroken at the thought that he would not be able to take them with him to the next world – and it is unlikely that he would have taken very kindly to suggestions that he might wish to return some of the best of them to the new English monarch. Still less might a favourable reaction to such a request have been expected from Louis XIV, who in 1661 inherited both Mazarin's power and his collections. But at least until 1661–2 Jabach still owned major pictures that had belonged to Charles I, including Titian's *Conjugal Allegory*, formerly known as *The Allegory of Alfonso d'Avalos, Marchese del Vasto* (fig. 166) and Leonardo's *Saint John the Baptist* (fig. 54) and, as he held no official position in the French government and as even his financial ascendancy was less than it had been, I imagine that it is just possible that carefully applied pressure might have made some impact. Be that as it may, it was in England, where the chances of recovery were strongest but where what there was to return was weakest, that the Committee for the King's Goods concentrated its efforts.

The powers given to the Committee were considerable. Officials at various ports in London and elsewhere were instructed to make sure that no royal statues or pictures were exported.[6] Within England itself, army officers, appointed for the purpose, were entitled to seize goods that had belonged (or were thought to have belonged) to Charles I – and were well remunerated for their successes. Their methods were pretty rough, and some perfectly innocent citizens certainly suffered injustice as a result of authorized, but nonetheless brutal, searches carried out on their property.[7] However, the Committee had two very effective tools at its disposal. In the first place, it was able to lay its hands on the official documents relating to the sales held on behalf of the King's creditors between 1649 and 1653, and second, it offered to reward 'any of our well affected subjects or others who shall discover unto us any of the said Goods wilfully concealed'.[8]

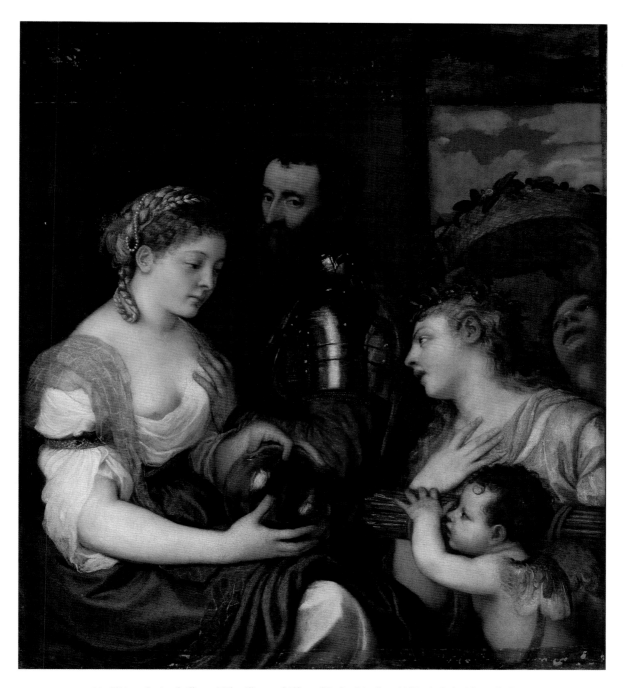

166 Titian, *Conjugal Allegory* (*The Allegory of Alfonso d'Avalos, Marchese del Vasto*), Paris, Musée du Louvre

Denunciations of course came in quickly, some of them anonymous. Among the most knowledgeable informers was George Geldorp (d. 1665), a painter of Flemish origin who had been a close friend of van Dyck and much involved with the London art world in pre-war days. He collaborated closely with the Committee for the King's Goods from the first, and it is possible that he was being honest when he claimed that the pictures formerly belonging to Charles I that were stored in his own house during the Commonwealth had been kept there only for safe-keeping.[9] It is odd, nonetheless, that when the Earl of Peterborough confessed that he had in his custody 'four or five pictures that possibly did belong to the King', he stated that he had bought one of them from Geldorp.[10] In any case, Geldorp pointed out owners right and left: 'Mr. Trion a Merchant hath divers Pictures One Raerre Peese of The Present King, the Prinses Royall, the duke of yorcke, the Prenses Elizabeth holding haer suster the Prinsesse Anna opan haer Lap all in one peese of S.ʳ Ant. v. dike' (fig. 167); 'M.ʳ Vaeytchell divers Raerre Pictures spesiall one [of] the duke of Buckingham and the Lord Francis of S.ʳ Ant.º Vandyke' (fig. 127); and 'Mr. Love [of Winchester] divers Pictures – one gret Peese of Tintorett', which may have been *The Muses* (fig. 50), 'and others of Jullio Romano'.[11]

Many owners naturally volunteered information about their royal pictures without having to be reported to the Committee by Geldorp or its other agents. Some had been the King's creditors, whom we have come across before, such as Edmund Harrison, the King's embroiderer living in Grub Street, who declared the few paintings that remained in his hands, including a portrait of Christian, Duke of Brunswick by Mytens (fig. 168).[12] He did not, of course, refer to the magnificent pictures that he had earlier sold on behalf of his syndicate and that had now left the country: Titian's *Pope Alexander VI Presenting Jacopo Pesaro to Saint Peter* (fig. 148) and Rubens's *Peace and War* (fig. 83). Others who admitted owning former royal property had bought it at second hand, so to speak, either from the original purchasers for cash or from those creditors to whom such goods had been granted in settlement of the King's debts, and in reading through their often pedestrian names – 'Mr Merriday', 'one Beedsome at Parssam Greene' and so on – we are once again made to realize how very widely works of art had spread through society since the days only twenty years earlier when almost everything of real consequence had belonged to some half dozen aristocratic collectors.[13]

But if they had not succeeded in disposing quickly of masterpieces that, so unexpectedly, had come into their hands, these Harrisons and Samwells, Merridays and Beedsomes paid dearly for their imprudence (or, as it might have been said, impudence) in having been caught up in the royal sale. The sums owed to them for loyalty and long service to the government had not – as they surely must have hoped – been paid in cash but in Raphaels and Titians, Correggios and van Dycks which were absolutely useless to them except as a promise of cash. And the only guarantee that such a promise was meaningful lay in a sealed receipt to the

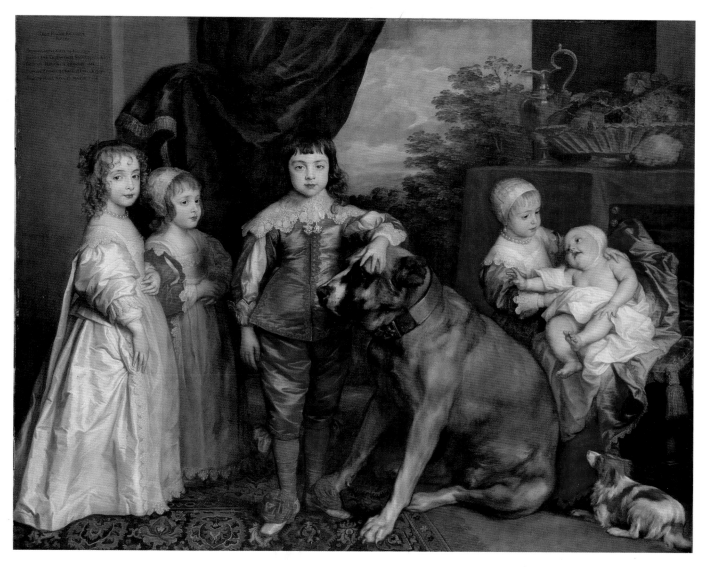

167 Anthony van Dyck, *The Five Eldest Children of Charles I*, Royal Collection Trust

effect that their new goods and chattels would be theirs 'for ever, to all intents and purposes whatsoever'.[14] This was now torn up, leaving these men with no possibility of ever recouping the sums owed to them.

It is perfectly understandable that the Crown should have made systematic and determined attempts to secure the restitution of what still remained of the collection, the legality of whose dispersion it could not accept. Indeed, though its behaviour was harsh, it is difficult to see

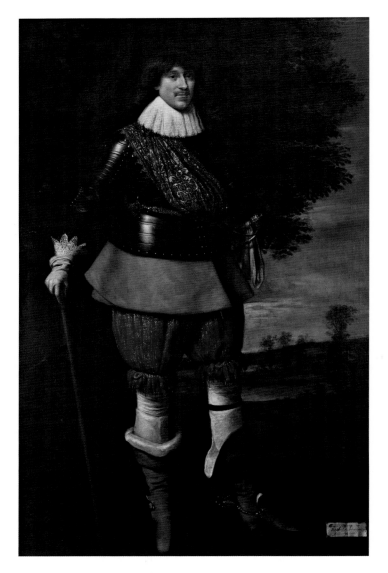

168 Daniel Mytens, *Christian, Duke of Brunswick and Lüneburg*, oil on canvas,
Royal Collection Trust

what other course it could have adopted. But it is also understandable that, whenever possible, anyone with a sizeable group of royal pictures and sculptures left on his hands at the time of the Restoration should have claimed – on occasion with a rather grating unctuousness – that his only purpose in getting hold of them had been to preserve them intact for Charles II.

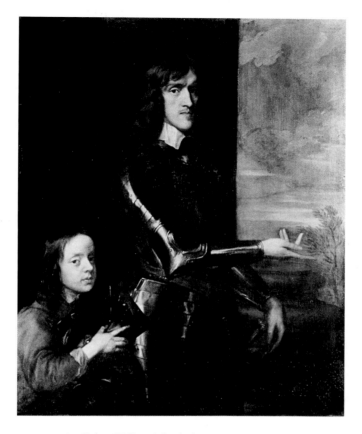

169 Robert Walker, *Colonel John Hutchinson and his Son*,
Earl Fitzwilliam Collection

I want to look at a few of the more remarkable collections built up in England during the Interregnum in order to test the verisimilitude of such claims. It so happens that the very first customer at the royal sale, Colonel John Hutchinson (bap. 1615–d. 1664; fig. 169) is better known to us than any of the others who followed him to Somerset House, thanks to the evocative memoir written by his widow Lucy (1620–1681) not long after his death[15] – 'his fame', it has been said, 'rests on his wife's commemoration of his character, not on his own achievements'.[16] While we can all agree that the evidence of a devoted spouse can be as unreliable as that of a deceived one, it is also true that testimony of this kind is invaluable for what it can tell us about hopes and aspirations. From our point of view, Mrs Hutchinson's most revealing comment about her husband is that although he always remained loyal to his Puritan upbringing and abominated 'the false, carnall and Antichristian Doctrines of Rome',[17] nonetheless he 'had great judgment in paintings, [en]graving, sculpture, and all excellent

170 Palma Giovane, *Venus and Cupid*, Royal Collection Trust

arts, wherein he was much delighted . . . and would rather chuse to have none than meane jewells or pictures'.[18] Hutchinson won fame in the Civil War for his resolute defence of Nottingham against royalist forces. He was one of the judges who sentenced the King to death on 27 January 1649, and almost exactly nine months later we find him buying £160 worth of the King's paintings on the first day of his posthumous sale. They included various still lifes and, more surprisingly, a 'naked Venus and Cupid' by Palma Giovane (fig. 170). A week later, his ambitions rose, and he bought no fewer than three pictures attributed to

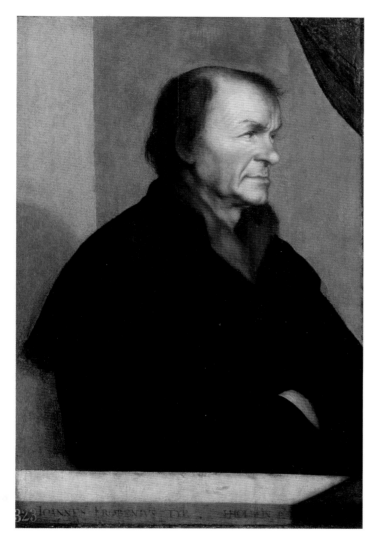

171 Hans Holbein the Younger, *Johann Froben*, Royal Collection Trust

Titian, one of which was among the most important items in the entire sale: his *Venus del Pardo* (fig. 29), the picture that Philip IV had given to Charles when, a quarter of a century earlier, he had gone to Madrid as Prince of Wales to woo the Infanta. It had been valued at £500 but Hutchinson had to pay £600 to get it. Over the next few months he added a fine Holbein to his collection, the portrait of Johann Froben (fig. 171) and all in all he spent £1,349 – more than any other purchaser in cash – for about twenty pictures, in addition to sculptures, tapestries and furnishings.[19]

He took his acquisitions to his house at Owthorpe in Nottinghamshire 'intending a very neate Cabinett for them'[20] and, together 'with the surveying of his buildings, and emprooving by enclosure the place he liv'd in', they 'employ'd him att home . . . and [he] pleas'd himselfe with musick and againe fell to the practise of his violl'.[21] If the story ended there, it would appear simple enough, and very fascinating and important for the light it sheds on the origin of the country-house collection and for the decisive evidence it provides against the conventional theory that, in seventeenth-century England, a love of art (Italian art especially) was confined to courtly circles. We would face no difficulty in accepting Mrs. Hutchinson's claim that, during his residence in London, her husband's

> only recreation . . . was in seeking out all the rare Artists he could heare of, and in considering their workes in payntings, sculptures, [en]gravings and all other such curiosities, insomuch that he became a greate Virtuoso and Patrone of ingenuity. And loath that the land should be disfurnisht of all the rarities that were in it, he lay'd out about £2,000 in the choycest peices of painting then sett to sale, most of which were bought out of the King's goods . . . and gave ready money for them.[22]

But the story does not end there.

When Colonel Hutchinson had bought the *Venus del Pardo*, he let it be known that he wished to dispose of it as soon as possible, and (for obvious reasons) the Spanish ambassador was keen to get hold of it so that it could be restored to the royal collection in Madrid. In fact, Hutchinson kept it for himself for four years. Then in October 1653 the French ambassador M. de Bordeaux began to hear rumours about its existence, but was told that the owner was particularly fond of it.[23] By 15 December, however, it was being offered for sale at £6,000; within three days the price had risen to £7,000. This was expensive, M. de Bordeaux agreed, especially as £2,000 had to put be down at once and the remainder found within three weeks, but he felt that the price was reasonable, as Colonel Hutchinson explained that he was selling it for the sum that he had paid for it.[24] The reason why the Colonel was able to make a profit of more than 1,100 per cent on the picture was simple enough, and M. de Bordeaux fully grasped it. Competition from his rival Alonso de Cárdenas meant that both ambassadors were now facing a seller's market.

Was Colonel Hutchinson an unscrupulous dealer who, like most of his brother officers, had been buying entirely for speculation? Or was he, as his wife insisted, a sensitive man with an exceptional feeling for quality? Or both at the same time (by no means an unusual combination)? When the monarchy was restored, he escaped the fate of other regicides, who were hanged, drawn and quartered, but he was discharged from the army and made ineligible for public office of any kind (and later imprisoned for alleged plotting). He was also denounced to the Lords' Committee for possessing one of Charles I's pictures, a Titian *Holy Family* (now

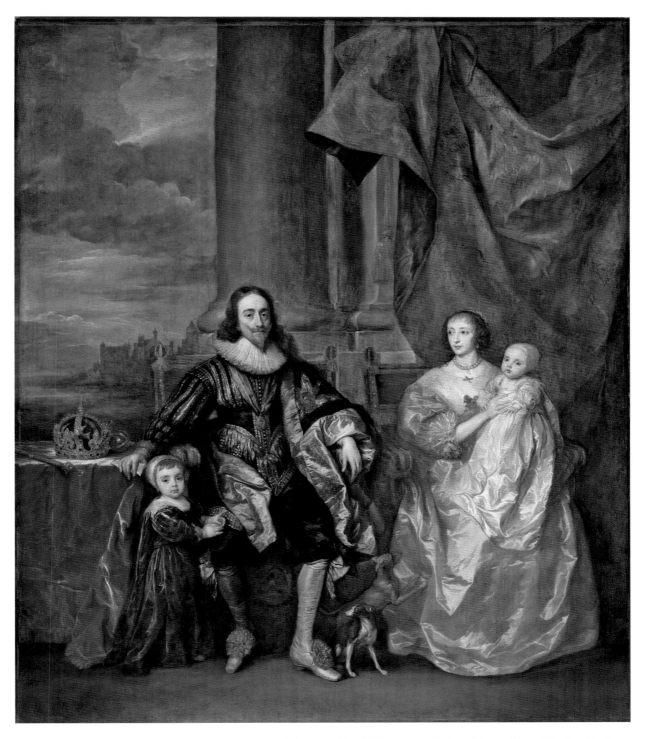

172 Anthony van Dyck, *Charles I and Henrietta Maria with their Two Eldest Children, Prince Charles and Princess Mary ('The Great Piece')*,
Royal Collection Trust

173 Emanuel de Critz, *John Tradescant the Younger and Hester, his Second Wife*,
Oxford, Ashmolean Museum

believed to be by Palma Giovane; Royal Collection Trust).[25] In fact, as we know, he had bought many more and some of these found their way back to the royal collection, including Palma's *Venus and Cupid* and the Holbein portrait. The whereabouts of most of the others is not known.

Let us turn now from a soldier to an artist. Emanuel de Critz (1608–1665) was the son of a serjeant painter to Charles I, and when war came his loyalty to the King was never in doubt; his brother joined the royal forces at Oxford and was killed at a skirmish there.[26] De Critz was included in the Second List of the King's creditors, and so great was his expertise that he became head of as many as three syndicates – the first, the fifth and the fourteenth. Their most spectacular acquisition was what de Critz himself described as 'that incompearable head in marble of yᵉ late King's, done by Cavaleere Berneeno'.[27] This had been valued at £800, by far the highest sum for a piece of sculpture. Among the pictures that he obtained were Tintoretto's *Esther before Ahasuerus* (fig. 49) and van Dyck's *Charles I and Henrietta Maria with their Two Eldest Children ('The Great Piece')* (fig. 172). In his house at Austin Friars in the City (three or four minutes' walk from present-day Liverpool Street Station), Emanuel de Critz kept three rooms full of the King's pictures (some stored on behalf of other acquirers).[28] It is curious to think of him painting portraits of members of his family and friends, including that of John Tradescant the Younger and Hester, his second wife (fig. 173), at a time when two such supreme masterpieces of royal portraiture, the Bernini and the van Dyck, were kept in an adjoining room.[29]

Not only was de Critz a confirmed loyalist in principle; he also had good reason for holding a personal grudge against Cromwell. After he was awarded two antique busts from the royal collection, each valued at the very high sum of £120, these were retained by the government as part of its scheme for refurbishing Whitehall Palace for the Lord Protector, and as a result he had to sustain a severe financial loss.[30] When therefore at the time of the Restoration Emanuel de Critz handed over a number of works of art from the former royal collection to the administrators of the new one, there is good reason to believe that he was being sincere in claiming that, since being assigned to him in 1651 to settle the King's debts, they had been 'preserved by him with great care and danger, his now Majestie [Charles II] having had oft notice from him of the same'. De Critz reminded the King that, among his other services to the State, he had rescued the bronze cast of the Farnese *Antinous* (commissioned by Charles I) after a fanatical Quaker, armed with a hammer, had threatened to smash it.[31]

Nevertheless, we know that de Critz, like almost everyone else who had obtained goods from the royal collection, had certainly had to dispose of quite a number of them, no doubt under heavy financial pressure. Among them were some major pictures such as Correggio's *Allegory of Vice* (fig. 157), which, as we saw, was bought by M. de Bordeaux for Mazarin, and a set of five, probably not very important, ancient statues, which Lord Northumberland used to adorn the splendid mansion he was having rebuilt in the Strand.

Lord Northumberland brings us conveniently to the last figure in this hurried survey of a few English collectors who were able to found or decisively enrich their collections (however ephemeral) on the basis of those established a generation earlier. In his youth, Northumberland's nephew, Philip Lord Lisle (1619–1698; fig. 174) had accompanied his father on embassies to Copenhagen and Paris. He supported Parliament during the Civil War, but refused to serve as a judge at the trial of Charles I.[32] However, he evidently had no qualms about buying a large number of works of art that had belonged to the King: he acquired between fifty and sixty paintings and nearly thirty pieces of sculpture, more than any other single private collector in England.[33] For Lisle was not, of course, one of the King's creditors nor was he buying goods in the hope of selling them again quickly at a profit. Indeed, he is, as far as I know, the only man in the whole country who was trying to build up a collection of Old Masters largely from scratch, as had been done earlier in the century. This means that he bought at second, or sometimes third hand, either from purchasers for cash at the initial sale such as Colonel Webb (with whose enterprising activities we are now beginning to become quite familiar and from whom was purchased *Summer (Ruth and Boaz)* attributed to Francesco Bassano (fig. 175) or from those royal servants to whom debts had been paid in pictures, such as Charles I's tailor, David Murray, whom we have also met before, who obtained *Chiron and Achilles* by Giulio Romano and his studio (fig. 176). The significance of this is that, unlike these *marchands amateurs* and creditors and unlike the early Stuart col-

174 Circle of John Weesop, *Philip Sidney, later 3rd Earl of Leicester*,
Penshurst Place, Collection of Viscount De L'Isle

lectors who, for the most part, had been obliged to secure from abroad mixed batches of pictures that they had never seen, Lord Lisle (or his advisers and agents) was able to select individual works that caught his fancy.

We can identify only a small fraction of the pictures that he bought in this way, but those that we can are, for the most part, important and of high quality: his panels by Polidoro da Caravaggio, for instance, showing scenes from the story of Psyche and fanciful decorative friezes (fig. 177), had been esteemed so highly by Charles I that when in the Palace of Whitehall they were hung in the company of his major Titians and the most famous of all his Raphaels.[34] Other very fine pictures that Lisle was able to acquire from the royal collection through various intermediaries were Jacopo Bassano's *The Good Samaritan* (fig. 41) and Holbein's portrait of William Reskimer (fig. 178).[35] It has to be said, however, that the significance of Lord Lisle's collection rests as much on the status of its owner as on the status

175 Attributed to Francesco Bassano, *Summer (Ruth and Boaz)*,
Royal Collection Trust

176 Giulio Romano and his studio, *Chiron and Achilles*,
Royal Collection Trust

177 Polidoro da Caravaggio, *Putti with Goats*, Royal Collection Trust

of its contents. Lisle was very evidently following in the footsteps of his uncle Lord Northumberland, but Northumberland had been a great figure in the land during the personal rule of the monarch, when Lisle was still only an adolescent. Thus Lisle proved to be the only nobleman to come to prominence during the war who was emulating the achievements of the previous generation in aiming to build up a family collection of Old Masters. In so doing he was reversing the situation of the last few years: pictures once again resumed their conventional course to, rather than from, the walls of the nobility. If the political situation had not changed so dramatically Lord Lisle would therefore surely have earned a noteworthy place in the history of art collecting. But the situation did change, and he found himself instructed to return all his carefully selected pictures to the restored monarchy.[36] He did so most reluctantly, as did his uncle Northumberland, who faced a conflict of interest, to say the very least, for he was on the Committee responsible for tracking down the King's goods, of which he himself owned a number. Neither man had any intention of allowing himself to be harassed as were so many poor artists and tradesmen, who hurried to hand over compromising possessions at the earliest possible moment. Lord Lisle declared haughtily that 'conceiving that some Pictures and Statues are in his Custody which might be the late King's Majesty's, that he would keep them in Safety, and be ready at His Majesty's Command, or at the Command of this House, to deliver them as he shall be directed'.[37] The absolutely final date fixed for the return of the King's goods was 29 September 1660.[38] Lord Lisle's were sent in two batches on 8 and 10 September.[39] *Noblesse oblige.*

I have long believed that no historical response to the past is more fatuous than to scold people who lived many centuries before us for not having had the same taste in art as we today would wish them to have done. Such a response becomes even more fatuous when we know almost nothing about the possibilities for making different choices that were open to them. Nonetheless, I want to run this risk by looking for a moment at Lord Lisle's collec-

178 Hans Holbein the Younger, *William Reskimer*, Royal Collection Trust

tion from a standpoint of presumption and ignorance. Why, when so much was available to him, did he buy what he did? His Bassanos were good, as were his Polidoros. But there were Titians on the market and Correggios and Rubenses.[40] Was it a question of money, or timing (though he seems to have already been collecting by 1650) or predilection?[41] I cannot even begin to answer a single one of these questions, but just to ask them does seem to me to throw some light on the achievements of Lord Arundel and the dukes of Buckingham and Hamilton, even if we exclude the King because of his very special position.

This volume opened with a short walk down Whitehall and along the Strand in January 1642, when the King left London for the last time before being taken back as a prisoner to be tried and executed: within half an hour or so, one could have passed palace after palace brimming with masterpieces, which, as regards quantity, quality and variety, could hardly have been rivalled anywhere else in Europe. Ten years or so later, the situation looks very different. Wallingford House is empty and the great Giorgiones and Titians once hanging on its walls are now the property of the Archduke Leopold Wilhelm in Brussels. In the Banqueting House in Whitehall, Rubens's ceiling canvases painted to celebrate the claims and aspirations of the Stuarts survive incongruously, but elsewhere the palace is still bare, 'those rich and costly hangings of Persian Arras and Turkey worke (like the Bishops) for their pride being taken downe'; 'if you will presume to be so unmannerly, you may [even] sit downe in the Chaire of State'.[42] St James's too has been stripped of its pictures and most of its sculptures.

The former Suffolk House, however, is looking much more 'modern' and handsome than it did ten years ago (fig. 179) because Lord Northumberland has been lavishly rebuilding it.[43] Within its rooms hang what is certainly the finest, and only, collection of major pictures remaining in London, which includes Titian's *Cardinal Georges d'Armagnac and his Secretary Guillaume Philandrier* (fig. 16) and *The Vendramin Family* (fig. 104).[44] Neither of these Titians was here in 1642.

York House next door contains little enough, for the Duke of Buckingham's faithful servant Mr Traylman has sent off to Antwerp and Zeeland all the pictures that can be removed without too much difficulty. Only the tapestries remain, and much of the sculpture, most conspicuously Giambologna's *Samson Slaying a Philistine* (fig. 65) mouldering away on the grounds, a forlorn reminder of the days when Charles and the 1st Duke of Buckingham were guests of Philip IV in Madrid.

In Durham House next door, treachery to the King's cause by the 4th Earl of Pembroke and the reluctance of his heir to take much part in public life have saved the superb portraits by van Dyck from being seized by the new regime. Before long, however, they will be sent to the nobly rebuilt country house of Wilton near Salisbury,[45] and meanwhile agents of the Spanish King are sifting through the Old Masters.

179 Charles Grignion after Samuel Wale, *South View of Northumberland House,*
London, British Museum

Further down the river, Somerset House now contains more paintings and tapestry and
furniture than it ever did when Queen Henrietta Maria resided there (though the chapel and
its extravagantly Catholic furnishings have long since been defaced and disposed of) but they
are there only until they are removed by army officers, merchants and agents recruited by
foreign powers. Troops have been quartered in Arundel House, and although sculptures lie
neglected in the grounds, only a few pictures remain, the Holbeins and Titians, van Dycks
and Rubenses having been shipped to the Low Countries, where the widowed countess keeps
a wary eye on them.

Although the vast majority of great pictures have left London, almost unnoticed by every-
one except those who lost or gained in the process, within twenty years or so the memory
of them will return to haunt the imagination of future generations for at least two centuries.
Throughout Europe a provenance from the collection of Charles I will carry a special charge.
Antiquarians will deplore what has been lost and, frightened that even the memory of it will
soon be dissipated, will lay their hands on all scattered documentation that can be tracked
down. Publishers will reprint inventories and sale catalogues. Arundel will earn from Horace
Walpole the designation of 'the father of vertù in England',[46] and the celebrated phrase will
remain attached to his name forever afterwards. And even the King's bitterest opponents
among 'Whig historians' will be ready to acknowledge his deeply felt love and promotion of
the arts as part mitigation of his disastrous crimes and follies, in a way that had never been
done in his lifetime.[47]

Eventually great pictures began to flow back to England: at first, the so-called 'Dutch gift' from the states of Holland and Low Friesland made to Charles II on his assumption to the throne in 1660. These were chosen from the cabinet of the merchant Gerard Reynst, who had died two years earlier (but who had not, as is often said, been a purchaser from the royal sale),[48] and among them were masterpieces believed to be by Raphael and Titian, respectively: *Isabella d'Este* (now attributed to Giulio Romano and believed to represent her daughter-in-law, Margherita Paleologo; fig. 180) and *Andrea Odone* (now attributed to Lotto; fig. 181).[49] Later came countless more, acquired on the Continent by successive waves of English collectors. Perhaps the first picture that had actually belonged to Charles I himself to return to England from abroad was, very appropriately, van Dyck's equestrian portrait of Charles I (fig. 147), which in 1706 was given by the Emperor Joseph I to the Duke of Marlborough.

Yet the above gives an utterly misleading impression of what really happened. Although the English became famous throughout Europe during the eighteenth century for the extravagance of their art collecting, it was very rare indeed for them to be able to buy anything of the kind that had characterized the Stuart collections.[50] Titian's *Vendramin Family* (fig. 104), which had been bought by Lord Northumberland, long remained the finest Old Master painting in England and, along with *Cardinal Georges d'Armagnac and his Secretary, Guillaume Philandrier* (fig. 16), probably the only major Titian. Despite what was often claimed – and believed – at the time, it is doubtful if a single Raphael of outstanding significance came to England after the death of Charles until the arrival at Blenheim in 1764 of the *Ansidei Madonna*, now in the National Gallery. I also doubt if there was any genuine Correggio except one that had belonged to Charles I and that was recovered at the Restoration (*The Holy Family with Saint Jerome*, still in the Royal Collection). Barely a single antique statue of outstanding reputation came to England during the eighteenth century, but, admittedly, not many had done so during the reign of Charles I. Allowing for a limited number of exceptions, it would be possible to run through most of the most celebrated names among those represented in the collections I have been talking about and record their absence in others for the next century and a half.

What replaced them in the great town and country houses of the aristocracy and (to a lesser extent) in the palaces of the monarchy were superb pictures by artists of a wholly different kind, whose early works could (at least in theory) have been accessible to the courtiers of Charles I but which were, for the most part, ignored by them, understandably enough in view of what they could get: artists such as Claude and Poussin, Dughet and Rosa, Gerrit Dou, Guercino and Murillo to name a few.[51] Nor am I even mentioning painters who flourished after the outbreak of the Civil War. It was not in fact until after the French Revolution and the Napoleonic invasion of Italy that significant numbers of pictures of the

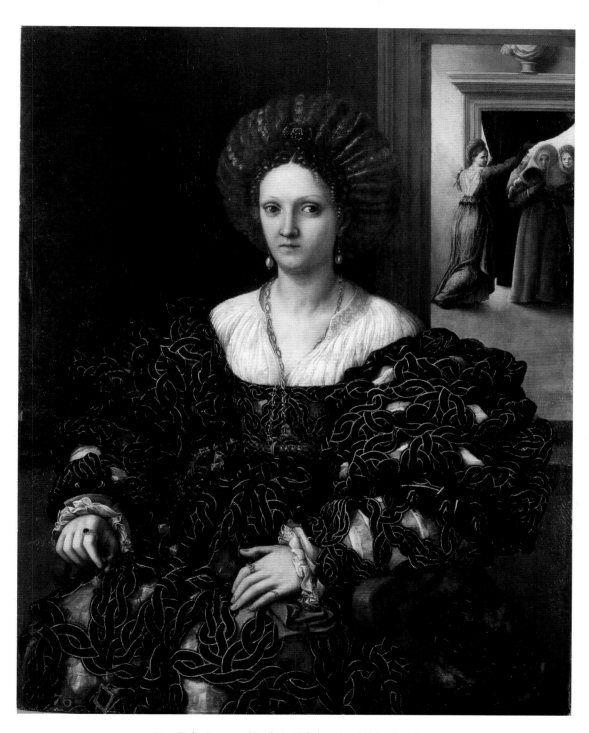

180 Giulio Romano, *Margherita Paleologo*, Royal Collection Trust

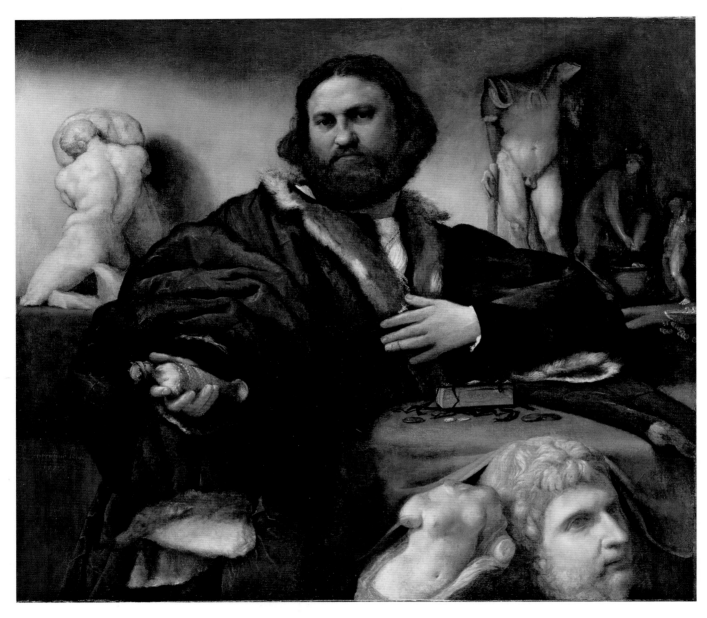

181 Lorenzo Lotto, *Andrea Odone*, Royal Collection Trust

same nature and quality as those that could have been seen in Whitehall and the Strand in January 1642 began once again to be imported into England.

As we look back over the centuries we do not have to resort to facile assumptions of progress to appreciate how fundamental were the differences between these two great artistic waves. Could anything be more absurd than to suggest that the Duke of Bridgewater, the Earl of Carlisle and Earl Gower – who in the 1790s acquired for purposes of speculation the masterpieces of French and Italian painting that had belonged to the ducs d'Orléans and thus at a blow changed the whole nature of collecting in England far more decisively than had their predecessors between 1620 and 1640 – were men of greater taste and scholarship than Lord Arundel, of more artistic passion and enterprise than Charles I? It was not for lack of such qualities that the Stuart collections proved to be so ephemeral, and to put this down to the Civil War is merely to postpone consideration of the more fundamental issues.

Without being crudely determinist, we have to risk the hypothesis that English collecting in the early seventeenth century was an anomaly, the outcome of a historical accident. It lacked a real substructure, such as was characteristic, in varying degrees, of the formation of all other private – and ultimately national – collections at different times and in different places. Collecting and the tastes associated with it had not spread widely or deeply enough in English society: it was not shared by the majority of the wealthy, powerful and educated, nor was it emulated in diluted form by many of more modest means, nor was it supported by a sympathetic public opinion, derived from some degree of familiarity with the arts.[52] When the Titians and Raphaels began to flow back to England after 1789, all these conditions were in place. But that is another story.

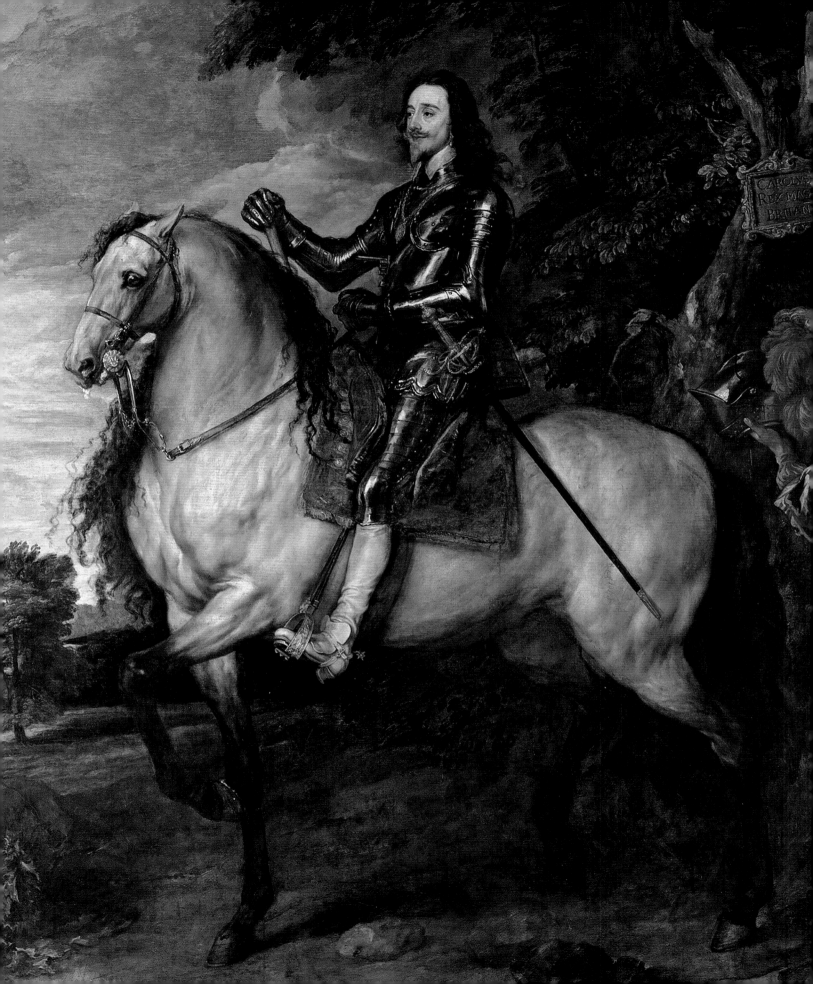

NOTES

ABBREVIATIONS

CSPD	*Calendar of State Papers, Domestic Series*
CSPV	*Calendar of State Papers Relating to English Affairs in the Archives of Venice*
HMC	*Reports of the Royal Commission on Historical Manuscripts*
JHC	*Journal of the House of Commons*
JHL	*Journal of the House of Lords*

I ART COLLECTORS IN LONDON ON THE EVE OF THE CIVIL WAR

1 Evelyn 1697, 70.

2 Hibbard 1991; Hibbard 2009.

3 Sandrart [1675], quoted in Hervey 1921, 256.

4 Bacon 1679, 57 (Apophthegm no. 18).

5 Wood 1990.

6 On Gerbier, see Williamson 1949, 26–60; Philip 1957; Betcherman 1970; Chaney 2000. For Buckingham's collection, see especially Fairfax 1758; Davies 1907 (the inventory was published in full by Jervis 1997); Davies 1914, 152–9; Martin 1966; McEvansoneya 1987; Brown 1995, 23–33; McEvansoneya 1996b; McEvansoneya 2003.

7 Huxley 1959.

8 Carpenter 1844, 24–6. See also Barnes, De Poorter, Millar and Vey 2004, 294–5 (with bibliography).

9 Longueville 1896, 43.

10 Gabrieli (ed.) 1955. Van Dyck's painting is described at length by Giovanni Pietro Bellori, who adds that it was brought to France during the English Civil War: Bellori [1672] 2005, 219. See also Summer (ed.) 1995–6.

11 He was the biased source for Bellori's account of van Dyck's career in London: Bellori 1672 [2005], 218–19.

12 Luzio 1913; Howarth 1981–2, 95–100; Whitaker 2002; Lapenta and Morselli 2006. On Lanier and Daniel Nijs's (or Nys's) role in the purchase, see Sainsbury 1859, 320–40 (appendix II); Anderson 2012; Bracken and Hill 2012, 187–91.

13 Mariette 1859–60, 330. For Lanier's collection, see Wilson 1994 and Wood 2002.

14 Carpenter 1844, 22–3; Millar 1982–3, 45–6, no. 6.

15 Letter from Gerbier to the Duke of Buckingham, 2 December 1624: Oxford, Bodleian Library, Tanner MS 73, fol. 491, quoted in Goodman 1839, II, 360.

16 Wittkower 1948, 51.

17 Oliver Millar, 'Introduction', in Millar (ed.) 1958–60, xiii–xvii.

18 Allen 1941.

19 Oliver Millar, 'Introduction', in Millar (ed.) 1958–60, xiv.

20 Oliver Millar, 'Foreword', in Millar (ed.) 1958–60, xi.

21 See, for example, the English translations of works by Baldassare Castiglione (*Book of the Courtier*, 1561, trans. Thomas Hoby) and Nicolas Faret (*The Honest Man; or The Art to Please in Court*,

1632, trans. Edward Grimeston). Henry Peacham's famous treatise *The Compleat Gentleman,* published in 1622, was dedicated to the Earl of Arundel's youngest son, William Howard, Lord Stafford. See Levy 1974.

22 Peacham 1612, 7.

23 See Smith 1907; Shakeshaft 1979; Howarth 1997, 235–40; Hill 2003a; Hill 2003b; Bracken and Hill 2012.

24 Avery and Watson 1973. For the contents of Prince Henry's art collection, see Strong 1986, 184–219; Parry 1981, 79–81; Wilks 1988; Wilks 2005; Wilks (ed.) 2007; MacLeod, Smuts and Wilks 2012–13.

25 Logan 1979 and Penny 2008, 470–2. An album of engravings after paintings in the Reynst collection was published by Gerard Reynst's heirs: *Variarum imaginum a celeberrimus artificibus pictarum Caelaturae,* Amsterdam, *c.*1660.

26 See Cust 1911–12; Cox 1911 (September; translated and classified by Hervey 1921, 473–500); Hervey 1921; Parry 1981, 108–35; Howarth 1985; Howarth and Penny 1985–6; White 1995; Jaffé 1996; Howarth 2002.

27 Clarendon [1702–4] 1840, I, 24.

28 This is attributed to the Earl of Carlisle: see Lodge 1827, VI, chapter 9, 10.

29 Jaffé 1996; Fletcher 1996, 66–8; Howarth 1998b; Chew 2003.

30 Lodge 1827, VI, chapter 9, 10.

31 Howarth 1985, 66–8.

32 See Springell 1963. On Hollar, see Pennington 1982; Godfrey 1992; Godfrey 1996; Turner 2009. For Hollar's work for the Earl in England, see Griffiths 1998, 87–96.

33 Lockyer 1981; Parry 1981, 137–45.

34 See British Library, Add. MS 17915 ['Catalogue of the Collections of Pictures and Models of George Villiers, Duke of Buckingham'], fol. 1v. It was later published by Fairfax 1758, 4 ('Advertisement' by Horace Walpole): 'It appears by a note of Mr. Vertue, in the original manuscript, that Thomas

earl of Arundel offered the first duke the value of 7000 l. in money or land for that single piece.' For the acquisition of the work and its price, see Philip 1957.

35 Hervey 1921, 263.

36 Letter from Peter Paul Rubens to Nicolas-Claude Fabri de Peiresc, 9 August 1629, quoted in Rubens 1955, 322.

37 Parry 1981, 213–29.

38 Loomie 1989, 266, no. 64: PRO S.P. 94/28, fol. 223: 'Presents given by the Kinge of Spain to the Prince of Wales'. On artworks acquired by the Prince of Wales during the Madrid visit, see Carducho [1633] 1979, 435–8; Millar 1977, 30; Brown 1990, 89. Most recently, see Elliott 2002, 23–8; Redworth 2004; Samson (ed.) 2006.

39 For the changes in this painting's attribution, see most recently Henry and Joannides (eds) 2012, 200–7.

40 For Hamilton's collection and its sources, see Waterhouse 1952; Savini-Branca 1965; Shakeshaft 1986; Brown 1995, 49–57; Borean and Mason (eds) 2007, 270–2.

41 Millar (ed.) 1958–60, 90; Millar 1977, 227, no. 20. The painting was last recorded at a Christie's auction in London on 20 March 1959 (lot 54, property of William Ropner, sold to Knoedler for 6,200 guineas).

42 McEvansoneya 1992, with bibliography.

43 Gardiner (ed.) 1880 and 1895; HMC 1887, part VI; HMC 1932.

44 Shakeshaft 1986, 117.

45 Ibid., 131, letter LIX.

46 Ibid., 130, letter LII. The painting has been attributed to Giulio Romano after a design by Raphael: see Henry and Joannides (eds) 2012, 144–7.

47 Shakeshaft 1986, especially 125 and letter XXVI.

48 Letter from Balthazar Gerbier to the Duke of Buckingham, 17 November 1624: Oxford, Bodleian Library, Tanner MS 73, fol. 487, quoted in Goodman 1839, II, 340.

2 ART COLLECTIONS IN LONDON ON THE EVE OF THE CIVIL WAR

1 See, for example, Pitacco 2007.

2 In Venice, Lady Arundel befriended Tizianello who dedicated his *Breve compendio della vita del famoso Titiano Vecellio di Cadore cavalliere, et pittore* to her, ostensibly owing to the number of works by his uncle that she and her husband owned. He also noted the particular reverence for Titian among English aristocracy in general: Tizianello [1622] 2009, 45 and 56.

3 Manilli 1650, 88. For the Bassanos' reputation in Spain, see Falomir 2001.

4 The Duke of Hamilton, who was certainly in a position to know, remarked that Veronese was 'a master not very much esteemed here by the King': quoted in Shakeshaft 1986, 124, letter XXI.

5 Howarth 1985, 142.

6 *CSPV* 1912, XVIII, 258 [letter dated 29 March 1624].

7 For the provenance of Rudolf II's paintings by Veronese, see Salomon 2006, 20–24.

8 Ridolfi [1642] 1984, 56.

9 Letter from the Earl of Arundel to William Petty, 5 December 1636, quoted in Hervey 1921, 395.

10 Müntz 1885, 268.

11 Davies 1907, 380.

12 Letter from Arthur Hopton in Madrid to the Earl of Arundel, 29 July 1631, quoted in Hervey 1921, 300.

13 See Grossmann 1951, 25, appendix II; Millar (ed.) 1958–60, 89, no. 71; Foucart-Walter 1985, 72–3; Schnapper 2005, 162–3 (Schnapper argues that the exchange could have taken place in 1630). The Titian can no longer be traced and Charles I's *Saint John the Baptist* by Leonardo is back in the Louvre.

14 Lightbown 1969.

15 Shearman 1972, 145–8.

16 The painting was acquired from Lord Pembroke in exchange for an album of Holbein portrait drawings, which was then given to Arundel. See Roberts 1989, 121.

17 Colvin 1963–82, IV, part 2, 251; Lightbown 1989b, 67.

18 See Haynes 1975; Howarth 1985, 77–96; Howarth and Penny 1985–6; Scott 2003, 11–22; Angelicoussis 2004; Vickers 2006.

19 For these ventures, see Roe 1740; Hervey 1921, 265–80; Ferrier 1970; Parry 1981, 120–1; Howarth 1985, 127–48.

20 The inscriptions were published by Selden 1628.

21 Sainsbury 1859, 283–9 and 309; Davies 1914, 157–8; Betcherman 1970, 255–6; Muller 1989, 62–4, 78 and 84–7; Scott 2003, 22–4.

22 Scott-Elliott 1959; Howarth 1989, 76–8; Scott 2003, 24–30. A few had also come from Madrid collections, as Charles I acquired antiques of Marcus Aurelius, Apollo and a bust of Faustina in 1623: Harris 1967.

23 See Norton 1957; Boucher 1991, 372–3; Hirst 1994–5, 25–8.

24 Scott-Elliott 1959, 220: 'una donna nuda sentada sopra li calcagni'.

25 Letter from Daniel Nijs, 13 June 1631, quoted in Scott-Elliott 1959, 220: 'une figure de femme accroupie de marbre, aucuns disent Venus delli Ely, autres Hélène de Troye, c'est la plus belle statue de tous'.

26 See Cust 1909; Vickers 1978; Lightbown 1981; Howarth 1989, 95–7; Raatschen 1996; Howarth 1998a; Marsden 1999; Avery 2002.

27 See Pope-Hennessy 1964, II, 460–5; Goldberg 1996, 529–30.

28 Sutton 1947.

29 Letter from Lord Maltravers to William Petty, 15 February 1632, quoted in Hervey 1921, 336.

30 Griffiths 1998, 96–8.

31 See most recently Roberts 2003.

32 Jaffé 1996, 26–8: 'Arundel's Holbein Collection'; Foister 1996; Foister 2004, 267–9; Foister 2006–7, 69–71.

33 Sandrart [1675], quoted in Hervey 1921, 256.

34 Painted for the Guildhall of the Hanseatic merchants in London, the allegories entered Prince Henry's collection after various peregrinations: see Rowlands 1985, 223–4, nos L13a and L13b; Foister 2004, 130–7; Petter-Wahnschaffe 2010, 132–61 and 362. George Vertue's description of Lord Arundel's Holbeins, and most especially the *Triumphs*, are quoted in Hervey 1921, 516–17.

35 Letter from Lord Maltravers to William Petty, 4 August 1637, quoted in Hervey 1921, 406.

On the Amerbach collection, see Landolt et al. 1991 (see especially Christian Müller, *Zeichnungen Alter Meister*, and Paul H. Boerlin, *Die Gemälde*).

36 Letter from Thomas Howard to Cosimo de' Medici, February 1621: 'Ringratio V. A. che si sia degnata di honorarmi di questa sua richiesta', quoted in Giglioli 1909, 335. See also Crinò 1960; Howarth 1985.

37 Andrews 1977, 146–7 (no. 16). See also Gordenker 2006, 193–5 and 204 (appendix).

38 Letter from George Conn to Cardinal Francesco Barberini, 23 February 1637, British Library, Add. MS 15390 ['Transcripts from the Papal Registers', vol. XL: 1637], fol. 122: 'ivi nacquero bellissime partite tra la M[aes]tà del Ré, ed il Sig. Conte [Arundel], al quale non vi é verso di cavare cosa alcuna dalle mani. Sua Maestà disse di volermi contare un miracolo del Sig.ʳ Conte, ed era, che avea [*sic*] mandato a donare al Gran Duca un quadro d'Olbins.' It was published and translated by Hervey 1921, 399.

39 Letter from the Earl of Arundel to Sir Dudley Carleton, 17 September 1619, quoted in Sainsbury 1859, 279–80; Hervey 1921, 131–2 and 162.

40 Malvasia 1678, II, 366.

41 Letter from Gregorio Panzani, the papal agent in London, to Cardinal Francesco Barberini, 11 July 1635, quoted in Wittkower 1948, 50–1: 'senza dubbio piaceranno più gli antichi buoni che li moderni per la rarità'.

42 Finaldi 1999; Wood 2000–1; Finaldi and Wood 2001–2, 223–31 and 448–50.

43 A second version of this composition was sent to the King of Spain: Maddicott 1998 and Weston-Lewis 1999. The allegorical ceiling canvases have been moved to Marlborough House in London.

44 See Millar (ed.) 1958–60, 48 and 123; Askew 1961; Bracken and Hill 2012, 185–7: the paintings came to London in 1626 through the agency of the ambasssador to Venice, Isaac Wake, and his father-in-law, Edward Conway. The Duke of Buckingham had a number of his paintings (including the Fetti) reproduced on the inside panels of a cabinet he commissioned shortly before his assassination: see Riccardi-Cubitt 2000; McEvansoneya 2003, 317–18.

45 Shakeshaft 1986, 129, letter XLII.

46 Martin 1970, 147–53; Held 1980, I, 390–3.

47 Sainsbury 1859, 233–45.

48 Letter from Francesco Vercellini (?) to the Earl of Arundel, *c.*17 July 1620, quoted in Hervey 1921, 175.

49 See Howarth 1990. On van Dyck's career in England, see Carpenter 1844, 10 and 22–46; Millar 1982–3 (with a useful annotated bibliography, p. 38); Rogers 1999; Millar 2001; Millar 2004; Hearn (ed.) 2009.

50 Carpenter 1844, 66–9. The title of the painting, 'Le Roy à la Ciasse', is given in a 1638 memorandum, possibly written by van Dyck himself, to an unknown recipient. The painting did not reappear until the second quarter of the eighteenth century, in France.

51 Letter from Cardinal Mazarin to Antoine de Bordeaux, 7 April 1654, quoted in Cosnac [1884] 1885, 218: 'Au surplus, quand vous rencontrerez quelque pièce curieuse et à bon marché, vous m'obligerez de l'acheter pour moi comme vous feriez pour vous-mesme; mais vous savez, s'il vous plaist, que les portraits de Vandeik sont estimés et non les autres peintures; c'est pourquoy je ne sçay pas si le tableau de Phsychée sera estimé.'

52 Lovelace 1659.

53 It may well have been painted primarily for the

Queen's House at Greenwich and was kept, unframed, in the King's gallery at Whitehall. See Millar 1982–3, 97–8, no. 58; Barnes, De Poorter, Millar and Vey 2004, 430–1.

54 It was in his possession in 1660: London, Parliamentary Archives, HL/PO/JO/10/1/285, Main Papers, 'Papers Relating to the King's Goods', undated May–11 June 1660, fol. 25, no. 86, calendared in HMC 1879, 90: 'Mr Lilly of Covent Garden 18 May 1660'; Millar 1977, 64. On Lely, see Millar 1978, and, most recently, Campbell (ed.) 2012.

3 'SCANDALOUS MONUMENTS AND PICTURES'?

1 *JHC*, III, 348 [20 December 1643]: 'Ordered, That Colonel Ven shall put the Ordinance, for Removal of scandalous Monuments and Pictures, in Execution in the several Churches and Chapels of Windsor and Eaton.'

2 For Charles I's admiration of Reni, see Wittkower 1948.

3 Letter from Cardinal Francesco Barberini to George Conn, 21 November 1637, British Library, Add. MS 15390 ['Transcripts from the Papal Registers', vol. XL: 1637], fols 482–3. For the relationship between England and the papacy, see Albion 1935; Hibbard 1983.

4 For this episode, see British Library, Add. MS 15390 ['Transcripts from the Papal Registers' XL: 1637], fols 244v–245r (1 May 1637), 450 (17 October 1637), 482–3 (21 November 1637); Madocks 1984; Madocks Lister 2000.

 The painting is thought to have been subsequently destroyed in France although its appearance is known through an etching by Giovanni Battista Bolognini and painted copies. However, for a recent reassessment and discovery of what may be part of the original canvas, see Guarino 2002–3; Montanari 2004, 77–8. Daniele Benati is preparing a publication on what he believes is another section of the original painting (for sale in 2012 at Adam Williams Fine Art).

5 Letter from Cardinal Francesco Barberini to Carlo Rossetti, 8 September 1640, Biblioteca Apostolica Vaticana, Barb. Lat. 8648, fol. 135r, quoted in Madocks 1984, 546: 'cosi per la storia come per il modo che il pittore l'ha descritto, il quadro mi pare lascivo e tanto più che fu scelta qua la favola, tanto più mi arresterò d'inviarlo per non aggiungere scandalo a codesti Heretici. Io vedrò di far fare uno schizzo e lo manderò a V. S. e quando nè alla Regina nè al Padre Filippo diano fastidio le cose suddette, è necessario che apparisca esser tutto comandamento di S. Maestà e che io sono stato mosso sollecitamente dai suoi ordini.'

6 Letter from Cardinal Francesco Barberini to Carlo Rossetti, 2 February 1641, Biblioteca Apostolica Vaticana, Barb. Lat. 8649, fol. 123v, quoted in Madocks 1984, 546: 'massime in questi tempi di Parlamento'.

7 This is confirmed by new documentary evidence from Sergio Guarino, '"Il quadro della Regina": La storia delle *Nozze di Bacco e Arianna* di Guido Reni', in Guarino 2002–3, 15–44 (31–2).

8 See, for example, Whinney and Millar 1957, 6. On interpretations surrounding the collecting of Rudolf II, see Trevor-Roper 1976, 97 and 101; DaCosta Kaufmann 1978.

 Judith Richards argued that relatively few people had access to images of the king and royalty in England: Richards 1986, 74.

9 The literature on art collecting is often subsumed to the vigorous debates on masques and theatrical performances at the Stuart court, but one can consult, for example, Parry 1981; Sharpe 1992, especially 222–33; Howarth 1997, 217–60. For an overview and reassessment, see Smuts 1981; Smuts 1987.

10 Haskell 2001.

11 'Relazione d'Inghilterra di Giovanni Sagredo,

Ambasciatore Staordinario ad Oliver Cromwell, 1656', published by Barozzi and Berchet (eds) 1856–77, IV (1863), 363–400 (383; see also 390).

12 Letter from Luis de Haro to Alonso de Cárdenas, undated, *c.* 1654, quoted in Berwick 1891, 492.

13 Loomie (ed.) 1987.

14 Puget de La Serre 1639, n.p. (fol. 61): 'à un des bouts de cette gallerie à trois costez il y a un portrait du Roy de la Grande-Bretaigne armé, à cheval, de la main de Monsieur le Chevallier Vandheich. Et à n'en mentir point, son pinceau en conservant la Majesté de ce Grand Monarque la [*sic*] tellement animée par son industrie, que si les yeux pouvoyent estre creus tous seuls, ils souttiendroient hardiment qu'il vit dans ce portrait tant l'aparance en est sensible.' On the van Dyck painting and its location, see Millar (ed.) 1970–2, 270; Raatschen 2001; Barnes, De Poorter, Millar and Vey 2004, 463–4.

15 On the Emperors series, see Wethey 1975, III [*The Mythological and Historical Paintings*], 235–40.

16 Loomie (ed.) 1987, 216.

17 Ibid., especially 297.

18 Letter from Balthazar Gerbier to the Duke of Buckingham, 8 February 1624: Oxford, Bodleian Library, Tanner MS 73, fol. 509, quoted in Goodman 1839, II, 373–4.

19 Letter from Peter Paul Rubens to Nicolas-Claude Fabri de Peiresc, 9 August 1629, quoted in Rubens 1955, 322.

20 Sterry 1675, 28. See also Pinto 1934, 151.

21 Letter from Daniel Nijs to Endymion Porter, 27 April 1628, quoted in Sainsbury 1859, 324–5.

22 Ashmole 1672, 496–7. See also Lightbown 1968; Lightbown 1989a, 253–4.

23 Gardiner 1886–91, I [1642–44], 34. See also Spraggon 2003, 234.

24 *JHC*, III, 26–7 [1 April 1643]: 'Ordered, That the Hangings and Household Stuff, at the Capuchins House belonging to the Queen, be delivered unto the Keeper of Somersett-house, upon Inventory, and a Receipt of them taken under the Hand of the Keeper of Somersett-house: And Mr. Browne is discharged of any further Attendance. Ordered, That the Committee appointed, concerning the Removal of the Capuchins, do search the Friars Studies, and peruse the Papers, and prepare a Declaration and Narrative of the Matter of Fact, and the whole Course of Proceedings, observed in the Removal of the Capuchins, and demolishing of the superstitious and idolatrous Monuments there; and that they take notice of the great Quantities of Beads, Crucifixes, and other superstitious Books and Pictures, found in the Friars Studies.'

25 Loomie 1998; Thurley 2009, 309–11.

26 *JHC*, III, 145 [26 June 1643].

27 *Mercurius Aulicus, Communicating the Intelligence and Affaires of the Court to the Rest of the Kingdome*, ed. Peter Heylyn, 25th week, 19 June 1644, 1040.

28 See Thurley 2002, 248–50.

29 *JHL*, V, 558 [16 January 1643].

30 *JHC*, III, 432 [19 March 1643]. See also Hervey 1921, 442.

31 *JHC*, III, 93–6 [20 May 1643]: 'Marquis of Hambleton's Pictures, &c. The Question being put, whether Leave shall be given for the conveying of the Pictures and Trunks of Marquis Hambleten into Scotland; It passed with the Negative. Ordered, That a Stay be made of the said Goods, until this House take further Order', and 98–9 [23 May 1643]: 'Ordered, That the Goods belonging to Marquis Hamilton, and shipped to be transported into Scotland, be delivered into the Custody of the Earl of Denbigh; who has engaged his Honour, that they shall be forthcoming, to be disposed of when this House shall require.'

32 See HMC 1911, 1–81.

33 *JHC*, III, 369 [16 January 1644]: 'Ordered, That it be referred to the Committee of the Lord Fairfax, to consider of the present raising Four thousand Pounds, out of the Pictures, and other things, of the Duke of Buckingham's, remaining at York House; or of the Pictures and Goods of the Duke of Richmond's and Marquess Hamilton's and that

the Committee inform themselves, of the Earl of Northumberland, or otherways, of the true State of the Pictures, and other things, of the Duke of Buckingham at York House, in what Condition they are assigned to remain there; and also to consider of the Estate of Mr. Harcie's in Mr. Courten's Hands; to raise the Four thousand Pounds; and to consider of any other Way for present raising of the same.'

34 Gardiner 1886–91, II [1644–7], 153.

35 *JHC*, IV, 216 [23 July 1645].

36 The French critic and biographer André Félibien recounts that the widow of Michel Particelli d'Emery, Mazarin's Comptroller General, had the painting ripped to shreds after her husband's death: Félibien [1666–8] 1725, III, 510; while Malvasia 1678, II, 51, states that the painting was burnt. Sergio Guarino, '"Il quadro della Regina": La storia delle *Nozze di Bacco e Arianna* di Guido Reni', in Guarino 2002–3, 15–44 (34) argues that Particelli's widow may have had more pragmatic motivations and had the painting cut into pieces in order to sell it off more easily.

37 Letter from Colonel Herbert Morley to William Lenthall, 5 June 1644, quoted in HMC 1891–7, I, 178; Thomas-Stanford 1910, 153–4.

The ship ran aground near the town of Arundel and it seems, understandably, to have been associated with Lord Arundel by Howarth 1985, 212. In the original lectures, Francis Haskell, following Howarth, took this to be a reference to paintings that Lord Arundel 'hoped to remove from England'. No tangible link, however, can be found.

38 The painting has not been identified. Geeraert De Lavallée (Antwerp, before 1605–after 1667) was a landscape and history painter whose works were often exported from Flanders to Spain (and from there to the Spanish colonies). This therefore conforms to contemporary accounts stating that the painting was destined for a church in Seville. However, these accounts also relate that it was quite large; this description must be considered rel-

ative as De Lavallée painted principally on copper and his works rarely exceeded 80 centimetres in height.

39 *The Sussex Picture, or, An Answer to the Sea-gull*, (1644). See Thomas-Stanford 1910, 154–5; Potter 1989, 45–8.

40 See Smuts 1987, 128–33; Smuts 1996; Portier 1996. These authors argue that the sums spent on paintings were relatively modest.

41 On 17 October 1627, Philip Burlamachi, the King's moneylender, complained to Endymion Porter that as a result of the payment of £15,000 towards the Mantuan purchase he was no longer in a position to equip Buckingham's army, which was hoping to lift Richelieu's siege of the Huguenots in La Rochelle: see Sainsbury 1859, 323.

42 On the history of the statue, see Walpole 1849, II, 392–6; 'The statue of Charles I', 1935, 258–68; Denoon 1933. On Le Sueur, see Avery 1982; Howarth 1989.

43 *CSPD: Interregnum* 1876–80, IX, 261 [31 July 1650].

44 *JHL*, XI, 98 [19 July 1660]; Denoon 1933, 469; Ball 1987.

45 *CSPD: Interregnum* 1876–80, IX, 261 [31 July 1650]: the inscription reads 'Exit tyrannus Regum ultimus, anno primo restitutœ libertatis Anglicœ 1648'.

46 *CSPD: Interregnum* 1876–80, IX, 453 [3 December 1650, Council of State, Day's Proceedings, note 5].

47 Huygens 1982, 83 [27 February 1652].

48 Ibid., 109 [11 April 1652].

49 Ibid., 43 [31 December 1651].

50 Martin 1994, 29–34. Discussion of the overall iconography of the ceiling can be found in Strong 1980, with reference to previous literature (though Francis Haskell did not accept all of Strong's conclusions). Since the lectures, two new studies have been published: Donovan 2004, 84–148, and especially Martin 2005. For the history of the Palace, see Dugdale 1950; Thurley 1999.

51 For a summary of the different proposed identifications, see Martin 2005, I, 211–17.

52 Martin 1994, 34.

53 Ibid., 34.

54 Haskell 2002.

55 For Dorothy Osborne, see Moore Smith (ed.) 1928, 7–9, 56 and 60–1.

56 Oswald 1952, 1024.

57 Clarendon [1702–4] 1840, I, 397.

58 Firth 1910, 118.

59 Wood 1994.

60 Wood 1993.

61 Clarendon [1702–4] 1840, I, 397.

62 Firth 1910, 118.

63 *JHC*, IV, 121 [23 April 1645].

64 Ibid.

65 Andrews 1977, 147–8 (no. 17); Wood 1994, 283 and 305; Gordenker 2006, 195–6 and 204 (appendix).

66 Wood 1990, 681; Brown and Ramsay 1990.

67 Ibid., 684; Penny 2008, 219–20.

4 EXILES AND EXPORTS

1 For Arundel's will, see Cust 1911–12 (August 1911), 280; Hervey 1921, 459–60. For the inventory of Lady Arundel's Tart Hall residence, see Cust 1911–12 (November, January and March).

2 Letter from Gabriele Balestrieri to the Duke of Modena, 1645, quoted in Venturi 1882, 251–2.

3 Howard 1987. See also Hervey 1921, 449–53.

4 Letter from John Evelyn to Samuel Pepys, 26 August 1689, reprinted in Pepys and Evelyn [1997] 2005, 193.

5 See Howarth 1985, 187–8; Howarth and Penny 1985–6, 22–3; Jaffé 1996, 31–2: 'Epitaph for a Collector'.

6 See Tierney 1834, II, 481; 'Will, Epitaph and Last Wishes of Thomas Howard, Earl of Arundel' (appendix II) in Hervey 1921, 459–61 (460).

7 British Library, Egerton MS 1636 [Richard Symonds, 'Observations Concerning Pictures and Paintings in England 1651–1652'], fol. 88v [new pagination]. It was published in Hervey 1921, 521; Beal 1984, 298.

 On the *Allegory*, see Fredericksen 1982. The attribution to Holbein is rejected by Rowlands 1985 (238, no. R47) but accepted by Foister 2004, 107–8, and Foister 2006–7, 61.

8 Letter from Antoine de Bordeaux to Cardinal Mazarin, 6 November 1653, quoted in Cosnac [1884] 1885, 193: 'ils ont besoing d'argent estant catholiques et endebtés'.

9 For the sale of works from the Arundel collection to Cardinal Mazarin, see Cosnac [1884] 1885, especially chapter VI; and Michel 1999, 209–10.

10 Letter from Antoine de Bordeaux to Cardinal Mazarin, 11 December 1653, quoted in Cosnac [1884] 1885, 197: 'une partie des plus belles pièces avoient esté portées en Flandre pour en éviter le pillage durant les troubles d'Angleterre'.

11 Vasari [1550/68] 1906, V, 41–2.

12 Letter from Luis de Haro to Alonso de Cárdenas, 17 December 1654, quoted in Berwick 1891, 493; Harris 1982.

13 Vasari [1550/68] 1906, VI, 206–7.

14 Tierney 1834, II, 507.

15 Ibid., 510.

16 Weijtens 1971; Dudok van Heel 1975.

17 Brown 1986, 213; Burke and Cherry 1997, I, 438.

18 Cust 1911–12 (August 1911), 281; Cox 1911 (August), 282.

19 Evelyn 1959, 515–18 (marbles) and 504, 528, 653–4 (library).

20 Ibid., 740–1 (entry for 9 May 1683).

21 Letter from John Evelyn to Samuel Pepys, 12 August 1689, reprinted in Pepys and Evelyn [1997] 2005, 193.

22 Passavant 1872, 298.

23 Cock 1726.

24 For Jabach as a collector, see Grouchy 1894; Grossmann 1951; Raimbault 2001–2; Schnapper 2005, 267–82.

25 Foucart-Walter 1985, 72–8.

26 On the formation and dispersal of the Imstenraedt brothers' collection, see Breitenbacher 1930, 206–16; Kurz 1943; Grossmann 1944; Šafařík 196; Ley 1971, 50–9; Seyfarth 1995.

27 Wethey 1975, III [*The Mythological and Historical Paintings*], 153–4.

28 Imstenraedt 1667. See Seyfarth 1999.

29 Breitenbacher 1930, 207.

30 This work made a huge impact when it returned to London after three and a half centuries and was presented at the exhibition *The Genius of Venice, 1500–1600* (Royal Academy of Arts, 1983–4).

31 Loomie 1989, 258.

32 McEvansoneya 1996a, 136 and 148.

33 Stoye 1952, 307–8.

34 McEvansoneya 1996b, 9.

35 Stoye 1952, 307–19; Duverger 1992, VI [1649–53], 70–7, 127–8, 131 and 146.

36 See British Library, Add. MS 17915 ['Catalogue of the Collections of Pictures and Models of George Villiers, Duke of Buckingham'], fol. IV.

37 McEvansoneya 1996b, 2 and notes 12, 13 and 26–8. Thornhill purchased the work from a 'M. Ronde' for 3,000 livres.

38 McEvansoneya 1996a, 151.

39 On Leopold Wilhelm and his collecting, see Garas 1967; Garas 1987; Brown 1995, 147–9 and 160–9; Schütz 1999; Mertens and Aumann (eds) 2003; Schreiber 2004, especially 89–130.

40 Letter from Stephen Goffe to William Aylesbury, 25 June 1648, quoted in McEvansoneya 1996a, 138. See also Duverger 1992, VI [1649–53], 146.

41 This is suggested by Sandrart [1675] 1925, 24.

42 *JHC*, III, 93–6 [20 May 1643]: 'Marquis of Hambleton's Pictures, &c. The Question being put, whether Leave shall be given for the conveying of the Pictures and Trunks of Marquis Hambleten into Scotland; It passed with the Negative. Ordered, That a Stay be made of the said Goods, until this House take further Order'; 98–9 [23 May 1643]: 'Ordered, That the Goods belonging to Marquis Hamilton, and shipped to be transported into Scotland, be delivered into the Custody of the Earl of Denbigh; who has engaged his Honour, that they shall be forthcoming, to be disposed of when this House shall require.'

43 *JHC*, III, 369 [16 January 1644]: 'Ordered, That it be referred to the Committee of the Lord Fairfax, to consider of the present raising Four thousand Pounds, out of the Pictures, and other things, of the Duke of Buckingham's, remaining at York House; or of the Pictures and Goods of the Duke of Richmond's and Marquess Hamilton's and that the Committee inform themselves, of the Earl of Northumberland, or otherways, of the true State of the Pictures, and other things, of the Duke of Buckingham at York House, in what Condition they are assigned to remain there; and also to consider of the Estate of Mr. Harcie's in Mr. Courten's Hands; to raise the Four thousand Pounds; and to consider of any other Way for present raising of the same.'

44 *JHL*, IX, 345–61 [23 July 1647]: 'A Letter from the Parliament of Scotland, was read, concerning the Duke of Hamilton's Goods. Ordered, That these Letters be sent to the House of Commons, that his Goods may be restored to him.'

45 *JHC*, V, 423–4 [8 January 1648]: 'A Message from the Lords, by Dr. Aylett and Mr. Eltonhead; the Lords have commanded us to put this House in mind of a Message, formerly sent to this House; That as well the Pictures as other Goods of the Lord Duke Hamilton be restored unto him, being in the Custody of the Earl of Denbigh, according to the Desires of the Parliament of Scotland, by Letter to both Houses in that behalf. Ordered, That as well the Pictures as other Goods of the Lord Duke Hamilton, in the Custody of the Earl of Denbigh, or any other, be restored unto the said Duke Hamilton, or such as by him are appointed to receive the same. Answer returned by the same Messengers; That this House has considered their Lordships Message: And do agree, That as well the Pictures as other Goods of the Duke Hamilton's, in the Custody of the Earl of Denbigh, or others, be restored, as is desired'.

46 Burnet [1677] 1852, 533.

47 Marshall 1973, 25.

48 This is one of the earliest paintings in the series of gallery views by Teniers: see Díaz Padrón and Royo-Villanova (eds) 1992; Scarpa Sonino 1992, 81–104; Brown 1995, 171–8; Klinge 2006.

49 In his catalogue of Italian paintings in the National Gallery, London (1975), Cecil Gould proposed that the Hamilton painting was another version (now lost) of *The Death of Acteon*, a theory accepted by Haskell but since refuted by Penny 2008, 253.

50 Shakeshaft 1986, 130, letter LII.

5 THE ROYAL SALE

1 *JHC*, VI, 128 [1 February 1649] and 172 [23 March 1649]. On Charles I and the sale, see Waagen 1854, I, 7–16, and II, 465–84; Hewlett 1890; Phillips 1896; Nuttall 1965; Oliver Millar, 'Introduction', in Millar (ed.) 1970–2, xi–xxv; Millar 1977, 55–60; Haskell 1989; MacGregor 1989a, 13–19; Brotton 2006; Millar 2007; Whitaker and Clayton 2007, especially 17–30; Beauchamp 2010.

2 Firth and Sangster Rait (eds) 1911, II, 160–8 (165): '4 July 1649: An Act for the Sale of the Goods and Personal Estate of the late King, Queen and Prince'.

3 Aylmer 1974.

4 While Oliver Millar believed that 'there is no evidence that the Trustees had access to any of Van der Doort's manuscripts', he also noted that van der Doort's successor, Jan van Belcamp, was involved in compiling the inventory: Oliver Millar, 'Introduction', in Millar (ed.) 1970–2, xviii.

5 Evelyn 1959, 366 (entry for 11 February 1656): 'I adventur'd to go to White-Hall, where of many years I had not ben, & found it very glorious & well furnish'd'.

 CSPD: Interregnum 1876–80, LXXVI, 360 [2 September 1654]: 'Petition of the well-affected creditors and servants of the late King to the Protector. An Ordinance on our behalf has been approved by Council in your absence: (1.) That the restraint laid on sale of the goods of the late King, not in use for the State, be taken off, and the goods sold for our relief, according to 2 Acts of Parliament. (2.) That there be further power for getting in the concealed personal estate of the late King.

We find, however, that your Highness intends to take a great part of the goods for your own use, which cannot be chosen till the trustees bring in their accounts, and meantime the said Ordinance cannot be passed. As it will be long before the accounts can pass, and many of us are perishing for want of bread, we beg you to pass so much of the Ordinance as concerns the getting in of moneys on discoveries, omitting only what relates to the goods.' See also Sherwood 1977, especially 27–9.

6 Sainsbury 1863, 168–9; Martindale 1979, 109–11; Simon 1991.

7 See Sherwood 1977, 27–8; King 1989, 319.

8 *The Whole Manner of the Treaty* 1654, 4.

9 London, Parliamentary Archives, HL/PO/JO/10/1/285, Main Papers, 'Papers Relating to the King's Goods', undated May–11 June 1660, fol. 95, calendared in HMC 1879, 91–2; Millar (ed.) 1970–2, 151, 327–8.

10 Millar (ed.) 1970–2, 190.

11 Ibid., 262. This refers either to a painting now in the Royal Collection (see Shearman 1983, 40) or to a work formerly in the collection of the Los Angeles County Museum of Art and sold at Sotheby's New York, 28 January 2010, lot 157. Both works are now attributed to Girolamo Mazzola Bedoli.

12 Two of the earliest of many such injunctions can be found in *JHC*, II, 278–80 [1 September 1641]: 'That all Crucifixes, Scandalous Pictures of any One or more Persons of the Trinity, and all Images of the Virgin Mary, shall be taken away and abol-

ished'; and *JHC*, IV, 464 [5 March 1646]: 'all Persons that shall make any Images or Pictures of the Trinity, or of any Person thereof; and all Persons in whom Malice appears, and they refuse to be reconciled; and the same appearing upon just Proof; all such Persons may be suspended from the Sacrament of the Lord's Supper.' See also Aston 1988, 75–6; Spraggon 2003, 77–80 and 86.

13 Millar (ed.) 1958–60, 186; Millar (ed.) 1970–2, 417; Shearman 1983, 63–4.

14 Millar (ed.) 1970–2, 217 and 416–17.

15 Millar (ed.) 1970–2, xiii, note 5; Loomie 1989, 258.

16 Letter from Cardinal Mazarin to M. de Croullé, 17 June 1650, published in Guizot 1854, I, 204; letter from Antoine de Bordeaux to Cardinal Mazarin, 10 March 1653, quoted in Cosnac [1884] 1885, 169–70: 'J'apporteray plus de soing pour en découvrir d'autres [tapestries] puisque c'est Vostre Eminence qui . . . a donné cet ordre.' See also Michel 1999, 210–13 and 216–17.

17 Letter from M. de Croullé to Cardinal Mazarin, 23 May 1650, 'Estat de quelques tableaux exposés en vente à la maison de Somerset – may 1650', published by Guizot 1854, I, 410–11. The list was later published in full by Cosnac [1884] 1885, 413–22. Michel 1999, 218, note 45, gives the number of paintings as 260, citing errors in the transcription.

18 Huygens [1982], 61 [23 January 1652] saw 'many antique and modern statues, though nearly all damaged'. In the upper gallery was 'a very large number of beautiful paintings, but all so badly cared for and so dusty it was a pitiable sight'.

19 Ibid.: 'Five or six Titians, however, surpassed everything else there, and yet these also could be purchased at a very reasonable price. . . . We found Mr. Spieringh busy around here, but he complained that everything was overpriced'.

20 Nuttall 1965, 302.

21 Letter from Lady Kerr to Lord Lothian, 27 November 1649, quoted in *Correspondence of Sir Robert Kerr*, II [1649–67] 1875, 254.

22 Nuttall 1965, 303.

23 As was the case with John Emery: see Nuttall 1965, 306.

24 See the pamphlet *To The Parliament, the Humble Proposal of Sir Balthazar Gerbier, Kt., Peter Larry, and George Gelders, concerning the representing in oil, Pictures of all the memorable Achievements since the Parliament's first sitting*, London, 1650 (British Library, Stowe MS 184, fol. 283). For an overview of the commission and its context, see Jansson 1995.

25 Gerbier 1653, Part 1, 93–144; Part 2, 1–96.

26 Nuttall 1965, 305; MacGregor 1989a, 17.

27 Millar (ed.) 1970–2, 122.

28 Oliver Millar, 'Introduction', in Millar (ed.) 1970–2, 323 [no. 20]; Haskell 1989, 227.

29 Mundy 1907–36, IV [*Travels in Europe, 1639–1647*, 1925], 70.

30 Loomie 1989, 263. *Tarquin and Lucretia* is attributed by Wethey to Palma Vecchio: Wethey 1975, III [*The Mythological and Historical Paintings*], 219–20. The miniaturist Peter Oliver copied the composition onto vellum around 1630–40 (now in the Victoria & Albert Museum).

31 See Loomie 1989 with previous literature. See also Brotton and McGrath 2008.

32 Loomie 1982, 291.

CSPD: Charles I 1877, CDXXX, 22 [9 October 1639: letter from Endymion Porter to Francis Windebank]: 'when I acquainted his Majesty with their negligence in that particular [the clash between the Spanish and United Provinces fleets] he told me that the resident [that is, the ambassador] was "a silly, ignorant, odd fellow"'.

33 Loomie 1982.

34 Ibid.; Loomie 1989, 258–9.

35 Ford [1845] 1966, III, 1126–7: Philip IV 'was so anxious to get them [the purchases from the sale] to Madrid that he turned out the Lords Clarendon and Cottington, then ambassadors from Charles II, being ashamed to exhibit what once belonged to his old friend and visitor. Clarendon never forgave this, and in 1664, writing to Fanshawe, alludes to the "infamous conduct of Philip in

buying so many goods of the crown from the murderers, which they should think an honour of returning before they made any demands on England".' See also Loomie 1989, 259, note 9.

36 See Burke 1984, I, 107–24, and II, 151–86; Burke and Cherry 1997, I, 109–87, especially 153–6; Burke 2002, 87–106, especially 92–8. See also Brown 1986, 209–13.

37 Letter from Luis de Haro to Alonso de Cárdenas, undated, c.1654, quoted in Berwick 1891, 489 and 492.

38 In August 1653, the Council of State instructed the Commissioners of Custom 'to permit the Spanish ambassador to export, free of duty, twenty-four chests of pictures, hangings and household stuff' for his use: Oliver Millar, 'Introduction', in Millar (ed.) 1970–2, xxii.

39 Millar (ed.) 1970–2, 313 (Titian) and 151 (Tintoretto); Loomie 1989, 264–5; Muñoz González 1998.

40 Letter from Alonso de Cárdenas to Luis de Haro, 11 August 1653, quoted in Léonardon 1900, 29.

41 For the purchase and arrival of the painting in Madrid, see Ford [1845] 1966, III, 1127; Berwick 1891, 490–1; Loomie 1989, 265. The painting was described as the 'pearl' of the collection and the King's favourite work shortly after its arrival in Spain (see Brown and Elliott (eds) 2002, 244) but the specific anecdote of the King's exclamation seems to appear for the first time two centuries later: see Ford [1845] 1966, III, 1127; Ruiz Manero 1992.

42 Letter from Luis de Haro to Alonso de Cárdenas, 17 December 1654, quoted in Berwick 1891, 493–4; Harris 1982, 436.

43 For a similar conclusion, see Brejon de Lavergnée 1987, 59–60; Raimbault 2001–2, 40; Schnapper 2005, 269. It is known that Jabach acquired paintings from the dealers Oudancourt and Linchbeck.

44 For Mazarin's collection, see Michel 1999, especially 200–22; Schnapper 2005, 189–214. For Antoine de Bordeaux's career, see Jusserand (ed.) 1929, part 1 [1648–65], 149–232.

45 See the correspondence published in Cosnac [1884] 1885, chapter VI; Loomie 1989; Michel 1999, 200–22.

46 Cosnac [1884] 1885, 228.

47 Letter from Cardinal Mazarin to Antoine de Bordeaux, 18 April 1654, quoted in Cosnac [1884] 1885, 223.

48 Millar 1963, I, 93.

49 See Cosnac [1884] 1885, 175, 186–7, 193–8, 241–2 and 299; Michel 1999, 203–4.

50 Letter from Alonso de Cárdenas to Luis de Haro, 11 August 1653, quoted in Léonardon 1900, 30; letter from Antoine de Bordeaux to Cardinal Mazarin, 23 October 1653, quoted in Cosnac [1884] 1885, 186–7.

51 See Cosnac [1884] 1885, 188–90, 195–8, 242 and 309; Schnapper 2005, 206–7.

52 Letter from Antoine de Bordeaux to Cardinal Mazarin, 25 May 1654, quoted in Cosnac [1884] 1885, 225: 'Je puis assurer Vostre Eminence que les deux tableaux qu'elle ne croit pas être du Corrège passent icy parmy tous les peintres et cognoisseurs pour estre de cet autheur; que le roy d'Angleterre les avoit acheptés le double de leur dernier prix et que de celui en détrempe l'ambassadeur d'Espagne a voulu donner trois cents livres plus qu'il ne m'avait esté vendu, pour rompre le marché.'

53 Letter from Antoine de Bordeaux to Cardinal Mazarin, 12 February 1654, quoted in Cosnac [1884] 1885, 212: 'Je n'ay point encore reçu des ordres pour achepter les pièces de van Dyck qui seront à bon prix. Si tost que Vostre Eminence aura faict sçavoir celles qui luy seront agréables, j'en arresteray le prix sans crainte d'estre surpris, ayant des experts assez fidèles moyennant quelque récompense.' See also p. 162.

54 Pembroke 1968, 3; Dreher 1977, 108, note 1; Burke 1984, II, 177–8; Vergara 1989; Brown 1995, 83; Brown and Elliott (eds) 2002, 261–72: 'Paintings bought by David Teniers for the Count of Fuensaldaña'.

55 See Millar (ed.) 1958–60, 22, 79 and 208; Roberts 1989, 121.

56 Pembroke 1968, 58–67.

57 Wethey 1975, III [*The Mythological and Historical Paintings*], 200.

58 Matías Díaz Padrón recently suggested that *The Continence of Scipio* could indeed be found in the Alcázar, miscatalogued as 'The Wedding of Alexander the Great': Díaz Padrón 2006.

On this work, see Millar 1951, 125–6; Vergara 1989, 129–30; Wood 1992; Kunzle 1994; Brown and Elliott (eds) 2002, 266–7; Barnes, De Poorter, Millar and Vey 2004, 135–6.

59 Letter from Antoine de Bordeaux to Cardinal Mazarin, 22 December 1653, quoted in Cosnac [1884] 1885, 204: 'Jusqu'à nouvel ordre, toutes les ventes des meubles et tapisseries du roy cesseront'.

6 FINAL DEPARTURES AND FIRST RETURNS

1 *JHL*, XI, 19 [9 May 1660].

2 Instructions given on 2 or 3 June 1662, Archivo General de Simancas, Estado, leg. 2532, quoted in Brown 1987, 13]: 'Si se propusiere alguna cosa sobre la restitución de las pinturas y tapizarías [tapicerías] que algunos ministros compraron . . . se escusará con que no tiene noticia desta materia. Si no obstante se hiziere instancia en que lo represente, podrá dezir que escrivará [escribirá] en ello algún correspondiente, para que lo proponga sin entrar en otra conferencia ni hazer ningún empeño, y dará quenta de lo que se ofreziere.' The author is grateful to Dr Clive H. Griffin for his translation.

3 Santos 1657, fol. 45r: 'Rey Carlo Estuardo . . . este Gran Principe (digno de mejor fortuna)'.

4 Santos 1657, fol. 45r/v: 'las ofrecio á los pies del Rey Nuestro Señor, que como tan superior en su conocimiento, las juzgò dignas desta Maravilla'.

5 Ollard 1994, 212 (see also 157 and 207).

The British interest in the holdings of the Escorial can be garnered by the early publication of a translation of Francisco de los Santos's guide: *The Escurial, or, A description of that wonder of the world for architecture and magnificence of structure built by K. Phillip the II*d* of Spain and lately consumed by fire, written in Spanish by Francisco de los Santos, a frier of the order of S. Hierome, translated into English by a servant of the Earl of Sandwich in his extraordinary embassie thither*, London, 1671.

6 *JHL*, XI, 27 [14 May 1660]: 'Ordered, That all Pictures and Statues belonging to His Majesty be stopped from Transportation, by the Officers of the Ports of London, and of all other Ports; until the further Pleasure of this House be known.'

7 *CSPD*: Charles II 1860, XXII, 379–82 [November 1660]: 'For Recovery and Grants of Crown Goods, Debts, Lands, Rents &c. . . . 16. John Cotterell and Wm. Hubbard. For permission to break up the ground, walls, doors, &c, in six houses in London, Middlesex, and Surrey, where they know are hid 12,000 l. in money, and valuable plate and jewels belonging to His Majesty, reserving for themselves a fifth part of the same.'

Overviews of the returns can be found in Hewlett 1890; Gleissner 1994; Brotton 2005, 115–35; Brotton 2006, chapters 13 and 14.

8 *By the King* 1660.

9 London, Parliamentary Archives, HL/PO/JO/10/1/285, Main Papers, 'Papers Relating to the King's Goods', undated May–11 June 1660, fol. 21, no. 80: 'Mr. Geldorp's discovery, 12 May 1660. Memorandum of divers Pictures and Status and Rarrities Belonging to the King', calendared in HMC 1879, 89.

10 London, Parliamentary Archives, HL/PO/JO/10/1/285, Main Papers, 'Papers Relating to the King's Goods', undated May–11 June 1660, fol. 16, no. 76: 'E. of Peterborough discovery 18 May 1660 . . . Informe the right honorable the Lords' Committee that there are in the custody of the Earl of

Peterborough four or five pictures that possibly did belong to the King. Three whereof he bought of Remy, one of Guiltrop [Geldorp] and one of a certaine Plumer living in the Strand that was the Kinges servant, and one of one Belcampe that had likewise been the King's servant.' The author is grateful to Oliver Millar for bringing this document to his attention.

11 London, Parliamentary Archives, HL/PO/JO/10/ 1/285, Main Papers, 'Papers Relating to the King's Goods', undated May–11 June 1660, fol. 21, no. 80: 'Mr. Geldorp's discovery, 12 May 1660. Memorandum of divers Pictures and Status and Rarritees Belonging to the King . . .', calendared in HMC 1879, 89.

12 London, Parliamentary Archives, HL/PO/JO/10/ 1/285, Main Papers, 'Papers Relating to the King's Goods', undated May–11 June 1660, fol. 11, no. 70, calendared in HMC 1879, 88: 'Edmund Harrison 19 May [1660]'.

13 London, Parliamentary Archives, HL/PO/JO/10/ 1/285, Main Papers, 'Papers Relating to the King's Goods', undated May–11 June 1660, fol. 21, no. 80: 'Mr. Geldorp's discovery, 12 May 1660. Memorandum of divers Pictures and Status and Rarritees Belonging to the King', calendared in HMC 1879, 89.

14 Nuttall 1965, 302.

15 Hutchinson [1806] 1973.

16 Firth 1891, 340.

17 Hutchinson [1806] 1973, 35.

18 Ibid., 4 and 12.

19 Nuttall 1965, 306.

20 Hutchinson [1806] 1973, 207.

21 Ibid., 207.

22 Ibid., 207.

23 Cosnac [1884] 1885, 189–98 and 200–3.

24 Letter from Antoine de Bordeaux to Cardinal Mazarin, 15 December 1653, quoted in Cosnac [1884] 1885, 198: 'le colonel qui la vend ne veut point reslacher des 6,000 livres qu'en effet elle lui a cousté'.

25 London, Parliamentary Archives, HL/PO/JO/10/ 1/285, Main Papers, 'Papers Relating to the King's Goods', undated May–11 June 1660, fol. 22: 'Mr. Geldorp's discovery, 12 May 1660. Memorandum of divers Pictures and Status and Rarritees Belonging to the King . . . Cornell Hutshanton' has 'one Madone of Titian, and divers other pictures, and one naket boy of Marbell very Raerre', calendared in HMC 1879, 89.

26 Nuttall 1965, 308. For the De Critz family, see Edmond 1978–80, 156–61.

27 London, Parliamentary Archives, HL/PO/JO/10/ 1/285, Main Papers, 'Papers Relating to the King's Goods', undated May–11 June 1660, fol. 26, no. 87: 'A particular [illegible] of such goods as are in the Custody of Ema. de Critz May 15th 1660', calendared in HMC 1879, 90. See also *CSPD: Charles II* 1860, 1, 6 [29–31 May 1660]: 'Case of Emanuel de Critz [who] spent 900 l. to rescue from Parliament the incomparable statue of the late King by Bernino.'

28 London, Parliamentary Archives, HL/PO/JO/10/ 1/285, Main Papers, 'Papers Relating to the King's Goods', undated May–11 June 1660, fol. 26, no. 87, calendared in HMC 1879, 90. See also British Library, Egerton MS 1636 [Richard Symonds, 'Observations Concerning Pictures and Paintings in England, 1651–1652'], fols 99v–100r [new pagination]; Beal 1984, 308–9.

29 MacGregor (ed.) 1983, 300–5.

30 London, Parliamentary Archives, HL/PO/JO/10/ 1/285, Main Papers, 'Papers Relating to the King's Goods', undated May–11 June 1660, fol. 26, no. 87, calendared in HMC 1879, 91.

31 London, Parliamentary Archives, HL/PO/JO/10/ 1/285, Main Papers, 'Papers Relating to the King's Goods', undated May–11 June 1660, fol. 26, no. 87, calendared in HMC 1879, 91.

32 See HMC 1966, 580.

33 Further research by Hilary Maddicott revealed that the number of works acquired by Lord Lisle was even higher, at sixty paintings and sixty pieces of sculpture: see Maddicott 1999.

34 Millar (ed.) 1958–60, 17–19; Shearman 1983, 196–200. Charles I's enthusiasm may have had a more practical motive: the unusual, elongated shape of these paintings meant that they were ideally suited for a double hanging, since they could conveniently fit below larger works.

35 Shearman 1983, 23; Rowlands 1985, 137.

36 *JHL*, XI, 34 [19 May 1660]. For the list of works of art returned by Lisle, see HMC 1966, 502–3.

37 *JHL*, XI, 34 [19 May 1660].

38 *By the King* 1660.

39 Millar 1977, 65.

40 Lord Lisle's holdings by these artists were indeed meagre: he purchased a copy of Titian's *Entombment* and a Madonna attributed to him (now given to Paris Bordone), as well as a work of collaboration between Rubens and Snyders. This is even more surprising considering that, as a member of the committee for the reservation of goods from the royal sale for the use of the state, he had easy access to all available works of art: see Maddicott 1999, 4 and 8–9.

41 Maddicott 1999 traces the vicissitudes of Lord Lisle's finances, which may have played a part in his collecting patterns.

42 *A Deep Sigh Breath'd* 1642, fol. 2v.

43 Wood 1993.

44 Evelyn gives an account of visiting the collection on 7 June 1658: Evelyn 1959, 391.

45 Lever 1967, 111; Pembroke 1968, 2 and 58–67.

46 Walpole 1849, I, 293. For this designation, see Aldrich, Fehl and Fehl (eds) 1991, xxxiv (note 21): the authors point out that the expression was probably coined by James Dallaway (who signed the footnote in which it appears), but that it was by then well established and already in common usage in Arundel's time.

47 See, for example, Gardiner 1882, I [1637–40], 92.

48 See Mahon 1949–50; Logan 1979, especially 85, note 103; Penny 2008, 470–2. An album of engravings after paintings in the Reynst collection was published by Gerard Reynst's heirs: *Variarum imaginum a celeberrimis artificibus pictarum Caelaturae*, Amsterdam, *c*.1660.

49 Shearman 1983, 118–19 and 144; Whitaker and Clayton, 2007, 136. On Reynst in Venice, see Borean and Mason (eds) 2007, 304–5.

50 Haskell 1999.

51 Haskell 1985.

52 Pears 1988, 106.

PUBLICATIONS CITED

Albion, Gordon, *Charles I and the Court of Rome: A Study in 17th-Century Diplomacy*. Louvain, 1935.

Aldrich, Keith, Philipp Fehl and Raina Fehl (eds), *Franciscus Junius: The Literature of Classical Art*, vol. 1: *The Painting of the Ancients: De pictura veterum According to the English Translation (1638)*. Berkeley, Los Angeles and Oxford, 1991.

Allen, Derek, 'Abraham Vanderdort and the coinage of Charles I, based on the notes of Miss Helen Farquhar', *Numismatic Chronicle and Journal of the Royal Numismatic Society*, vol. 1, 1941, pp. 54–75.

Anderson, Christina M., 'Daniel Nijs's cabinet and its sale to Lord Arundel in 1636', *Burlington Magazine*, vol. 154, no. 1308, March 2012, pp. 172–6.

Andrews, Keith, *Adam Elsheimer: Paintings, Drawings, Prints*. New York, 1977.

Angelicoussis, Elizabeth, 'The collection of classical sculptures of the Earl of Arundel, "Father of Vertu in England"', *Journal of the History of Collections*, vol. 16, no. 2, 2004, pp 143–59.

Ashmole, Elias, *The Institution, Laws & Ceremonies of the Most Noble Order of the Garter*. London, 1672.

Askew, Pamela, 'The parable paintings of Domenico Fetti', *Art Bulletin*, vol. 43, no. 1, March 1961, pp. 21–45.

Aston, Margaret, *England's Iconoclasts*, vol. 1: *Laws and Images*. Oxford, 1988.

Avery, Charles, 'Hubert Le Sueur, the "unworthy Praxiteles" of King Charles I', *Walpole Society*, vol. 48, 1982, pp. 135–209.

————, ' "Sculpture gone wild": Bernini and the English', in Chantal Grell and Milovan Stanić (eds), *Le Bernin et l'Europe: Du baroque triomphant à l'âge romantique*. Paris, 2002, pp. 160–78.

Avery, Charles, and Katherine Watson, 'Medici and Stuart: a Grand Ducal gift of "Giovanni Bologna" bronzes for Henry Prince of Wales (1612)', *Burlington Magazine*, vol. 115, no. 845, August 1973, pp. 493–507.

Aylmer, Gerald E., *The King's Servants: The Civil Service of Charles I, 1625–1642*, rev. edn, London and Boston, 1974.

Bacon, Francis, *Baconiana, or, Certain Genuine Remains of Sr Francis Bacon, Baron of Verulam and Viscount of St. Albans, in arguments civil and moral, natural, medical, theological, and bibliographical*, ed. Thomas Tenison. London, 1679.

Ball, R. M., 'On the statue of King Charles at Charing Cross', *Antiquaries Journal*, vol. 67, 1987, pp. 97–101.

Barnes, Susan J., Nora De Poorter, Oliver Millar and Horst Vey, *Van Dyck: A Complete Catalogue of the Paintings*. New Haven and London, 2004.

Barozzi, Nicolò, and Guglielmo Berchet (eds), *Le relazioni degli stati europei lette al senato dagli ambasciatori Veneti nel secolo decimosettimo*, 10 vols in 11. Venice, 1856–77.

Beal, Mary, *A Study of Richard Symonds: His Italian Notebooks and their Relevance to Seventeenth-Century Painting Techniques*. New York, 1984.

Beauchamp, Peter, 'The "servant" extraordinary: Some account of the life of Thomas Beauchamp (1623–1697), clerk to the trustees for the sale of King Charles I's collections', *British Art Journal*, vol. 11, no. 1, spring 2010, pp. 6–18.

Bellori, Giovanni Pietro, *The Lives of the Modern Painters, Sculptors and Architects* [Rome, 1672], ed. Alice Sedgwick Wohl and Helmut Wohl. New York, 2005.

Berwick y de Alba, Duchess of, *Documentos escogidos del Archivo de la Casa de Alba*. Madrid, 1891.

Betcherman, Lita-Rose, 'The York House collection and its keeper', *Apollo*, vol. 92, October 1970, pp. 250–9.

Borean, Linda, and Stefania Mason (eds), *Il collezionismo d'arte a Venezia: Il Seicento*. Venice, 2007.

Boucher, Bruce, *The Sculpture of Jacopo Sansovino*. New Haven, 1991.

Bracken, Susan, 'Copies of Old Master paintings in Charles I's collection: The role of Michael Cross (*fl.* 1632–60)', *British Art Journal*, vol. 3, no. 2, summer 2002, pp. 28–31.

Bracken, Susan, and Robert Hill, 'Sir Isaac Wake, Venice and art collecting in early Stuart England. A new document', *Journal of the History of Collections*, vol. 24, no. 2, 2012, pp. 183–98.

Breitenbacher, Anton, 'Die Sammlung Imstenraedt in der Gemäldesammlung des Erzbistums Olmütz in Kremsier und Olmütz', *Jahrbuch des Kölnischen Geschichtsvereins*, vol. 12, 1930, pp. 206–16.

Brejon de Lavergnée, Arnauld, *L'Inventaire Le Brun de 1683: La Collection des tableaux de Louis XIV*. Paris, 1987.

Brotton, Jerry, 'The art of restoration: King Charles II and the restitution of the English royal art collection', *Court Historian*, vol. 10, no. 2, December 2005, pp. 115–35.

––––, *The Sale of the Late King's Goods: Charles I and his Art Collection*. London, 2006.

Brotton, Jerry, and David McGrath, 'The Spanish acquisition of King Charles I's art collection: The letters of Alonso de Cárdenas, 1649–1651', *Journal of the History of Collections*, vol. 20, no. 1, 2008, pp. 1–16.

Brown, Christopher, and Nigel Ramsay, 'Van Dyck's collection: Some new documents', *Burlington Magazine*, vol. 132, no. 1051, October 1990, pp. 704–9.

Brown, Jonathan, *Velázquez, Painter and Courtier*. New Haven, 1986.

––––, 'Felipe IV, el rey de coleccionistas', *Fragmentos: Revista de Arte*, no. 11, 1987, pp. 4–20.

––––, 'Felipe IV, Carlos I y la cultura del coleccionismo en dos cortes del siglo diecisiete', in John Elliott and Angel García Sanz (eds), *La España del Conde Duque de Olivares*. Valladolid, 1990, pp. 83–97.

––––, *Kings and Connoisseurs: Collecting Art in Seventeenth-Century Europe*. New Haven and London, 1995.

Brown, Jonathan, and John Elliott (eds), *The Sale of the Century: Artistic Relations between Spain and Great Britain, 1604–1655*, exh. cat., Museo Nacional del Prado, Madrid, 2002.

Burke, Marcus B., 'Private Collections of Italian Art in Seventeenth-Century Spain', doctoral dissertation, 3 vols in 2, New York University, 1984.

––––, 'A golden age of collecting', in Marcus B. Burke and Peter Cherry, *Collections of Paintings in Madrid, 1601–1755*, ed. Maria L. Gilbert, 2 vols. Los Angeles, 1997, vol. 1, pp. 109–87.

––––, 'Luis de Haro as minister, patron and collector of art', in Jonathan Brown and John Elliott (eds), *The Sale of the Century: Artistic Relations between Spain and Great Britain, 1604–1655*, exh. cat., Museo Nacional del Prado, Madrid, 2002, pp. 87–106.

Burke, Marcus B., and Peter Cherry, *Collections of Paintings in Madrid, 1601–1755*, ed. Maria L. Gilbert, 2 vols. Los Angeles, 1997.

Burnet, Gilbert, *The Memoirs of the Lives and Actions of James and William, Dukes of Hamilton and Castle-Herald*. [London, 1677] Oxford, 1852.

By the King: A Proclamation For Restoring and Discovering his Majesties Goods. London, 14 August 1660.

Calendar of State Papers Domestic Series: Charles I, ed. William Douglas Hamilton, vol. CDXXX [October 1639]. London, 1877.

Calendar of State Papers Domestic Series: Charles II, ed. Mary Anne Everett Green, vols I–XXII [May–November 1660]. London, 1860.

Calendar of State Papers Domestic Series: Interregnum, ed. Mary Anne Everett Green, vols IX [March–August 1650] and LXXVI [September–October 1654]. London, 1876–80.

Calendar of State Papers Relating to English Affairs in the Archives of Venice, ed. Allen B. Hinds, vol. XVIII [1623–5]. London, 1912.

Campbell, Caroline (ed.), *Peter Lely: A Lyrical Vision*, exh. cat., The Courtauld Gallery, London, 2012.

Caramanna, Claudia, 'La fortuna delle opere di Jacopo Bassano e dei suoi figli nelle collezioni europee del Seicento', doctoral dissertation, University of Padua, 2009.

Carducho, Vincente, *Diálogos de la pintura* [1633], ed. Francisco Calvo Serraller. Madrid, 1979.

Carpenter, William Hookham, *Pictorial Notices: Consisting of a Memoir of Sir Anthony van Dyck*. London, 1844.

Chaney, Edward, 'Notes towards a biography of Sir Balthazar Gerbier', in Edward Chaney (ed.), *The Evolution of the Grand Tour: Anglo-Italian Cultural Relations since the Renaissance*. London and Portland, 2000, pp. 215–25.

Chew, Elizabeth V., 'The Countess of Arundel and Tart Hall', in Edward Chaney (ed.), *The Evolution of English Collecting: Receptions of Italian Art in the Tudor and Stuart Periods*. New Haven and London, 2003, pp. 285–314.

Clarendon, Edward Hyde, Earl of, *The History of the Rebellion and Civil Wars in England*, [1702–4] 2 vols. Oxford, 1840.

Cock, Christopher, *A Catalogue of the Remaining Collection of Sir Robert Gayer's Fine Pictures, with a very valuable Marble Bust, Tables, &c; as likewise several valuable Paintings, Collected Abroad by Mr. Thomas Crawford, formerly belonging to the Arundel Collection, &c. will be sold by auction at Mr. Cock's new Auction Room in Poland-Street the Corner of Broad-Street near Golden Square, on Tuesday the 5th. of April 1726*. London, 1726.

Colvin, Howard Montagu, *The History of the King's Works*, 6 vols. London, 1963–82.

Correspondence of Sir Robert Kerr, First Earl of Ancram and his Son William, Third Earl of Lothian, 2 vols. Edinburgh, 1875.

Cosnac, Gabriel-Jules de, *Les Richesses du Palais Mazarin* [1884]. Paris, 1885.

Cox, Mary L., 'Inventory of pictures, etc., in the possession of Aletheia, Countess of Arundel at the time of her death in Amsterdam in 1654', *Burlington Magazine*, vol. 19, no. 101, August 1911, pp. 282–6.

————, 'Inventory of the Arundel collection', *Burlington Magazine*, vol. 19, no. 102, September 1911, pp. 323–5.

Crinò, Anna Maria, 'Altri documenti sul ritratto di Southwell dello Holbein e su una statuetta di Lucrezia del Dürer', *Rivista d'Arte*, vol. 35, 1960, pp. 143–51.

Cust, Lionel, 'Notes on pictures in the royal collections – XIII: The triple portrait of Charles I by van Dyck and the bust by Bernini', *Burlington Magazine*, vol. 14, no. 72, March 1909, pp. 337–41.

————, 'Notes on the collections formed by Thomas Howard, Earl of Arundel and Surrey', *Burlington Magazine*, vol. 19, no. 101, August 1911, pp. 278–81; vol. 20, no. 104, November 1911, pp. 97–100; vol. 20, no. 106, January 1912, pp. 233–6; vol. 20, no. 108, March 1912, pp. 341–3; vol. 21, no. 113, August 1912, pp. 256–8.

DaCosta Kaufmann, Thomas, 'Remarks on the collections of Rudolf II: The Kunstkammer as a form of *representatio*', *Art Journal*, vol. 38, no. 1, autumn 1978, pp. 22–8.

Davies, Randall, 'An inventory of the Duke of Buckingham's pictures, etc. at York House in 1635', *Burlington Magazine*, vol. 10, no. 48, March 1907, pp. 376, 379–82.

————, *The Greatest House at Chelsea*. London, 1914.

A Deep Sigh Breath'd Through the Lodgings at White-Hall, Deploring the Absence of the Court, and the Miseries of the Pallace. London, 1642.

Denoon, D. G., 'The statue of King Charles I at Charing Cross', *Transactions of the London and Middlesex Archaeological Society*, new ser. vol. VI, 1933, pp. 460–86.

Díaz Padrón, Matías, ' "La continencia de Escipión" de van Dyck, del Alcázar de Madrid, identificada en la Christ Church de Oxford', *Goya*, vol. 311, 2006, pp. 85–94.

Díaz Padrón, Matías, and Mercedes Royo-Villanova (eds), *David Teniers, Jan Brueghel y los gabinetes de pinturas*, exh. cat., Museo Nacional del Prado, Madrid, 1992.

Donovan, Fiona, *Rubens and England*. New Haven and London, 2004.

Dreher, Faith Paulette, 'David Teniers II again', *Art Bulletin*, vol. 59, no. 1, March 1977, pp. 108–10.

Dudok van Heel, S. A. C., 'De kunstverzamelingen Van Lennep met de Arundel-tekeningen', *Jaarboek van het Genootschap Amstelodamum*, vol. 67, 1975, pp. 137–48.

Dugdale, George S., *Whitehall through the Centuries*. London, 1950.

Duverger, Erik, *Antwerpse kunstinventarissen uit de zeventiende eeuw*, 14 vols. Brussels, 1992.

Edmond, Mary, 'Limners and picturemakers: New light on the lives of miniaturists and large-scale portrait-painters working in London in the sixteenth and seventeenth centuries', *Walpole Society*, vol. 47, 1978–80, pp. 60–242.

Elliott, John, 'A troubled relationship: Spain and Great Britain, 1604–1655', in Jonathan Brown and John Elliott (eds), *The Sale of the Century: Artistic Relations between Spain and Great Britain, 1604–1655*, exh. cat., Museo Nacional del Prado, Madrid, 2002, pp. 17–38.

Evelyn, John, *Numismata: A Discourse of Medals, Antient and Modern*. London, 1697.

––––, *The Diary of John Evelyn*, ed. E. S. de Beer, 6 vols. London, New York and Toronto, 1959.

Fairfax, Brian, *A Catalogue of the Curious Collection of Pictures of George Villiers, Duke of Buckingham*. London, 1758.

Falomir, Miguel, *Los Bassano en la España del siglo de oro*, exh. cat., Museo Nacional del Prado, Madrid, 2001.

Félibien, André, *Entretiens sur les vies et sur les ouvrages des plus excellens peintres, anciens et modernes* [1666–8], 6 vols. Paris, 1725.

Ferrier, R. W., 'Charles I and the antiquities of Persia: The mission of Nicholas Wilford', *Iran*, vol. 8, 1970, pp. 51–6.

Finaldi, Gabriele (ed.), *Orazio Gentileschi at the Court of Charles I*, exh. cat., National Gallery, London, 1999.

Finaldi, Gabriele, and Jeremy Wood, 'Orazio Gentileschi at the court of Charles I', in Keith Christiansen and Judith W. Mann (eds), *Orazio and Artemisia Gentileschi*, exh. cat., Museo del Palazzo di Venezia, Rome, Metropolitan Museum of Art, New York, and Saint Louis Art Museum, 2001–2, pp. 223–31.

Firth, Charles Harding, 'John Hutchinson (1615–1664)', in Sidney Lee (ed.), *Dictionary of National Biography*, vol. XXVIII. London, 1891, pp. 339–40.

Firth, Charles Harding, *The House of Lords during the Civil War*. London, 1910.

Firth, Charles Harding, and Robert Sangster Rait (eds), *Acts and Ordinances of the Interregnum, 1642–1660*, 3 vols. London, 1911.

Fletcher, Jennifer, 'The Arundels in the Veneto', *Apollo*, vol. 144, August 1996, pp. 63–9.

Foister, Susan, ' "My foolish curiosity". Holbein in the collection of the Earl of Arundel', *Apollo*, vol. 144, August 1996, pp. 51–6.

––––, *Holbein and England*. New Haven and London, 2004.

––––, *Holbein in England*, exh. cat., Tate Britain, London, 2006–7.

Ford, Richard, *A Hand-book for Travellers in Spain and Readers at Home* [1845], 3 vols. Carbondale, IL, 1966.

Foucart-Walter, Elisabeth, *Les Peintures de Hans Holbein le Jeune au Louvre*. Paris, 1985.

Fredericksen, Burton B., 'E cosi desio me mena', *J. Paul Getty Museum Journal*, vol. 10, 1982, pp. 21–38.

Gabrieli, Vittorio (ed.), 'A new Digby letter-book "In Praise of Venetia"', *National Library of Wales Journal*, 1955, vol. 9, pp. 113–18, 440–62; vol. 10, pp. 81–106.

Garas, Klára, 'Die Entstehung der Galerie des Erzherzogs Leopold Wilhelm', *Jahrbuch der Kunsthistorischen Sammlungen in Wien*, vol. 63, 1967, pp. 39–80.

————, 'Die Sammlung Buckingham und die Kaiserliche Galerie', *Wiener Jahrbuch für Kunstgeschichte*, vol. 40, 1987, pp. 111–21.

Gardiner, Samuel Rawson (ed.), 'The Hamilton Papers: Being selections from original letters in the possession of His Grace the Duke of Hamilton and Brandon, relating to the years 1638–1650', *Camden Society*, new ser. vol. 27, 1880; 'Hamilton Papers: Addenda', *Camden Society*, new ser. vol. 53, 1895.

————, *The Fall of the Monarchy of Charles I, 1637–1649*, 2 vols. London, 1882.

————, *History of the Great Civil War, 1642–1649*, 3 vols. London, 1886–91.

Gerbier, Balthazar, *Les effects pernicieux de meschants favoris et grands ministres d'estat, es provinces Belgiques, en Lorraine, Germanie, France, Italie, Espagne, & Angleterre: et des-abuzé d'erreurs populaires, sur le subject de Jaques & Charles Stuart, roys de la Grande Bretagne*. The Hague, 1653.

Giglioli, Odoardo H., 'Giovanni Holbein (il giovane): ritratto di Riccardo Southwell', *Rivista d'Arte*, vol. 6, nos 5–6, September–December 1909, pp. 333–8.

Gleissner, Stephen, 'Reassembling a royal art collection for the restored king of Great Britain', *Journal of the History of Collections*, vol. 6, no. 1, 1994, pp. 103–15.

Godfrey, Richard T., *Wenceslaus Hollar: A Bohemian Artist in England*, exh. cat., Yale Center for British Art, New Haven, 1992.

————, 'Hollar's prints for the Earl of Arundel: Copies of lost works from the Arundel collection', *Apollo*, vol. 144, August 1996, pp. 36–8.

Goldberg, Edward L., 'Artistic relations between the Medici and the Spanish courts, 1587–1621, Part II', *Burlington Magazine*, vol. 138, no. 1121, August 1996, pp. 529–40.

Goodman, Godfrey, *The Court of King James the First*, ed. John Sherren Brewer, 2 vols. London, 1839.

Gordenker, Emilie E. S., 'Hidden treasures: Collecting Elsheimer's paintings in Britain', in Rüdiger Klessmann (ed.), *Devil in the Detail: The Paintings of Adam Elsheimer 1578–1610*, exh. cat., National Gallery of Scotland, Edinburgh, Dulwich Picture Gallery, London, and Städelsches Kunstinstitut, Frankfurt, 2006, pp. 193–207.

Griffiths, Antony, *The Print in Stuart Britain, 1603–1689*. London, 1998.

Grossmann, Fritz, 'Notes on the Arundel and Imstenraedt collections – I', *Burlington Magazine*, vol. 84, no. 495, June 1944, pp. 151–4; 'Notes on the Arundel and Imstenraedt collections – II', *Burlington Magazine*, vol. 85, no. 496, July 1944, pp. 172–6.

————, 'Holbein, Flemish paintings and Everhard Jabach', *Burlington Magazine*, vol. 93, no. 574, January 1951, pp. 16–25.

Grouchy, Emmanuel-Henri, vicomte de, 'Everhard Jabach, collectionneur parisien (1695)', *Mémoires de la Société de l'Histoire de Paris et de l'Île-de-France*, vol. 21, 1894, pp. 217–92.

Guarino, Sergio, *L'Arianna di Guido Reni*, exh. cat., Musei Capitolini, Rome, and Pinacoteca Nazionale, Bologna, 2002–3.

Guizot, François, *Histoire de la République d'Angleterre et de Cromwell (1649–1658)*, 2 vols. Paris, 1854.

Hale, John R., *England and the Italian Renaissance: The Growth of Interest in its History and Art*. London, 1954.

Harris, Enriqueta, 'Velázquez and Charles I: Antique busts and modern paintings from Spain for the royal collection', *Journal of the Warburg and Courtauld Institutes*, vol. 30, 1967, pp. 414–19.

————, 'Velázquez as connoisseur', *Burlington Magazine*, vol. 124, no. 952, July 1982, pp. 436–40.

Haskell, Francis, 'The market for Italian art in the 17th century', *Past & Present*, no. 15, April 1959, pp. 48–59.

————, 'The British as collectors', in Gervase Jackson-Stops (ed.), *The Treasure Houses of Britain: Five Hundred Years of Private Patronage and Art Collecting*, exh. cat., National Gallery of Art, Washington, DC, 1985, pp. 50–9.

————, 'Charles I's collection of pictures', in Arthur MacGregor (ed.), *The Late King's Goods: Collections, Possessions and Patronage of Charles I in the Light of the Commonwealth Sale Inventories*. London and Oxford, 1989, pp. 203–31.

————, 'Venetian art and English collectors of the seventeenth and eighteenth centuries', *Verona Illustrata*, no. 12, 1999, pp. 7–18.

————, 'The political implications of art patronage in seventeenth-century Europe', in *Mélanges en hommage à Pierre Rosenberg: Peintures et dessins en France et en Italie, XVIIe–XVIIIe siècles*. Paris, 2001, pp. 228–35.

————, 'Come si costruisce un re: Carlo I d'Inghilterra e i suoi ritrattisti', in Renzo Zorzi (ed.), *Le metamorfosi del ritratto*. Florence, 2002, pp. 137–45.

Haynes, Denys E. L., *The Arundel Marbles*. Oxford, 1975.

Hearn, Karen (ed.), *Dynasties: Painting in Tudor and Jacobean England, 1530–1630*, exh. cat., Tate Gallery, London, 1995–6.

———— (ed.), *Van Dyck and Britain*, exh. cat., Tate Britain, London, 2009.

Held, Julius, *The Oil Sketches of Peter Paul Rubens: A Critical Catalogue*, 2 vols. Princeton, 1980.

Henry, Tom, and Paul Joannides (eds), *Late Raphael*, exh. cat., Museo Nacional del Prado, Madrid, and Musée du Louvre, Paris, 2012.

Hervey, Mary F. S., *The Life, Correspondence and Collections of Thomas Howard, Earl of Arundel*. Cambridge, 1921.

Hewlett, Henry G., 'Charles the First as a picture collector', *Nineteenth Century*, vol. 28, no. 162, August 1890, pp. 201–17.

Hibbard, Caroline M., *Charles I and the Popish Plot*. Chapel Hill, 1983.

————, 'The role of a Queen Consort: The household and court of Henrietta Maria, 1625–1642', in Ronald G. Asch and Adolf M. Birke (eds), *Princes, Patronage and the Nobility: The Court at the Beginning of the Modern Age, c.1450–1650*, London, Oxford and New York, 1991, pp. 393–414.

————, 'The Somerset House chapel and the topography of London Catholicism', in Marcello Fantoni, George Gorse and R. Malcolm Smuts (eds), *The Politics of Space: European Courts, ca. 1500–1750*. Rome, 2009, pp. 317–38.

Hill, Robert, 'The ambassador as art agent: Sir Dudley Carleton and Jacobean collecting', in Edward Chaney (ed.), *The Evolution of English Collecting: Receptions of Italian Art in the Tudor and Stuart Periods*. New Haven and London, 2003a, pp. 240–55.

————, 'Ambassadors and art collecting in early Stuart Britain: The parallel careers of William Trumbull and Sir Dudley Carleton, 1609–1625', *Journal of the History of Collections*, vol. 15, no. 2, 2003b, pp. 211–28.

Hirst, Michael, 'The artist in Rome, 1496–1501', in Michael Hirst and Jill Dunkerton (eds), *Making & Meaning: The Young Michelangelo*, exh. cat., National Gallery, London, 1994–5, pp. 13–82.

Howard, Thomas, Earl of Arundel, *Remembrances of Things Worth Seeing in Italy Given to John Evelyn 25 April 1646 by Thomas Howard, 14th Earl of Arundel*, ed. John Martin Robinson. London, 1987.

Howarth, David, '"Mantua Peeces": Charles I and the Gonzaga collections', in David Chambers and Jane Martineau (eds), *Splendours of the Gonzaga*, exh. cat., Victoria & Albert Museum, London, 1981–2, pp. 95–100.

————, *Lord Arundel and his Circle*. London and New Haven, 1985.

––––, 'Charles I, sculpture and sculptors', in Arthur MacGregor (ed.), *The Late King's Goods: Collections, Possessions and Patronage of Charles I in the Light of the Commonwealth Sale Inventories*. London and Oxford, 1989, pp. 73–113.

––––, 'The arrival of van Dyck in England', *Burlington Magazine*, vol. 132, no. 1051, October 1990, pp. 709–10.

––––, *Images of Rule: Art and Politics in the English Renaissance, 1485–1649*. London, 1997.

––––, 'Bernini and Britain', in Aidan Weston-Lewis (ed.), *Effigies and Ecstasies: Roman Baroque Sculpture and Design in the Age of Bernini*, exh. cat., National Gallery of Scotland, Edinburgh, 1998a, pp. 29–36.

––––, 'The patronage and collecting of Aletheia, Countess of Arundel, 1606–54', *Journal of the History of Collections*, vol. 10, no. 2, 1998b, pp. 125–38.

––––, 'The Arundel collection: Collecting and patronage in England in the reigns of Philip III and Philip IV', in Jonathan Brown and John Elliott (eds), *The Sale of the Century: Artistic Relations between Spain and Great Britain, 1604–1655*, exh. cat., Museo Nacional del Prado, Madrid, 2002, pp. 69–86.

Howarth, David, and Nicholas Penny, *Thomas Howard, Earl of Arundel: Patronage and Collecting in the Seventeenth Century*, exh. cat., Ashmolean Museum, Oxford, 1985–6.

Hutchinson, Lucy, *Memoirs of the Life of Colonel Hutchinson* [written *c*.1670, first pubd 1806], ed. James Sutherland. London, New York and Toronto, 1973.

Huxley, Gervas, *Endymion Porter: The Life of a Courtier, 1587–1649*. London, 1959.

Huygens, Lodewijck, *The English Journal, 1651–1652*, ed. Alfred G. H. Bachrach and R. G. Collmer. Leiden, 1982.

Imstenraedt, Franciscus, *Iconophylacium sive Artis apelleae thesaurarium*. Vienna, 1667.

Jaffé, David, with Denise Allen, Dawson W. Carr, Arianne Faber Kolb and Eva Kleeman, 'The Earl and Countess of Arundel: Renaissance collectors', *Apollo*, vol. 144, August 1996, pp. 3–35.

Jansson, Maija, 'Remembering Marston Moor: The politics of culture', in Susan D. Amussen and Mark A. Kishlansky (eds), *Political Culture and Cultural Politics in Early Modern England: Essays Presented to David Underdown*. Manchester and New York, 1995, pp. 255–76.

Jervis, Simon, 'Furniture for the first Duke of Buckingham', *Furniture History: Journal of the Furniture History Society*, vol. 33, 1997, pp. 48–74.

Journal of the House of Commons, London, 1802–.

Journal of the House of Lords, London, 1767–1830.

Jusserand, Jean Jules (ed.), *Recueil des instructions données aux ambassadeurs et ministres de France depuis les traités de Westphalie jusqu'à la Révolution française*, vol. XXIV [*Angleterre*]. Paris, 1929.

King, Donald, 'Textile furnishings', in Arthur MacGregor (ed.), *The Late King's Goods: Collections, Possessions and Patronage of Charles I in the Light of the Commonwealth Sale Inventories*. London and Oxford, 1989, pp. 307–21.

Klinge, Margret, 'David Teniers and the theatre of painting', in Ernst Vegelin van Claerbergen (ed.), *David Teniers and the Theatre of Painting*, exh. cat., The Courtauld Gallery, London, 2006, pp. 10–39.

Kunzle, David, 'Van Dyck's *Continence of Scipio* as a metaphor of statecraft at the early Stuart court', in John Onians (ed.), *Sight and Insight: Essays on Art and Culture in Honour of E. H. Gombrich at 85*. London, 1994, pp. 169–89.

Kurz, Otto, 'Holbein and others in a seventeenth-century collection', *Burlington Magazine*, vol. 83, no. 488, November 1943, pp. 279–82.

Landolt, Elisabeth, et al., *Das Amerbach-Kabinett*, 5 vols, exh. cat., Sammeln in der Renaissance, Kunstmuseum, Basel, 1991.

Lapenta, Stefania, and Raffaella Morselli, *Le collezioni Gonzaga: La quadreria nell'elenco dei beni del 1626–1627*. Milan, 2006.

Léonardon, Henri, 'Une dépêche diplomatique relative à des tableaux acquis en Angleterre pour Philippe IV', *Bulletin Hispanique*, vol. 2, no. 1, 1900, pp. 25–34.

Lever, Tresham, *The Herberts of Wilton*. London, 1967.

Levy, F. J., 'Henry Peacham and the art of drawing', *Journal of the Warburg and Courtauld Institutes*, vol. 37, 1974, pp. 174–90.

Ley, Henry, 'The Imstenraedt collection', *Apollo*, vol. 113, July 1971, pp. 50–9.

Lightbown, Ronald, 'Christian van Vianen at the court of Charles I', *Apollo*, vol. 77, June 1968, pp. 426–39.

----, 'Van Dyck and the purchase of paintings for the English Court', *Burlington Magazine*, vol. 111, no. 796, July 1969, pp. 418–21.

----, 'Bernini's busts of English patrons', in Moshe Barasch, Lucy Freeman Sandler and Patricia Egan (eds), *Art, the Ape of Nature: Studies in Honor of H. W. Janson*. New York, 1981, pp. 439–76.

----, 'Charles I and the art of the goldsmith', in Arthur MacGregor (ed.), *The Late King's Goods: Collections, Possessions and Patronage of Charles I in the Light of the Commonwealth Sale Inventories*. London and Oxford, 1989a, pp. 233–55.

----, 'Charles I and the tradition of European princely collecting', in Arthur MacGregor (ed.), *The Late King's Goods: Collections, Possessions and Patronage of Charles I in the Light of the Commonwealth Sale Inventories*. London and Oxford, 1989b, pp. 53–72.

Lockyer, Roger, *Buckingham: The Life and Political Career of George Villiers, First Duke of Buckingham, 1592–1628*. London and New York, 1981.

Lodge, Edmund, *Portraits of Illustrious Personages of Great Britain*, 12 vols in 6. London, 1827.

Logan, Anne-Marie S., *The 'Cabinet' of the Brothers Gerard and Jan Reynst*. Amsterdam, Oxford and New York, 1979.

Longueville, Thomas, *The Life of Sir Kenelm Digby*. London, New York and Bombay, 1896.

Loomie, Albert J., 'Alonso de Cárdenas and the Long Parliament, 1640–1648', *English Historical Review*, 97, 1982, pp. 289–307.

---- (ed.), *Ceremonies of Charles I: The Note Books of John Finet, 1628–1641*. New York, 1987.

----, 'New light on the Spanish Ambassador's purchases from Charles I's collection, 1649–53', *Journal of the Warburg and Courtauld Institutes*, LII, 1989, pp. 257–67.

----, 'The destruction of Rubens's "Crucifixion" in the Queen's Chapel, Somerset House', *Burlington Magazine*, vol. 140, no. 1147, October 1998, pp. 680–2.

Lovelace, Richard, 'Peinture: A panegyrick to the best picture of friendship, Mr. Pet. Lilly', in *Lucasta: Posthume Poems of Richard Lovelace*. London, 1659.

Luzio, Alessandro, *La galleria dei Gonzaga venduta all'Inghilterra nel 1627–1628*. Milan, 1913.

McEvansoneya, Philip, 'Some documents concerning the patronage and collections of the Duke of Buckingham', *Rutgers Art Review*, vol. 8, 1987, pp. 27–38.

----, 'An unpublished inventory of the Hamilton collection in the 1620s and the Duke of Buckingham's pictures', *Burlington Magazine*, vol. 134, no. 1073, August 1992, pp. 524–6.

----, 'The sequestration and dispersal of the Buckingham collection', *Journal of the History of Collections*, vol. 8, no. 2, 1996a, pp. 133–54.

----, 'Vertue, Walpole and the documentation of the Buckingham collection', *Journal of the History of Collections*, vol. 8, no. 1, 1996b, pp. 1–14.

----, 'Italian paintings in the Buckingham collection', in Edward Chaney (ed.), *The Evolution of English Collecting: Receptions of Italian Art in the Tudor and Stuart Periods*. New Haven and London, 2003, pp. 315–36.

MacGregor, Arthur (ed.), *Tradescant's Rarities: Essays on the Foundation of the Ashmolean Museum, 1683, with a Catalogue of the Surviving Early Collections*. Oxford, 1983.

––––, 'The King's Goods and the Commonwealth sale: Materials and context', in Arthur MacGregor (ed.), *The Late King's Goods: Collections, Possessions and Patronage of Charles I in the Light of the Commonwealth Sale Inventories*. London and Oxford, 1989a, pp. 13–52.

–––– (ed.), *The Late King's Goods: Collections, Possessions and Patronage of Charles I in the Light of the Commonwealth Sale Inventories*. London and Oxford, 1989b.

MacLeod, Catharine, R. Malcolm Smuts and Timothy Wilks (eds), *The Lost Prince: The Life and Death of Henry Stuart*, exh. cat., National Portrait Gallery, London, 2012–13.

McIntyre, Paul, 'Correggio ed i collezionisti inglesi nella prima metà del Seicento', *Aurea Parma*, vol. 74, no. 3, September–December 1990, pp. 215–28.

Maddicott, Hilary, 'The provenance of the "Castle Howard" version of Orazio Gentileschi's "Finding of Moses"', *Burlington Magazine*, vol. 140, no. 1139, February 1998, pp. 120–2.

––––, 'A collection of the Interregnum period: Philip, Lord Viscount Lisle, and his purchases from the "Late King's Goods", 1649–1660', *Journal of the History of Collections*, vol. 11, no. 1, 1999, pp. 1–24.

Madocks, Susan, '"Trop de beautez découvertes": New light on Guido Reni's late "Bacchus and Ariadne"', *Burlington Magazine*, vol. 126, no. 978, September 1984, pp. 544–7.

Madocks Lister, Susan, '"Trumperies brought from Rome": Barberini gifts to the Stuart court in 1635', in Elizabeth Cropper (ed.), *The Diplomacy of Art: Artistic Creation and Politics in Seicento Italy (Papers from a Colloquium held at the Villa Spelman, Florence, 1998)*. Milan, 2000, pp. 151–76.

Mahon, Denis, 'Notes on the "Dutch Gift" to Charles II', *Burlington Magazine*, vol. 91, no. 560, November 1949, pp. 303–5; vol. 91, no. 561, December 1949, pp. 349–50; vol. 92, no. 562, January 1950, pp. 12–18.

Malvasia, Carlo Cesare, *Felsina pittrice: Vite de' pittori bolognesi*, 2 vols. Bologna, 1678.

Manilli, Giacomo, *Villa Borghese fuori di Porta Pinciana*. Rome, 1650.

Mariette, Pierre-Jean, *Abecedario de P. J. Mariette et autres notes inédites de cet amateur sur les arts et les artistes*, vol. 4, ed. Philippe de Chennevières et Anatole de Montaiglon, Archives de l'Art Français. Paris, 1859–60.

Marsden, Jonathan, 'Portrait busts', in Jane Roberts, *The King's Head: Charles I, King and Martyr*, exh. cat., The Queen's Gallery, London, 1999, pp. 36–41.

Marshall, Rosalind K., *The Days of Duchess Anne: Life in the Household of the Duchess of Hamilton, 1656–1716*. London, 1973.

Martin, Gregory, 'Rubens and Buckingham's "fayrie ile"', *Burlington Magazine*, vol. 108, no. 765, December 1966, pp. 613–18.

––––, *The Flemish School, circa 1600–circa 1900*, National Gallery Catalogues. London, 1970.

––––, 'The Banqueting House ceiling: Two newly discovered projects', *Apollo*, vol. 139, February 1994, pp. 29–34.

––––, *Rubens: The Ceiling Decoration of the Banqueting Hall*, Corpus Rubenianum Ludwig Burchard, pt 15, 2 vols. London, 2005.

Martindale, Andrew, *The Triumphs of Caesar by Andrea Mantegna in the Collection of Her Majesty the Queen at Hampton Court*. London, 1979.

Mertens, Jozef, and Franz Aumann (eds), *Krijg en kunst: Leopold Willem (1614–1662), Habsburger Landvoogd en kunstverzamelaar*, exh. cat., Alden Biesen, 2003.

Michel, Patrick, *Mazarin, prince des collectionneurs: Les collections et l'ameublement du cardinal Mazarin (1602–1661): Histoire et analyse*. Paris, 1999.

Millar, Oliver, 'Van Dyck's "Continence of Scipio" at Christ Church', *Burlington Magazine*, vol. 93, no. 577, April 1951, pp. 125–6.

──── (ed.), *Abraham van der Doort's Catalogue of the Collections of Charles I*, Walpole Society, vol. 37, 1958–60.

────, *The Tudor, Stuart and Early Georgian Pictures in the Collection of Her Majesty the Queen*, 2 vols. London, 1963.

──── (ed.), *The Inventories and Valuations of the King's Goods, 1649–1651*, Walpole Society, vol. 43, 1970–2.

────, *The Age of Charles I: Painting in England, 1620–1649*, exh. cat., Tate Gallery, London, 1972–3.

────, *The Queen's Pictures*. London, 1977.

────, *Sir Peter Lely, 1618–1680*, exh. cat., National Portrait Gallery, London, 1978.

────, *Van Dyck in England*, exh. cat., National Portrait Gallery, London, 1982–3.

────, 'The years in London: Problems and reassessments', in Hans Vlieghe (ed.), *Van Dyck, 1599–1999: Conjectures and Refutations*. Turnhout, 2001, pp. 129–38.

────, 'Van Dyck in England', in Susan J. Barnes, Nora De Poorter, Oliver Millar and Horst Vey, *Van Dyck: A Complete Catalogue of the Paintings*. New Haven and London, 2004, pp. 419–28.

────, 'The collection of Charles I, review of Jerry Brotton, *The Sale of the Late King's Goods: Charles I and his Art Collection*, *Court Historian*, vol. 12, no. 1, June 2007, pp. 71–80.

Montanari, Tomaso, 'Francesco Barberini, *L'Arianna* di Guido Reni e altri doni per la corona d'Inghilterra: L'ultimo atto', in Maria Grazia Bernardini (ed.), *Studi sul Barocco romano: Scritti in onore di Maurizio Fagiolo dell'Arco*. Milan, 2004, pp. 77–88.

Moore Smith, G. C. (ed.), *The Letters of Dorothy Osborne to William Temple*. Oxford, 1928.

Muller, Jeffrey M., *Rubens: The Artist as Collector*. Princeton, 1989.

Mundy, Peter, *The Travels of Peter Mundy in Europe and Asia, 1608–1667*, ed. Richard Carnac Temple, 6 vols. London, 1907–36.

Muñoz González, M. Jesús, 'Las compras de pintura italiana realizadas en la almoneda de Carlos I de Inglaterra por Alonso de Cárdenas', in *El Mediterráneo y el arte español: Actas del XI Congreso Español historia del Arte*, Valencia, 1996. Valencia, 1998, pp. 198–201.

Müntz, Eugène, 'Le Château de Fontainebleau au XVIIe siècle d'après des documents inédits, I: Le Château de Fontainebleau en 1625 d'après le Diarium du Commandeur Cassiano dal Pozzo', *Mémoires de la Société de l'Histoire de Paris et de l'Île-de-France*, vol. 12, 1885, pp. 255–78.

Norton, Paul F., 'The lost sleeping cupid of Michelangelo', *Art Bulletin*, vol. 39, no. 4, December 1957, pp. 251–7.

Nuttall, W. L. F., 'King Charles I's pictures and the Commonwealth sale', *Apollo*, vol. 82, 1965, pp. 302–9.

Ollard, Richard, *Cromwell's Earl: A Life of Edward Mountagu, 1st Earl of Sandwich*. London, 1994.

Oswald, Arthur, 'Lamport Hall, Northamptonshire – II', *Country Life*, vol. 112, no. 2907, 3 October 1952, pp. 1022–5.

Parry, Graham, *The Golden Age Restor'd: The Culture of the Stuart Court, 1603–1642*. New York, 1981.

Passavant, Johann David, *Raphael of Urbino and his Father Giovanni Santi*. London and New York, 1872.

Peacham, Henry, *The Gentleman's Exercise*. London, 1612.

Pears, Iain, *The Discovery of Painting: The Growth of Interest in the Arts in England, 1680–1768*. New Haven and London, 1988.

Pembroke, Sidney Charles Herbert, sixteenth Earl of, *A Catalogue of the Paintings & Drawings in the Collection at Wilton House, Salisbury, Wiltshire*. London and New York, 1968.

Pennington, Richard, *A Descriptive Catalogue of the Etched Work of Wenceslaus Hollar, 1607–1677*. Cambridge and New York, 1982.

Penny, Nicholas, *The Sixteenth-Century Italian Paintings*, vol. II: *Venice 1540–1600*, National Gallery Catalogues. London, 2008.

Pepys, Samuel, and John Evelyn, *Particular Friends: The Correspondence of Samuel Pepys and John Evelyn*, ed. Guy de la Bédoyère. Woodbridge, [1997] 2005.

Petter-Wahnschaffe, Katrin, *Hans Holbein und der Stalhof in London*. Berlin and Munich, 2010.

Philip, I. G., 'Balthazar Gerbier and the Duke of Buckingham's pictures', *Burlington Magazine*, vol. 99, no. 650, May 1957, pp. 155–6.

Phillips, Claude, *The Picture Gallery of Charles I*. London, 1896.

Pinto, Vivian de Sola, *Peter Sterry, Platonist and Puritan, 1613–1672*. Cambridge, 1934.

Pitacco, Francesca, 'Dal secolo d'oro ai secoli d'oro: I collezionisti stranieri e i loro agenti', in Linda Borean and Stefania Mason (eds), *Il collezionismo d'arte a Venezia: Il Seicento*. Venice 2007, pp. 103–23.

Pope-Hennessy, John, *Catalogue of Italian Sculpture in the Victoria and Albert Museum*, 3 vols. London, 1964.

Portier, François, 'Prices paid for Italian pictures in the Stuart age', *Journal of the History of Collections*, vol. 8, no. 1, 1996, pp. 53–69.

Potter, Lois, *Secret Rites and Secret Writing: Royalist Literature, 1641–1660*. Cambridge and New York, 1989.

Puget de la Serre, Jean, *Histoire de l'entrée de la reyne mère du roy très-Chrétien dans la Grande-Bretaigne*. London, 1639.

Raatschen, Gudrun, 'Plaster casts of Bernini's bust of Charles I', *Burlington Magazine*, vol. 138, no. 1125, December 1996, pp. 813–16.

————, 'Van Dyck's *Charles I on Horseback with M. de Saint Antoine*', in Hans Vlieghe (ed.), *Van Dyck, 1599–1999: Conjectures and Refutations*. Turnhout, 2001, pp. 139–50.

Raimbault, Christine, 'Evrard Jabach, quelques précisions sur la constitution des collections', *Bulletin de l'Association des Historiens de l'Art Italien*, vol. 8, 2001–2, pp. 35–45.

Redworth, Glyn, *The Prince and the Infanta: The Cultural Politics of the Spanish Match*. New Haven and London, 2004.

Reinhardt, Sophie, *Tizian in England: Zur Kunstrezeption am Hof Karls I*, Frankfurt and New York, 1999.

Reports of the Royal Commission on Historical Manuscripts:

Seventh Report, Part 1: *Report and Appendix*. London, 1879.

Eleventh Report, Appendix: The Manuscripts of the Duke of Hamilton, K. T. (series 22). London, 1887.

Fourteenth Report, Appendix: The Manuscripts of His Grace the Duke of Portland, Preserved at Welbeck Abbey, 4 vols, London, 1891–7.

Report on the Manuscripts of the Earl of Denbigh, Preserved at Newnham Paddox, Warwickshire, Part V (series 68). London, 1911.

Supplementary Report on the Manuscripts of His Grace the Duke of Hamilton, ed. Jane Harvey McMaster and Marguerite Wood. London, 1932.

Report on the Manuscripts of the Right Honourable Viscount De l'Isle V. C., Preserved at Penshurst Place, Kent: De l'Isle and Dudley Manuscripts, vol. VI: *Sidney Papers, 1626–1698* (series 77), ed. G. Dyfnallt Owen. London, 1966.

Riccardi-Cubitt, Monique, 'The Duke of Buckingham's *cabinet d'amateur*: An aesthetic, religious and political statement', *British Art Journal*, vol. 1, no. 2, spring 2000, pp. 77–86.

Richards, Judith, '"His Nowe Majestie" and the English monarchy: The kingship of Charles I before 1640', *Past & Present*, no. 113, November 1986, pp. 70–96.

Ridolfi, Carlo, *The Life of Tintoretto, and of his Children Domenico and Marietta* [Venice, 1642], ed. Catherine and Robert Enggass. University Park, PA, 1984.

Roberts, Jane, 'The limnings, drawings and prints in Charles I's collection', in Arthur MacGregor (ed.), *The Late King's Goods: Collections, Possessions and Patronage of Charles I in the Light of the Commonwealth Sale Inventories*. London and Oxford, 1989, pp. 115–29.

————, *The King's Head: Charles I, King and Martyr*, exh. cat., The Queen's Gallery, London, 1999.

————, 'Thomas Howard, the collector Earl of Arundel and Leonardo's drawings', in Edward Chaney (ed.), *The Evolution of English Collecting: Receptions of Italian Art in the Tudor and Stuart Periods*. New Haven and London, 2003, pp. 256–83.

Roe, Thomas, *The Negotiations of Sir Thomas Roe in his Embassy to the Ottoman Porte, from the year 1621 to 1628 inclusive*. London, 1740.

Rogers, Malcolm, 'Van Dyck in England', in Christopher Brown and Hans Vlieghe (eds), *Van Dyck, 1599–1641*, exh. cat., Koninklijk Museum voor Schone Kunsten, Antwerp, and Royal Academy of Arts, London, 1999, pp. 79–91.

Rowlands, John, *Holbein: The Paintings of Hans Holbein the Younger, Complete Edition*. Oxford, 1985.

Rubens, Peter Paul, *The Letters of Peter Paul Rubens*, ed. Ruth Saunders Magurn. Cambridge, MA, 1955.

Ruiz Manero, José María, 'Pintura italiana del siglo XVI en España, II: Rafael y su escuela: originales de Rafael conservados en España y de procedencia española y copias de los mismos', *Cuadernos de Arte e Iconografía*, vol. 5, no. 10, 1992, n.p.

Šafařík, Eduard A., 'The origin and fate of the Imstenraed collection', *Sborník Prací Filosofické Fakulty Brněnské University*, vol. 8, 1964, pp. 171–82.

Sainsbury, William Noël, *Original Unpublished Papers Illustrative of the Life of Sir Peter Paul Rubens, as an Artist and a Diplomatist*. London, 1859.

————, 'Extracts from state papers of the Interregnum (1649–1660)', *Fine Arts Quarterly Review*, vol. 1, May–October 1863, pp. 166–71.

Salomon, Xavier F., *Veronese's Allegories: Virtue, Love, and Exploration in Renaissance Venice*, exh. cat., Frick Collection, New York, 2006.

Samson, Alexander (ed.), *The Spanish Match: Prince Charles's Journey to Madrid, 1623*. Aldershot and Burlington, 2006.

Sandrart, Joachim von, *Academie der Bau-, Bild- und Mahlerey-Künste* [Nuremberg, 1675], ed. A. R. Peltzer. Munich, 1925.

Santos, Francisco de los, *Descripción breve del monasterio de S. Lorenzo el Real del Escorial*. Madrid, 1657.

Savini-Branca, Simona, *Il collezionismo veneziano nel '600*. Padua, 1965.

Scarpa Sonino, Annalisa, *Cabinet d'amateur: Le grandi collezioni d'arte nei dipinti dal XVII al XIX secolo*. Milan, 1992.

Schnapper, Antoine, *Curieux du grand siècle: Collection et collectionneurs dans la France du 17e siècle*, rev. Mickaël Szanto and Sophie Mouquin. Paris, 2005.

Schreiber, Renate, *'Ein Galeria nach meinem Humor': Erzherzog Leopold Wilhelm*. Vienna and Milan, 2004.

Schütz, Karl, 'The collection of Archduke Leopold Wilhelm', in Klaus Bussmann and Heinz Schilling (eds), *1648: War and Peace in Europe*, vol. II: *Art and Culture*. Münster, 1999, pp. 181–90.

Scott, Jonathan, *The Pleasures of Antiquity: British Collectors of Greece and Rome*. New Haven and London, 2003.

Scott-Elliot, Anne H., 'The statues from Mantua in the collection of King Charles I', *Burlington Magazine*, vol. 101, no. 675, June 1959, pp. 218–27.

Selden, John, *Marmora arundelliana: siue Saxa graece incisa, ex venerandis priscae orientis gloriae ruderibus, auspicijs & impensis*. London, 1628.

Seyfarth, Jutta, 'Die Bildersammlung der Familie Imstenraedt: Ein Barockkabinett in Köln', in Hiltrud Kier and Frank Günter Zehnder (eds), *Lust und Verlust: Kölner Sammler zwischen Trikolore und Preußenadler*. Cologne, 1995, pp. 31–5.

Seyfarth, Jutta, 'Ein Schatzhaus des Apelles (Iconophylacium): Beschreibung der Bildersammlung des Kölner Ratsherrn Franz von Imstenraedt, 1667', in Werner Schäfke (ed.), *Coellen eyn Croyn: Renaissance und Barock in Köln*. Cologne, 1999, pp. 157–254.

Shakeshaft, Paul, 'The English ambassadors in Venice, 1604–1639', MA report, Courtauld Institute of Art, London, 1979.

————, '"To much bewiched with thoes intysing things": The letters of James, third Marquis of Hamilton

and Basil, Viscount Feilding, concerning collecting in Venice, 1635–1639', *Burlington Magazine*, vol. 128, no. 995, February 1986, pp. 114–32.

Sharpe, Kevin M., *The Personal Rule of Charles I*. New Haven, 1992.

––––, *Image Wars: Promoting Kings and Commonwealths in England, 1603–1660*. New Haven and London, 2010.

Shearman, John K. G., *Raphael's Cartoons in the Collection of Her Majesty the Queen and the Tapestries for the Sistine Chapel*. London, 1972.

––––, *The Early Italian Pictures in the Collection of Her Majesty the Queen*. Cambridge and New York, 1983.

Sherwood, Roy, *The Court of Oliver Cromwell*. London, 1977.

Simon, Robin, '"Roman-cast similitude": Cromwell and Mantegna's *Triumphs of Caesar*', *Apollo*, vol. 134, October 1991, pp. 223–7.

Smith, Logan Pearsall, *The Life and Letters of Sir Henry Wotton*, 2 vols. Oxford, 1907.

Smuts, R. Malcolm, 'The political failure of Stuart cultural patronage', in G. F. Lytle and Stephen Orgel (eds), *Patronage in the Renaissance*. Princeton, 1981, pp. 165–87.

Smuts, R. Malcolm, *Court Culture and the Origins of a Royalist Tradition in Early Stuart England*. Philadelphia, 1987.

––––, 'Art and the material culture of majesty in early Stuart England', in R. Malcolm Smuts (ed.), *The Stuart Court and Europe: Essays in Politics and Political Culture*. Cambridge, 1996, pp. 86–112.

Spraggon, Julie, *Puritan Iconoclasm during the English Civil War*. Woodbridge, 2003.

Springell, Francis C., *Connoisseur and Diplomat: The Earl of Arundel's Embassy to Germany in 1636*. London, 1963.

'The statue of Charles I and site of the Charing Cross', in G. H. Gater and E. P. Wheeler (eds), *Survey of London*, vol. XVI: *St Martin-in-the-Fields: Charing Cross*. London, 1935.

Sterry, Peter, *A Discourse of the Freedom of the Will*. London, 1675.

Stone, Lawrence, 'The market for Italian art', *Past & Present*, no. 16, November 1959, pp. 92–4.

Stoye, John Walter, *English Travellers Abroad, 1604–1667: Their Influence in English Society and Politics*. London, 1952.

Strong, Roy, *Britannia Triumphans: Inigo Jones, Rubens and Whitehall Palace*. London, 1980.

––––, *Henry, Prince of Wales and England's Lost Renaissance*. London, 1986.

Summer, Ann (ed.), *Death, Passion and Politics: Van Dyck's Portraits of Venetia Stanley and George Digby*, exh. cat., Dulwich Picture Gallery, London, 1995–6.

Sutton, Denys, 'Thomas Howard, Earl of Arundel and Surrey, as a collector of drawings', *Burlington Magazine*, vol. 89, no. 526, January 1947, pp. 2–9; vol. 89, no. 527, February 1947, pp. 32–4; vol. 89, no. 528, March 1947, pp. 75–7.

Thomas-Stanford, Charles, *Sussex in the Great Civil War and the Interregnum, 1642–1660*. London, 1910.

Thurley, Simon, *Whitehall Palace: An Architectural History of the Royal Apartments, 1240–1698*. New Haven and London, 1999.

––––, 'The Stuart Kings, Oliver Cromwell and the Chapel Royal, 1618–1685', *Architectural History*, no. 45, 2002, pp. 238–74.

––––, 'The politics of court space in early Stuart London', in Marcello Fantoni, George Gorse and R. Malcolm Smuts (eds), *The Politics of Space: European Courts, ca. 1500–1750*. Rome, 2009, pp. 293–316.

Tierney, Mark A., *The History and Antiquities of the Castle and Town of Arundel*, 2 vols. London, 1834.

Tizianello, *Breve compendio della vita del famoso Titiano Vecellio di Cadore cavalliere, et pittore* [Venice, 1622], ed. Lionello Puppi. Milan, 2009.

Trevor-Roper, Hugh, *Princes and Artists: Patronage and Ideology at Four Habsburg Courts, 1517–1633*. New York, Hagerstown, San Francisco and London, 1976.

Turner, Simon, *Wenceslaus Hollar*, 4 vols [*The New Hollstein German Engravings, Etchings and Woodcuts, 1400–1700*], Ouderkerk aan den IJssel, 2009–10.

Vasari, Giorgio, *Le vite de' più eccellenti pittori, scultori ed architettori* [1550, rev, edn 1568], ed. Gaetano Milanesi, 9 vols. Florence, 1906.

Venturi, Adolfo, *La R. Galleria Estense in Modena*. Modena, 1882.

Vergara, W. Alexander, 'The Count of Fuensaldaña and David Teniers: Their purchases in London after the Civil War', *Burlington Magazine*, vol. 131, no. 1031, February 1989, pp. 127–32.

Vickers, Michael, 'Rupert of the Rhine: A new portrait by Dieussart and Bernini's *Charles I*', *Apollo*, vol. 107, March 1978, pp. 161–9.

––––, *The Arundel and Pomfret Marbles in Oxford*. Oxford, 2006.

Waagen, Gustav Friedrich, *Treasures of Art in Great Britain*, 3 vols. London, 1854.

Walpole, Horace, *Anecdotes of Painting in England . . . with additions by the Rev. James Dallaway*, ed. Ralph N. Wornum, 3 vols. London, 1849.

Waterhouse, Ellis K., 'Paintings from Venice for seventeenth-century England: Some records of a forgotten transaction', *Italian Studies*, vol. 7, 1952, pp. 1–23.

Weijtens, F. H. C., *De Arundel-collectie: Commencement de la fin Amersfoort, 1655*. Utrecht, 1971.

Weston-Lewis, Aidan, 'Orazio Gentileschi's two versions of "The Finding of Moses" reassessed', in Gabriele Finaldi (ed.), *Orazio Gentileschi at the Court of Charles I*, exh. cat., National Gallery, London, 1999, pp. 39–52.

Wethey, Harold E., *The Paintings of Titian*, 3 vols. London, 1975.

Whinney, Margaret, and Oliver Millar, *English Art, 1625–1714*. Oxford, 1957.

Whitaker, Lucy, 'L'accoglienza della collezione Gonzaga in Inghilterra', in Raffaella Morselli (ed.), *Gonzaga: La celeste galleria: L'esercizio del collezionismo*, exh. cat., Palazzo Te and Palazzo Ducale, Mantua, 2002, pp. 233–49.

Whitaker, Lucy, and Martin Clayton, *The Art of Italy in the Royal Collection: Renaissance and Baroque*, exh. cat., The Queen's Gallery, London, 2007.

White, Christopher, *Anthony van Dyck: Thomas Howard, the Earl of Arundel*, Malibu, 1995.

The Whole Manner of the Treaty with the Several Speches that Passed in the Banqueting-house at White-hall Between His Highness the Lord Protector and the Lords Embassadors of the United Provinces of Holland. London, 1654.

Wilks, Timothy V., 'The Court Culture of Prince Henry and his Circle, 1603–1613', doctoral dissertaion, University of Oxford, 1988.

––––, '"Paying special attention to the adorning of a most beautiful gallery": The pictures in St James's Palace, 1609–49', *Court Historian*, vol. 10, no. 2, December 2005, pp. 149–72.

–––– (ed.), *Prince Henry Revived: Image and Exemplarity in Early Modern England*. London, 2007.

Williamson, Hugh Ross, *Four Stuart Portraits*. London, 1949.

Wilson, Michael I., *Nicholas Lanier, Master of the King's Musick*. Aldershot, 1994.

Wittkower, Rudolf, 'Inigo Jones – "Puritanissimo Fiero"', *Burlington Magazine*, vol. 90, no. 539, February 1948, pp. 50–1.

Wood, Jeremy, 'Van Dyck's "cabinet de Titien": The contents and dispersal of his collection', *Burlington Magazine*, vol. 132, no. 1051, October 1990, pp. 680–95.

––––, 'Van Dyck's pictures for the Duke of Buckingham: The elephant in the carpet and the dead tree with ivy', *Apollo*, vol. 136, no. 365, July 1992, pp. 37–47.

––––, 'The architectural patronage of Algernon Percy, 10th Earl of Northumberland', in John Bold and Edward Chaney (eds), *English Architecture, Public and Private: Essays for Kerry Downes*. London and Rio Grande, 1993, pp. 55–80.

––––, 'Van Dyck and the Earl of Northumberland: taste and collecting in Stuart England', in Susan J. Barnes and Arthur K. Wheelock Jr. (eds), *Van Dyck 350* (Studies in the History of Art, vol. XLVI. Center for Advanced Study in the Visual Arts. Symposium Papers XXVI). Washington, DC, 1994, pp. 281–326.

––––, 'Orazio Gentileschi and some Netherlandish Artists in London: The patronage of the Duke of Buckingham, Charles I and Henrietta Maria', *Simiolus: Netherlands Quarterly for the History of Art*, vol. 28, no. 3, 2000–1, pp. 103–28.

––––, 'Nicholas Lanier (1588–1666) and the origins of drawings collecting in Stuart England', in Christopher Baker, Caroline Elam and Genevieve Warwick (eds), *Collecting Prints and Drawings in Europe, c.1500– 1750*. Burlington, VT, 2002, pp. 85–119.

ILLUSTRATIONS

19 Raphael (1483–1520), *Baldassare Castiglione*, 1514–15, oil on canvas, 82 × 67 cm. Musée du Louvre, Paris

20 Sebastiano del Piombo (*c.*1485–1547), *Ferry Carondelet and his Secretaries*. *c.*1510–12, oil on panel, 112.5 × 87 cm. Museo Thyssen-Bornemisza, Madrid

21 Peter Paul Rubens (1577–1640), *Thomas Howard, 2nd Earl of Arundel*, 1629–30, pen and brush in brown ink over black and red chalk on paper, sheet 27.5 × 19.3 cm. Ashmolean Museum, University of Oxford

22 Daniel Mytens (*c.*1590–1647), *Aletheia, Countess of Arundel, c.*1618, oil on canvas, 207 × 127 cm. National Portrait Gallery, London

23 Wenceslaus Hollar (1607–1677), *Würzburg Castle*, 1636, etching, 8.7 × 13.8 cm. British Museum, London

24 Gerrit van Honthorst (1590–1656), *George Villiers, 1st Duke of Buckingham with his Family*, 1628, oil on canvas, 132.5 × 192.8 cm. Royal Collection Trust

25 Peter Paul Rubens (1577–1640), *The Duke of Buckingham on Horseback,* 1625, oil on panel, 46.6 × 51.7 cm. Kimbell Art Museum, Fort Worth

26 Titian (*c.*1488–1576), *Ecce Homo*, 1543, oil on canvas, 242 × 361 cm. Kunsthistorisches Museum, Vienna

27 Juan de la Corte (1597–1660), *The Arrival of the Prince of Wales in Madrid*, 1623, oil on canvas, 158 × 285 cm. Museo de Historia, Madrid

28 Melchior Tavernier (1594–1665), *Prince Charles, James I and Diego Hurtado de Mendoza, the Spanish Ambassador, at a Banquet in York House, London, Held in Honour of the Ambassador*, 1624, engraving, 12 × 13.5 cm. British Museum, London

29 Titian (*c.*1488–1576), *Venus del Pardo ('Jupiter and Antiope'), c.*1551, oil on canvas, 196 × 385 cm. Musée du Louvre, Paris

30 Daniel Mytens (*c.*1590–1647), *James, 3rd Marquess and later 1st Duke of Hamilton*, 1629, oil on canvas, 221 × 139.7 cm. Scottish National Portrait Gallery, Edinburgh. Purchased with help from the Art Fund, the National Heritage Memorial Fund and the Pilgrims Trust 1987

31 Raphael (1483–1520) (?and workshop), *Saint Margaret*, 1518, oil on poplar panel, 191.3 × 123 cm. Kunsthistorisches Museum, Vienna

32 Giorgione (1477–1510), *The Three Philosophers*, 1508/9, oil on canvas, 125.5 cm × 146.2 cm. Kunsthistorisches Museum, Vienna

33 Antonella da Messina (*c.*1430–1479), the San Cassiano Altarpiece, 1475–6, oil on poplar panel, centre panel: 115 × 63 cm, left panel: 55.5 × 35 cm, right panel: 56.8 × 35.6 cm. Kunsthistorisches Museum, Vienna

34 Michelangelo (1475–1564), *The Dying Slave*, 1513–15, marble, 227.7 × 72.4 × 53.5 cm. Musée du Louvre, Paris

35 Detail of fig. 58

36 Titian (*c.*1488–1576), *The Entombment, c.*1520, oil on canvas, 148 × 212 cm. Musée du Louvre, Paris

37 Titian (*c.*1488–1576), *Nymph and Shepherd*, 1570–75, oil on canvas, 186.5 × 209 cm. Kunsthistorisches Museum, Vienna

38 Titian (*c.*1488–1576), *Federico Gonzaga, Duke of Mantua*, 1529, oil on canvas, 125 cm × 99 cm. Museo Nacional del Prado, Madrid

39 Anthony Van Dyck (1599–1641), *Nicholas Lanier*, 1628, oil on canvas, 111 × 87.6 cm. Kunsthistorisches Museum, Vienna

40 Jacopo Bassano (*c.*1510–1592), *The Journey of Jacob, c.*1561, oil on canvas, 129.4 × 184.2 cm. Royal Collection Trust

41 Jacopo Bassano (*c.*1510–1592), *The Good Samaritan, c.*1545–50, oil on canvas, 64.8 × 84.2 cm. Royal Collection Trust

42 Paolo Veronese (1528–1588), *Christ and the Woman of Samaria,* 1585, oil on canvas, 143 × 289 cm. Kunsthistorisches Museum, Vienna

43 Paolo Veronese (1528–1588), *Christ and the Centurion, c.*1571, oil on canvas, 192 cm × 297 cm. Museo Nacional del Prado, Madrid

44 Paolo Veronese (1528–1588), *Wisdom and Strength, c.*1580, oil on canvas, 214.6 × 167 cm. The Frick Collection, New York

45 Paolo Veronese (1528–1588), *The Choice between Virtue and Vice, c.*1580, oil on canvas, 219.1 × 169.5 cm. The Frick Collection, New York

46 Jacopo Tintoretto (1518–1594), *The Origin of the Milky Way, c.*1575, oil on canvas, 149.4 × 168 cm. National Gallery, London

47 Jacopo Tintoretto (1518–1594), *Christ Washing the Feet of his Disciples,* 1548–9, oil on canvas, 210 cm × 533 cm. Museo Nacional del Prado, Madrid

48 Jacopo Tintoretto (1518–1594), *The Woman Taken in Adultery,* 1547, oil on canvas, 189 × 355 cm. Gemäldegalerie Alte Meister, Staatliche Kunstsammlungen, Dresden

49 Jacopo Tintoretto (1518–1594), *Esther before Ahasuerus, c.*1546–7, oil on canvas, 207.7 × 275.5 cm. Royal Collection Trust

50 Jacopo Tintoretto (1518–1594), *The Muses,* 1578, oil on canvas, 206.7 × 309.8 cm. Royal Collection Trust

51 Correggio (1489–1534), *Jupiter and Io,* 1530, oil on canvas, 162 × 73.5 cm. Kunsthistorisches Museum, Vienna

52 Correggio (1489–1534), *Jupiter and Ganymede,* 1530, oil on canvas, 163.5 cm × 72 cm. Kunsthistorisches Museum, Vienna

53 Bernadino Luini (1480–1532), *Salome with the Head of Saint John the Baptist, c.*1525–30, oil on canvas, 62 cm × 78 cm. Museo Nacional del Prado, Madrid

54 Leonardo da Vinci (1452–1519), *Saint John the Baptist,* 1513–16, oil on panel, 69 × 57cm. Musée du Louvre, Paris

55 Raphael (1483–1520), *Saint Paul Preaching at Athens, c.*1515–1516, bodycolour on paper, mounted on canvas, 343 × 442 cm. Royal Collection Trust

56 Raphael (1483–1520), *Death of Ananias, c.*1515–6, bodycolour on paper, mounted on canvas, 342 × 532 cm. Royal Collection Trust

57 Raphael (1483–1520), *Saint George and the Dragon, c.*1506, oil on panel, 28.5 × 21.5 cm. National Gallery of Art, Washington, D.C., Andrew W. Mellon Collection

58 Raphael (1483–1520), *The Holy Family (La Perla), c.*1518, oil on canvas, 147.4 cm × 116 cm. Museo Nacional del Prado, Madrid

59 Hubert Le Sueur (*c.*1585–1670), *Borghese Gladiator, c.*1630, bronze, 151.0 × 203.0 × 119.0 cm. Royal Collection Trust

60 Roman copy of a 5th- or 4th-century BC Greek original, *Aphrodite,* marble. Ashmolean Museum, University of Oxford

61 Daniel Mytens (*c.*1590–1647), *Thomas Howard, 2nd Earl of Arundel, c.*1618, oil on canvas, 207 × 127 cm. National Portrait Gallery, London

62 Unknown British artist, *Four Antique Sculptures: Sleeping Cupids*, 17th century, drawing, 24 × 16.1 cm. Royal Collection Trust

63 Roman, *Aphrodite* or *Crouching Venus*, marble, height: 119 cm. Royal Collection Trust

64 Unknown British artist, *Four Sculptures: Helen of Troy, a Divinity, a Standing Male and a Lely Venus*, 17th century, drawing, 23.8 × 17.8 cm. Royal Collection Trust

65 Giambologna (1519–1608), *Samson Slaying a Philistine*, 1560–62, marble, 209.9 × 76 × 66 cm. Victoria and Albert Museum, London, purchased with the assistance of The Art Fund

66 Hendrick van der Borcht the Younger (1614–1666) after Parmigianino (1503–1540), *The Virgin Embracing the Christ Child*, 1637, etching, 14.8 × 10.6 cm. British Museum, London

67 Hendrick van der Borcht the Younger (1614–1666) after Parmigianino (1503–1540), *The Death of Lucretia*, 1638, etching, 11 × 7.2 cm. British Museum, London

68 Philip Fruytiers (1610–1666), *Thomas Howard, Earl of Arundel is Presented with Arms by his Children to Mark his Appointment to Lead the Army against Scotland in 1639*, 1643, oil on copper, 40.6 × 55.9 cm. The Collection of His Grace The Duke of Norfolk, Arundel Castle

69 Hans Holbein the Younger (*c*.1497–1543), *Thomas Howard, 3rd Duke of Norfolk*, *c*.1538–9, oil on panel, 80.1 × 61.4 cm. Royal Collection Trust

70 Lucas Vorsterman the Elder (1595–1675) after Hans Holbein the Younger (1497/8–1543), *The Triumph of Riches*, *c*.1624–30, pen and black ink with black and red chalk and blue watercolour, heightened with white, 31 × 96 cm. Ashmolean Museum, University of Oxford

71 Lucas Vorsterman the Elder (1595–1675) after Hans Holbein the Younger (1497/8–1543), *The Triumph of Poverty*, *c*.1624–30, pen and brown ink, with brown wash, bodycolour, and black and red chalk, heightened with white, 43.4 × 58.5 cm. British Museum, London

72 Hans Holbein the Younger (1497/8–1543), *Christina of Denmark, Duchess of Milan*, 1538, oil on oak panel, 179.1 × 82.6 cm. National Gallery, London

73 Hans Holbein the Younger (1497/8–1543), *Sir Richard Southwell*, 1536, oil on panel, 47.5 × 38 cm. Galleria degli Uffizi, Florence

74 Adam Elsheimer (1578–1610), *The Exaltation of the True Cross*, 1605–8/9, oil on copper, 48.5 × 35 cm. Städel Museum, Frankfurt

75 Orazio Gentileschi (1563–1639), *The Finding of Moses*, early 1630s, oil on canvas, 242 × 281 cm. National Gallery, London (on loan from a private collection)

76 Michelangelo Merisi da Caravaggio (1571–1610), *The Death of the Virgin*, 1601–5/6, oil on canvas, 369 × 245 cm. Musée du Louvre, Paris

77 Guido Reni (1575–1642), *Nessus Abducting Deianira*, 1617–21, oil on canvas, 239 × 193 cm. Musée du Louvre, Paris

78 Domenico Fetti (*c*.1589–1623), *The Good Samaritan*, *c*.1618–22, oil on panel, 60 × 43.2 cm. The Metropolitan Museum of Art, New York

79 Domenico Fetti (*c*.1589–1623), *Hero and Leander*, 1621–2, oil on poplar panel, 41 × 97 cm. Kunsthistorisches Museum, Vienna

80 Domenico Fetti (*c*.1589–1623), *Andromeda and Perseus*, 1621–2, oil on poplar panel, 40.5 × 72.5 cm. Kunsthistorisches Museum, Vienna

81 Peter Paul Rubens (1577–1640), *Lady Arundel and her Retinue*, 1620, oil on canvas, 262.5 × 266 cm. Alte Pinakothek, Munich

82 Peter Paul Rubens (1577 -1640), *The Apotheosis of the Duke of Buckingham,* before 1625, oil on oak panel, 64 × 63.7 cm. National Gallery, London

83 Peter Paul Rubens (1577 -1640), *Minerva protects Pax from Mars ('Peace and War'),* 1629–30, oil on canvas, 203.5 × 298 cm. National Gallery, London

84 Peter Paul Rubens (1577–1640), *Landscape with Saint George and the Dragon,* 1635, oil on canvas, 152.5 × 226.9 cm. Royal Collection Trust

85 Anthony van Dyck (1599–1641), *The Three Eldest Children of Charles I,* 1635, oil on canvas, 151 × 154 cm. Galleria Sabauda, Turin

86 Anthony Van Dyck (1599–1641), *Charles I (Le Roi à la chasse),* c.1635, oil on canvas, 266 × 207 cm. Musée du Louvre, Paris

87 Anthony van Dyck (1599–1641), *Cupid and Psyche,* 1640, oil on canvas, 200.2 × 192.6 cm. Royal Collection Trust

88 Detail of fig. 156

89 Giovanni Battista Bolognini (1611–1688) after Guido Reni (1575–1642), *Bacchus and his Companions Finding Ariadne Abandoned on the Island of Naxos,* c.1650–80, etching, 49.2 × 106 cm. British Museum, London

90 *The Sussex Picture* or *An Answer to the Seagull (The Seagull, or the New Apparition in the Star-Chamber at Westminster),* 1644 (frontispiece). British Library, London

91 Hubert Le Sueur (1566–1688), *Charles I on Horseback,* 1633, bronze. Trafalgar Square, London

92 Peter Paul Rubens (1577–1640), the ceiling of the Banqueting House, 1632–4, oil on canvas, 33.5 × 16.9 m. Banqueting House, Whitehall, London

93 Peter Paul Rubens (1577–1640), the ceiling of the Banqueting House: *The Union of England and Scotland,* 1632–4, oil on canvas. Banqueting House, Whitehall, London

94 Peter Paul Rubens (1577–1640), the ceiling of the Banqueting House: *The Benefits of James I's Government,* 1632–4, oil on canvas. Banqueting House, Whitehall, London

95 Peter Paul Rubens (1577–1640), the ceiling of the Banqueting House: *The Apotheosis of James I,* 1632–34, oil on canvas. Banqueting House, Whitehall, London

96 The Music Room at Lamport Hall, Northamptonshire, photograph published in *Country Life,* vol. CXII, no. 2907, 3 October 1952

97 Anthony van Dyck (1599–1641), *Algernon Percy, 10th Earl of Northumberland as Lord High Admiral,* c.1638, oil on canvas, 131 × 223 cm. Collection of the Duke of Northumberland, Alnwick Castle

98 Anthony van Dyck (1599–1641), *Algernon Percy, 10th Earl of Northumberland, his First Wife, Lady Anne Cecil, and their Daughter, Lady Catherine Percy,* c.1633–1635, oil on canvas, 134 × 181.5 cm. Petworth House, National Trust

99 Adam Elsheimer (1578–1610), *Eight Saints and Prophets,* c.1605, oil on silvered copper. Petworth House, National Trust

100 Adam Elsheimer (1578–1610), *Tobias and the Angel,* c.1605, oil on silvered copper, 9 × 7 cm. Petworth House, National Trust

101 Andrea del Sarto (1486–1530), *Virgin and Child with the Infant Saint John the Baptist and Three Angels (The Corsini Madonna),* c.1513, oil on canvas, 132.1 × 96.5 cm. Petworth House, Collection of Lord Egremont

102 Andrea del Sarto (1486–1530), *Virgin and Child with Saint Anne, the Infant John the Baptist and Two Angels,* c.1515, oil on canvas, 134.6 × 99.1 cm. Petworth House, Collection of Lord Egremont

103 Palma Vecchio (*c.*1480–1528), *A Venetian Woman*, *c.*1520, oil on panel, 77.5 × 64.1 cm. National Gallery, London

104 Titian (*c.*1488–1576) and workshop, *The Vendramin Family*, begun *c.*1540–43, completed *c.*1550–1560, oil on canvas, 206.1 × 288.5 cm. National Gallery, London

105 Titian (*c.*1488–1576), *Perseus and Andromeda*, 1554–6, oil on canvas, 175 × 192 cm. Wallace Collection, London

106 Anthony van Dyck (1599–1641), *Olivia, Wife of Endymion Porter*, *c.*1637, oil on canvas, 135.9 × 106 cm. Syon House, Middlesex

107 Peter Lely (1618–1680), *Charles I and James, Duke of York*, *c.*1647, oil on canvas, 126.4 × 146.7 cm. Syon House, Middlesex

108 Polidoro da Caravaggio (*c.*1495–1543), *Psyche Abandoned on a Rock*, *c.*1527–8, oil on pine panel, 85.7 × 161.5 cm. Royal Collection Trust

109 Workshop of Giulio Romano (*c.*1499–1546), *Sacrifice of a Goat to Jupiter*, *c.*1536–9, oil on panel, 123.0 × 66.2 cm. Royal Collection Trust

110 Detail of fig. 20

111 Hans Holbein the Younger (1497/8–1543), *Dr Chambers*, 1543, oil on oak panel, 58 × 39.7 cm. Kunsthistorisches Museum, Vienna

112 Anthony van Dyck (1599–1641), *Thomas Howard, Earl of Arundel, with his Grandson Thomas, later 5th Duke of Norfolk*, 1635–6, oil on canvas, 143 × 120 cm. The Collection of His Grace The Duke of Norfolk, Arundel Castle

113 Wenceslaus Hollar (1607–1677) after Cornelis Schut (1597–1655), *Allegory on the Death of Thomas Howard, Earl of Arundel*, 1650, etching, 43 × 31.9 cm. British Museum, London

114 Hans Holbein the Younger (1497/8–1543), *An Allegory of Passion*, *c.*1532–6, oil on panel, 45.4 × 45.4 cm. The J. Paul Getty Museum, Los Angeles

115 Raphael (1483–1520), *Pope Leo X with Cardinals Giulio de' Medici and Luigi de' Rossi*, 1518, oil on panel, 155.5 × 119.5 cm. Galleria degli Uffizi, Florence

116 Giuliano Bugiardini (1475–1554), *Pope Leo X with Cardinals Giulio de' Medici and Innocenzo Cibo*, oil on canvas, 157 × 117.5 cm. Galleria Corsini, Rome

117 Hans Holbein the Younger (1497/8–1543), *Erasmus*, 1523, oil on panel, 73.6 × 51.4 cm. National Gallery, London (on loan from the Longford Castle Collection, Wiltshire)

118 Charles Le Brun (1619–1690), *The Family of Everhard Jabach*, 1647, oil on canvas, 276 × 325 cm. Formerly Kaiser-Friedrich Museum, Berlin (destroyed 1945)

119 Hans Holbein the Younger (1497/8–1543), *Nicholas Kratzer*, 1528, oil on canvas, 83 × 67 cm. Musée du Louvre, Paris

120 Hans Holbein the Younger (1497/8–1543), *Thomas Godsalve and his Son, John*, 1528, oil on oak panel, 35 × 36 cm. Gemäldegalerie Alte Meister, Staatliche Kunstsammlungen, Dresden

121 Hans Holbein the Younger (1497/8–1543), *Anne of Cleves*, *c.*1539, oil on canvas, 65 × 48 cm. Musée du Louvre, Paris

122 Rowland Lockey (*c.*1565–1616), after Hans Holbein the Younger (1497/8–1543), *The Family of Sir Thomas More*, 1592, oil on canvas, 251.5 × 350.5 cm. Nostell Priory, National Trust

123 Albrecht Dürer (1471–1528), *Katharina Fürlegerin*, 1497, watercolour on linen, 43 × 56 cm, Städel Museum, Frankfurt

124 Antonello da Messina (*c.*1430–1479), *Saint Sebastian*, 1478, oil on canvas, 171 × 85.5 cm. Gemäldegalerie Alte Meister, Staatliche Kunstsammlungen, Dresden

125 Titian (*c.*1488–1576), *The Flaying of Marsyas*, *c.*1576, oil on canvas, 212 × 207 cm. The Archbishop's Gallery, Kroměříž, Czech Republic

126 Anthony van Dyck (1599–1641), *Charles I and Henrietta Maria*, 1632, oil on canvas, 113.5 × 63 cm. The Archbishop's Gallery, Kroměříž, Czech Republic

127 Anthony van Dyck (1599–1641), *George Villiers, 2nd Duke of Buckingham, and Lord Francis Villiers*, 1635, oil on canvas, 186.7 × 137.2 cm. The Royal Collection, London

128 Peter Paul Rubens (1577–1640) and Jan Brueghel the Elder (1568–1625), *Nature Adorned by the Three Graces*, *c.*1615, oil on panel, 131 × 96.7 cm. Kelvingrove Art Gallery and Museum, Glasgow

129 David Teniers the Younger (1610–1690), *Archduke Leopold Wilhelm*, 1652, oil on canvas, 203.5 × 136 cm. Kunsthistorisches Museum, Vienna

130 Orazio Gentileschi (1563–1639), *The Rest on the Flight into Egypt*, 1626–8, oil on canvas, 138.5 × 216 cm. Kunsthistorisches Museum, Vienna

131 Peter Paul Rubens (1577–1640), *Daniel in the Lions' Den*, *c.*1614–16, oil on canvas, 224.2 × 330.5 cm. National Gallery of Art, Washington, D.C., Ailsa Mellon Bruce Fund

132 David Teniers the Younger (1610–1690), *The Gallery of Archduke Leopold Wilhelm*, 1651, oil on canvas, 96 × 129 cm. Musées Royaux des Beaux-Arts, Musée d'Art Ancien, Brussels

133 Carlo Saraceni (1579 - 1620), *Judith with the Head of Holofernes*, 1610–15, oil on canvas, 90 × 79 cm. Kunsthistorisches Museum, Vienna

134 Titian (*c.*1488–1576), *The Death of Actaeon*, *c.*1559–75, oil on canvas, 178.8 × 197.8 cm. National Gallery, London

135 Paolo Veronese (1528–1588), *The Adoration of the Magi*, 1580–88, oil on canvas, 117 × 174 cm. Kunsthistorisches Museum, Vienna

136 Paolo Veronese (1528–1588), *Christ Healing a Woman with an Issue of Blood*, 1565–70, oil on canvas, 102 × 136 cm. Kunsthistorisches Museum, Vienna

137 Detail of fig. 161

138 *The Execution of Charles I*, *c.*1649, oil on canvas, 163.20 × 296.80 cm. Scottish National Portrait Gallery (on loan from the collection of Lord Dalmeny)

139 Workshop of Giulio Romano (*c.*1499–1546), *The Omen of Claudius's Imperial Power*, *c.*1536–9, oil on panel, 121.4 × 93.5 cm. Royal Collection Trust

140 Workshop of Giulio Romano (*c.*1499–1546), *Nero Playing while Rome Burns*, *c.*1536–9, oil on panel, 121.5 × 106.7 cm. Royal Collection Trust

141 Andrea Mantegna (1431–1506), *The Triumphs of Caesar: The Musicians*, *c.*1484–92, tempera on canvas, 270.2 × 280.5 cm. Royal Collection Trust

142 Andrea Mantegna (1431–1506), *The Triumphs of Caesar: The Corselet Bearers*, *c.*1484–92, tempera on canvas, 270.8 × 280.4 cm. Royal Collection Trust

143 Titian (*c.*1488–1576), *Salome with the Head of Saint John the Baptist*, *c.*1550, oil on canvas, 87 × 80 cm. Museo Nacional del Prado, Madrid

144 Luca Cambiaso (1527–1585), *The Assumption of the Virgin* (fragment), oil on canvas, 170.3 × 161.9 cm. Royal Collection Trust

145 Titian (*c.*1488–1576), *Saint Margaret Triumphing over the Devil*, *c.*1560, oil on canvas, 198 × 167.6 cm. Private collection, Switzerland

146 Titian (*c.*1488–1576), *Emperor Charles V on Horseback*, 1548, oil on canvas, 335 × 283 cm. Museo Nacional del Prado, Madrid

147 Anthony van Dyck (1599–1641), *Charles I on Horseback,* *c.*1637–8, oil on canvas, 367 × 292.1 cm. National Gallery, London

148 Titian (*c.*1488–1576), *Pope Alexander VI Presenting Jacopo Pesaro to Saint Peter,* *c.*1513, oil on canvas, 145 × 183 cm. Koninklijk Museum voor Schone Kunsten, Antwerp

149 Andrea del Sarto (1486–1530), *Virgin and Child with Saint Matthew and an Angel (Madonna della Scala),* *c.*1522, oil on canvas, 177 × 135 cm. Museo Nacional del Prado, Madrid

150 Aegidius Sadeler II (*c.*1570–1629) after Titian (*c.*1488–1576), *D. Oct. Augustus,* etching and engraving, 35.6 × 24.4 cm. British Museum, London

151 Aegidius Sadeler II (*c.*1570–1629) after Titian (*c.*1488–1576), *C. Caesar Caligula,* etching and engraving, 35.2 × 24.4 cm. British Museum, London

152 Titian (*c.*1488–1576), *The Allocution of Alfonso d'Avalos, Marchese del Vasto,* 1540–41, 223 × 165 cm. Museo Nacional del Prado, Madrid

153 Correggio (1489–1534), *Venus with Mercury and Cupid ('The Education of Cupid'),* *c.*1525, oil on canvas, 155.6 × 91.4 cm. National Gallery, London

154 Anthony van Dyck (1599–1641), *Everhard Jabach,* *c.*1636–1637, oil on canvas. 113 × 91.5 cm. The State Hermitage Museum, St Petersburg

155 Anthony van Dyck (1599–1641), *Charles I with M. de Saint-Antoine,* 1633, oil on canvas, 370 × 270 cm. Royal Collection Trust

156 Correggio (1489–1534), *Venus and Cupid with a Satyr ('Jupiter and Antiope'),* *c.*1528, oil on canvas, 188 × 125 cm. Musée du Louvre, Paris

157 Correggio (1489–1534), *Allegory of Vice,* 1528–30, tempera on canvas, 142 × 85.5 cm. Musée du Louvre, Paris

158 Correggio (1489–1534), *Allegory of Virtue,* 1528–30, tempera on canvas, 142 × 85.5 cm. Musée du Louvre, Paris

159 Albrecht Dürer (1471–1528), *Self-portrait,* 1498, oil on panel, 52 × 41 cm. Museo Nacional del Prado, Madrid

160 Andrea Mantegna (1430/1–1506), *The Dormition of the Virgin,* *c.*1462, tempera on panel, 54.5 × 42 cm. Museo Nacional del Prado, Madrid

161 David Teniers the Younger (1610–1690), *Archduke Leopold Wilhelm in his Picture Gallery in Brussels,* 1651–3, oil on copper, 104.8 × 130.4 cm. Museo Nacional del Prado, Madrid

162 Anthony van Dyck (1599–1641), *Philip Herbert, 4th Earl of Pembroke and his Family,* *c.*1635–8, oil on canvas, 27.9 × 43.2 cm. The Collection of the Earl of Pembroke, Wilton House, Wiltshire

163 Titian (*c.*1488–1576), *Venus and Cupid with an Organ Player,* *c.*1550, oil on canvas, 138 × 222.4 cm. Museo Nacional del Prado, Madrid

164 Anthony van Dyck (1599–1641), *The Continence of Scipio,* 1620–21, oil on canvas, 183 × 232.5 cm. Christ Church Picture Gallery, University of Oxford

165 Detail of fig. 87

166 Titian (*c.*1488–1576), *Conjugal Allegory ('The Allegory of Alfonso d'Avalos, Marchese del Vasto'),* 1536–8, oil on canvas, 121 × 107 cm. Musée du Louvre, Paris

167 Anthony van Dyck (1599–1641), *The Five Eldest Children of Charles I,* 1637, oil on canvas, 163.2 × 198.8 cm. Royal Collection Trust

168 Daniel Mytens (*c.*1590–1647), *Christian, Duke of Brunswick and Lüneburg*, 1624, oil on canvas, 220.6 × 140 cm. Royal Collection Trust

169 Robert Walker (1599–1658), *Colonel John Hutchinson and his Son,* c.1648, oil on canvas, 126.4 × 101.6 cm. Earl Fitzwilliam Collection

170 Palma Giovane (1548–1628), *Venus and Cupid,* c.1570–1610, oil on canvas, 175.9 × 106.2 cm. Royal Collection Trust

171 Hans Holbein the Younger (*c.*1497–1543), *Johann Froben,* c.1522–3, oil on panel, 48.8 × 32.4 cm. Royal Collection Trust

172 Anthony van Dyck (1599–1641), *Charles I and Henrietta Maria with their Two Eldest Children, Prince Charles and Princess Mary ('The Great Piece')*, 1632, oil on canvas, 303.8 × 256.5 cm. Royal Collection Trust

173 Emanuel de Critz (1608–1665), *John Tradescant the Younger and Hester, his Second Wife,* 1657, oil on canvas, 72 × 118 cm. Ashmolean Museum, University of Oxford

174 Circle of John Weesop (fl. 1641–1653), *Philip Sidney, later 3rd Earl of Leicester*, n.d., oil on canvas, 123.2 × 99.1 cm. The Collection of Viscount De L'Isle, Penshurst Place, Kent

175 Attributed to Francesco Bassano (1549–1592), *Summer (Ruth and Boaz)*, c.1570–90, oil on canvas, 115.5 × 167.4 cm. Royal Collection Trust

176 Giulio Romano (*c.*1499–1546) and his studio, *Chiron and Achilles*, 1540, oil on poplar panel, 128.1 × 82.9 cm. Royal Collection Trust

177 Polidoro da Caravaggio (*c.*1495–1543), *Putti with Goats*, c.1527–8, oil on pine panel, 31 × 120 cm. Royal Collection Trust

178 Hans Holbein the Younger (*c.*1497–1543), *William Reskimer*, c.1532–3, oil on panel, 46 × 33.5 cm. Royal Collection Trust

179 Charles Grignion (1717–1810) after Samuel Wale (1720–1786), *South View of Northumberland House*, 1761, etching, 9.3 × 14.7 cm. British Museum, London

180 Giulio Romano (*c.*1499–1546), *Margherita Paleologo*, c.1531, oil on panel, 115.5 × 90 cm. Royal Collection Trust

181 Lorenzo Lotto (*c.*1480–1556), *Andrea Odone*, 1527, oil on canvas, 104.6 × 116.6 cm. Royal Collection Trust

182 Detail of fig. 147

PHOTOGRAPH CREDITS

© RMN-Grand Palais (Musée du Louvre) / Hervé Lewandowski: 120, 121, 158

Nostell Priory, By kind permission of Lord St. Oswald and the National Trust: 122

© The Archbishop's Gallery, Kroměříž, Czech Republic / © Mondadori Electa / The Bridgeman Art Library 125, 126

© CSG CIC Glasgow Museums Collection: 128

© Royal Museums of Fine Arts of Belgium, Brussels / Photograph by J. Geleyns / www.roscan.be: 132

Koninklijk Museum voor Schone Kunsten, Antwerp, Belgium / The Bridgeman Art Library: 148

© The State Hermitage Museum / photo by Yuri Molodkovets: 154

© RMN-Grand Palais (Musée du Louvre) / René-Gabriel Ojéda: 156

© RMN-Grand Palais (Musée du Louvre) / Jean Schormans: 157

© Collection of the Earl of Pembroke, Wilton House, Wilts. / The Bridgeman Art Library: 162

By permission of the Governing Body of Christ Church, Oxford: 164

© Viscount De L'Isle from his private collection: 174

INDEX